A *O*

artists' and illustrators' encyclopedia

John Quick

Advertising and Promotion Manager
Film Division, Olin Mathieson Chemical Corporation

artists' and illustrators' encyclopedia

new york st. louis **McGRAW-HILL BOOK COMPANY**

san francisco düsseldorf johannesburg kuala lumpur

london mexico montreal new delhi panama

rio de janeiro singapore sydney toronto

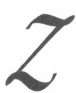

To my wife Hope

preface

The intent of this book is three-fold: (1) to describe the wide range of methods and materials used in the arts and graphic arts to produce a visual end-product; (2) to present information as quickly and easily as possible; and (3) to make the entries brief, yet complete enough to solve problems or serve as guides to further study.

Today there are more tools and techniques available than ever before. Also, a great many persons are involved in more than one medium. In commercial art a person is expected to be familiar with photography and printing. This sort of versatility is now coming to be associated with fine artists. They are working in graphics, printing, photography, and electronics, and dealing with such materials as plastics, adhesives, and welding equipment. In many areas people are routinely using materials developed within the last ten or fifteen years.

This encyclopedia attempts to survey an extremely broad area yet serve as a useful working tool. In some cases it may eliminate a great deal of costly, or time-consuming, trial and error on the part of both amateur and professional. It's a simple fact that some things work better than others. There are certain surfaces that require special paints, certain inks that can't be mixed with other inks without curdling, and various papers specially designed for certain specific uses. Frequently, the choice of the proper brush can make the difference between success and failure. Finally, there are materials and techniques that simply shouldn't be used at all, from the standpoint of reliability, permanence, or the safety of the artist.

In the visual arts, a lot of decision making lies between the conception and the execution of an idea, and this book succeeds if it

provides the artist or craftsman with a few new choices or new ideas. Likewise, as new materials are developed, and additional choices accrue, their characteristics and applications will be reviewed in future editions of this book. To this end, any suggestions from readers are cordially invited.

I wish to thank the many people who contributed to this book, especially product manufacturers and distributors who were so generous with information and assistance. I am particularly indebted to Mr. Dick Woolley and Mr. Marsh Faber who reviewed the manuscript. Their wide experience and training (ranging from physics to film production) were of considerable importance to a book of this sort.

John Quick

contents

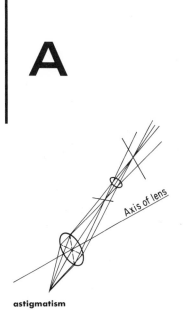

astigmatism

abbozzo A sketch or first draft of a work of art.

aberrations There are sometimes faults in lenses that prevent them from bringing light rays to a perfect focus. Some of the more common aberrations are as follows.

 astigmatism. A condition that does not allow point focus at all. Such a lens produces two clearly separated image lines perpendicular to each other.

 chromatic aberration. A defect in which rays of light of different colors come to focus in different planes.

 coma. An optical aberration affecting only off-axis points in the lens field. These image points are distorted into various unsymmetrical shapes.

 spherical aberration. An aberration which occurs because the rays farthest from the axis of the lens intersect ahead of those rays closer to the axis of the lens.

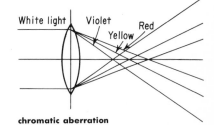

chromatic aberration

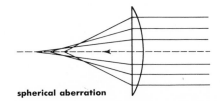

spherical aberration

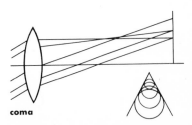

coma

abrasives Abrasives are used to surface and finish materials such as glass, metals, stone, and wood. Natural abrasives include corundum, diamond, emery, garnet, pumice, quartz, sand, and tripoli. Artificial abrasives include aluminum oxide, boron carbide, and silicon carbide. *See also* SANDPAPER.

acetate colors Opaque, waterproof paints that can be used on smooth surfaces such as acetate, glass, foil, and most plastic surfaces without crawling or peeling. The colors mix well together, are brilliant, and thin with tap water.

acetate materials Cellulose acetate is an improvement on a product once known as celluloid. It is available in pads, rolls, and sheets, and comes in several weights. The transparent variety has a number of uses. The lighter weights are useful for covering drawings and prints. With enough care, acetate can be folded, but if creased too sharply it is apt to crack. The matte finish material is very good for making overlays in opaque colors and inks for color separations. Special inks and colors must be used, however. Colored acetate materials are discussed under MATERIALS FOR COLORING LIGHT.

acetic acid (1) Used in etching to clean plates just before the mordant is applied. For this purpose, cp (chemically pure) acetic acid should be used. This is a commercial grade of about 30 percent strength and is used undiluted. The plate is immersed for about five minutes. (2) Used in photography as the active ingredient in stop baths. For this purpose, glacial acetic acid is used. This is 99 percent acetic acid, but only a small amount is used with a much larger amount of water—normally making only about a 2 percent solution.

adhesives Various commercial adhesives include glues, latex cements, pastes, pyroxylin cements, rubber cements, and special compounds of synthetic rubbers and synthetic resins. A few of the more familiar adhesives are listed below.

 casein glue. A glue which is available in powder form and is mixed with water for use. It is water-resistant when dry and is particularly useful in gluing one wood surface to another, or to plywood. It is also suitable for wood veneering and for gluing plastic laminates to wood.

 cement for alabaster and marble repair work. Can be made by mixing 12 parts portland cement, 8 parts fine sand, and 1 part infusorial earth with enough sodium silicate (water glass) to form a thick paste. This material sets in one day.

 cements and solvents for plastic. These are many and varied. Problems concerning their use should be discussed with distributors of plastic materials. There are special cements or solvents for the

following bonds: acrylic to acrylic; acrylic to wood, metals, glass, and vinyl; butyrate, acetate, and triacetate; vinyl to vinyl; styrofoam to styrofoam; polystyrene to itself or to acrylics, cloth, cork, and wood; nylon to nylon; nylon to metal; phenolics; polyester to acrylic; epoxies; and cellulose acetate.

cheese glue. A development of the Middle Ages and both a glue and a cement. If hard cheese is soaked in water, then crumbled up and ground with lime and a little water, it makes a sticky mixture that dries very hard and is not affected by moisture.

contact cement. A liquid, ready-to-use neoprene-based adhesive. It is water-resistant and no clamping is required for its use. It is good for gluing wood veneering, metal to metal, leather to leather, and wood and cloth to cloth or wood. It is also very good for gluing plastic laminates to wood; rubber to leather or to wood; and plywood panels to frames or studs. Pieces to be fastened must be aligned perfectly when brought together, since there is no chance for later adjustment or repositioning.

dextrin. An adhesive made by processing wheat starch. Purchased as a white powder, it is dissolved in hot water to make a syrup. It is often used as an adhesive in collage work, and as a binder in poster paints and designers' colors. It also has applications as a sizing for paper and for various operations in bookbinding.

epoxy cement. Consists of two parts, resin and hardener, which are mixed together for use. It has a setting time of about eight to ten hours, and bonds almost anything. It is useful for repairing china and for general patching, sealing, and soldering. It is perhaps best used for gluing metal to wood, and metal to metal.

fish glue. An impure gelatin prepared from the heads, bones, and skins of fish. The glue made from skins is the clearest and the best, but it is easily spoiled by bacterial decomposition and is generally inferior to animal glue as an adhesive.

household cement. A vinyl-base liquid that is clear and fast-drying (five to fifteen minutes) and water-resistant. It is best used for china repairing, but is also acceptable for gluing paper to paper or cloth, and cloth to cloth or wood.

liquid hide glue. A brown animal glue. It is a reliable adhesive and has a clamping time of forty to fifty minutes. It is best for gluing leather to leather or to wood, but is also acceptable for gluing wood to wood and plywood, wood veneering, plastic laminates to wood, paper to paper or cloth, and cloth to cloth or wood.

liquid solder. A material that requires no heat or mixing. It is water-resistant and best used for patching, sealing, and fastening. It is usually a household cement made electrically conductive by the addition of powdered metals.

marouflage. A traditional nonaqueous adhesive and also a term to describe mounting canvas on wood. In use, a thick coating of white lead in oil is brushed onto a board or wall, and also on the back

of the canvas to be mounted. (If any oil has settled on the top of the lead, it should be first poured off.) The two are then placed together and the canvas pressed out smoothly with the palms of the hands. The usual safeguards should be taken when using white lead. It is poisonous.

model airplane cement. An extremely fast-drying cement used for gluing balsa wood and other woods. Some kinds will also glue metal to metal, and metal to wood.

mucilage. A common adhesive, used mostly for gluing paper to paper. It can be made from the following ingredients, mixed by volume: 1 part gum arabic (or gum acacia), 1 part rice starch, 4 parts sugar, and 10 parts water. The gum arabic should be warmed with some of the water until it has a jellylike consistency. The sugar and the starch are mixed with enough water to make a smooth paste. The two mixtures are then combined with the remaining water and boiled until clear. The material is then ready for use. (One-half teaspoon of 40 percent formaldehyde may be added to each pint of the mixture to make it mildew-resistant.)

paste. Can be any of a group of adhesives made chiefly from flour or starch. Flour itself consists of a mixture of gluten and starch, and smoother pastes can be made from starch alone. The starch from wheat, corn, rice, potatoes, and arrowroot makes a good adhesive. A simple paste for mounting paper can be made with 1 part wheat flour and 10 parts water (by volume). Enough of the cold water is added to the flour to make a thin batter. This is stirred until all the lumps are gone. The remaining water is added and the mixture heated in a double boiler. It is stirred until it becomes a thick paste. To each pint of this paste, during mixing, should be added $\frac{1}{4}$ teaspoon of alum and $\frac{1}{2}$ teaspoon of 40 percent formaldehyde. These materials will make the paste dry to a harder coat and provide protection against mildew.

plastic resin adhesives. Powdered, urea-based glues that mix easily with water. They have good water-resistance and require about six to eight hours clamping. They are best used for wood veneering, and acceptable for gluing wood to wood and plywood, plastic laminates to wood, and woods for outdoor use.

polystyrene cement. A specially formulated solvent used in assembling polystyrene plastic models.

rubber cement. A gum rubber which is dissolved in benzol and which has a great many applications in the graphic arts. When used for paste-up purposes, rubber cement is easily handled. Excess cement is easily removed by rubbing, and previously cemented pieces can be removed by peeling them apart. It should not, however, be used for permanent works of art. In time it turns dark drown, stains paper, and loses adhesion.

spray adhesives. Made by several manufacturers and packaged in aerosol cans. Adhesives of this type are used mostly for paper.

If glued parts are left in place for any length of time, the adhesive becomes permanent.

stay-flat adhesive. *See* STAY-FLAT ADHESIVE *as a major heading.*

waterproof glue. A two-part resorcinol resin adhesive. It is fully waterproof and requires overnight clamping. It is best for use in marine applications and with wood for outdoor use. It is acceptable for use in gluing wood to wood and plywood, wood veneering, and plastic laminates to wood.

wax. An adhesive with properties that make it an excellent paper cement. Equipment is necessary to keep it warm and to apply it to paper. In smaller operations, hot plates and brushes can be used. In large facilities, automatic wax-coating machines are used, some of which are capable of handling large sheets. *See also* DRY MOUNTING.

white glue. A liquid, ready-to-use polyvinyl acetate resin. It sets fast (twenty to thirty minutes in clamps) and dries clear. It is best for gluing paper to paper or cloth, and cloth to cloth or wood. It is also very good for gluing wood to wood and plywood, wood veneering, plastic laminates to wood, and leather to leather or wood. It is strong and nonstaining.

adobe Adobe is an unburnt, sun-dried mortar of clay or mud. It is sometimes made with a filler of straw, and often fabricated in the form of bricks or blocks. The word derives from the Spanish *adobar,* "to plaster."

aerosol sprays *See* SPRAY PRODUCTS.

agate burnishers Burnishers for gold leaf are often made of agate, a hard, semiprecious stone. Sometimes the word "agate" alone is used to describe this tool. It has a wooden handle and agate heads of different configurations. It is also used for smoothing folds in paper patterns and for pressing down transfer lettering.

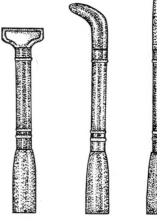

agate burnishers

aggregate The coarse or inert ingredients mixed with cement in the making of concrete. *See also* CONCRETE.

air The white space on a printed page.

airbrush An airbrush is a precision paint sprayer that is held like a pencil and is used where subtle blending and shading effects are needed. Smooth, delicate tones are characteristic of airbrush work, and it is widely used for retouching photographs and for producing original art. The basic parts of the airbrush are the air supply (either compressor or carbon dioxide tank), the hose, the regulator, and the airbrush spray unit. A wide range of water-soluble paints, dyes, and inks can be used. The portions of photographs and artwork that are not to be airbrushed are protected by masks called *friskets.* Larger

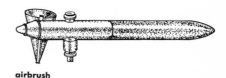

airbrush

devices, called spray guns, are used for spraying through stencils and for covering large areas with an even layer of paint.

ala de mosca A variety of fine granite or very hard rock found in Peru. It is used in sculpture.

alabaster Alabaster is a soft, translucent stone that is sometimes veined. It is easily worked with marble tools and will take a high polish that is permanent without the use of an artificial coating. Calcareous alabaster, sometimes called oriental alabaster, is a variety of carbonate of lime that is milky white in color and veined with yellow, red, or brown. Gypseous alabaster, or white alabaster, is a variety of sulfate of lime or gypsum.

Some of the common varieties include: *agate,* a deep semitranslucent brown with white mottling; *crystal,* a translucent white; *gabro rosso,* a mottled brown with sections of deep brown; *marbo black,* a marblelike pattern of black and white; *pink,* a deep pink color, sometimes veined; and *statuario,* a white alabaster, considerably more opaque than crystal.

albarium A Latin term meaning a thin, white stucco.

alla prima Alla prima painting is the process of executing a complete oil painting in one sitting. All the pigments are painted on in a single application, with the lighter colors usually being applied first, followed by the darker ones.

alumina Alumina is the common name of aluminum oxide. It is a lightweight white powder used as an extender in oil paints, as an inert base for lakes, and as an abrasive in the preparation of gesso panels.

aluminum plate A thin sheet of aluminum used in offset lithography. Images are produced on them photographically.

aluminum stearate This material is a white powder that forms gels with oil or turpentine. In small amounts it is used in paints to prevent the separation of pigments from oil binders, and in varnishes to produce a matte finish. Too much aluminum stearate in an oil paint used for fine painting will produce a film that is soft, crumbly, and slow-drying.

amassette Painters formerly used this instrument to mix colors on their palettes. Amassettes were made of horn, wood, or ivory and have since been replaced by the palette knife.

aniline colors These are dyes made from aniline, a derivative of coal tar. They constitute a wide range of lake colors, a number of which

are suitable for permanent painting. Certain aniline colors, however, are prone to fading and find only limited use in house paints, inks, and dyes. They are usually more permanent than vegetable colors, and are in general poisonous.

antimony Antimony is a metal that does not contract when cooled and is therefore used extensively in type-metal formulations containing a large proportion of lead. It gives added hardness to the type character and also a sharp outline. Type metal is used in typecasting, electrotyping, and stereotyping.

antistatic brushes Brushes that remove dust and static electricity from photographic negatives, filters, and other materials. They operate either from an electrical power supply or from small, self-contained radioactive sources.

appliqué Ornamental work made of one material and applied to another to produce a pattern or a design.

aquafortis Nitric acid diluted with from 1 to 5 parts water and used by etchers as a mordant for biting in plates. *See also* ETCHING ACIDS.

aquarelle A term commonly used to describe a watercolor drawing or painting executed in thin, transparent watercolors, as distinguished from opaque watercolor mediums such as tempera or casein. It may also refer to printed plates that are colored with watercolor with the use of stencils.

aquatint The aquatint technique is an intaglio process, but a method of biting tones instead of lines, thus producing very rich, dark tones as well as delicate, transparent tints. In this process, a copper or steel plate is dusted with powdered asphaltum or resin before being exposed to the action of the acid. Because the mordant cannot act upon the covered portions, a mottled surface is produced. The aquatint print resembles a drawing in watercolor, india ink, or sepia. The process is seldom used by itself, but is often combined with etching, drypoint, and other intaglio mediums. Like other engraving processes in the fine arts, the plate is printed on a hand press in a limited edition signed by the artist. (*See illustration on following page.*)

aquatint mezzotint An etching process in which the plate is prepared by the biting of a solid tone of aquatint. The design is then worked up with a scraper and burnisher, similar to the method used in mezzotint. The final result resembles a mezzotint print. (*See illustration on following page.*)

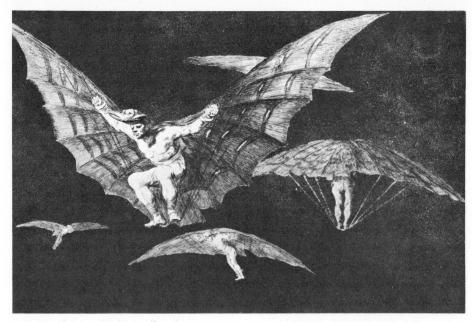

aquatint Goya, y Lucientes, Francisco.
THE BIRDMEN, "THE PROVERBS." (Spanish,
eighteenth century.) (*Courtesy of Museum
of Fine Arts, Boston.*)

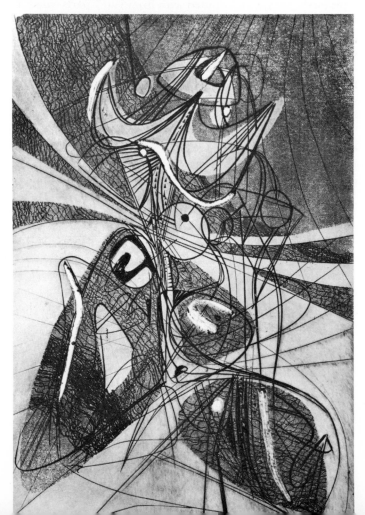

aquatint, mezzotint, etching Stanley William
Hayter. ABSTRACT DESIGN. (1946.) $5\frac{1}{4} \times 3\frac{7}{16}$
inches. (*Eugene Fuller Memorial Collection. Seattle
Art Museum.*)

aquatone A planographic printing process using plates that are produced photomechanically. A zinc plate is coated with sensitized gelatin and when exposed is developed in alcohol and water, then baked. The light-fixed bichromate image remains on the plate. It differs from the *collotype* process in that finer (200- to 400-line) halftone screens are used.

artwork A general term used in layout and printing. It refers to photographs, drawings, paintings, handlettering, and other graphic material. Since the end use of artwork is to be photographed for printing plates, it must be kept clean and flat. It is usually protected by a paper, tissue, or acetate flap, and is often mounted on stiff cardboard.

asbestine This is a kind of talc that is used to give body to polymer emulsion colors. It imparts a matte finish to gloss paints, and is also an inert pigment and will slightly tint colors.

asphaltum Liquid asphaltum dries to a hard surface when applied to etching plates, and it protects them from corrosion and scratching. It is sometimes used as a very soft ground, as a stop-out varnish, and for coating the backs of plates to protect them from the action of the mordant during the etching process. Under no circumstances should this material be used as a pigment in permanent painting.

atomizer A device for spraying fixative on a drawing. It consists of a pair of small metal tubes placed at right angles to each other. A stream of air from the larger blows across an open end of the smaller, the opposite end of which is in the fixative solution. Air is provided by blowing with the mouth and spray is thrown out. This method is now seldom used, mostly because of the introduction of fixatives in aerosol spray cans.

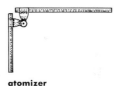

atomizer

aurum mussivum *See* MOSAIC GOLD.

azo dye Dye formed by the reaction of a diazo and a coupler, as in the diazotype process.

B

backup (1) After a sheet of paper has been printed on one side, it is "backed up" with printing on the other side. Often the ink must be dry before the reverse side can be printed, so a day may pass before the backing-up operation takes place. Some presses, however, can print a sheet and back it up in one operation. (2) The process of filling in the back of a thin copper electrotype to make it solid. (3) A sheet of paper glued to the back of a mount to counteract the curl from work glued to the front.

ball clay *See* CERAMICS TERMS.

ballusters The sections of wood used to make the frames on which silk, or some other material, is stretched in the silk-screen process.

bamboo pens *See* REED PENS.

baren The traditional Japanese tool for pressing paper against an inked wood block to produce a print. It consists of a circular pad made of a braided mat covered with a bamboo sheath. A circular movement is used as pressure is applied.

base An inert pigment, such as alumina, used in the manufacture of lakes.

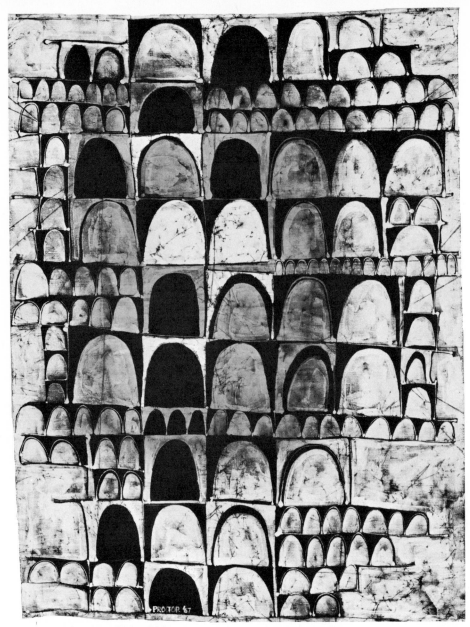

batik wall hanging Richard M. Proctor. ARCH FORMS. (1967.) (*Courtesy of the artist. Photograph by William Eng.*)

batik Batik is a resist technique for applying color and designs to fabrics. Melted wax is used to block out the areas *not* to be affected by the dyes. As each color is dyed it is then protected by a wax coating before the next color is applied. A typical wax blend is a combination of 1 part beeswax and 2 parts paraffin. It should be melted and held at a temperature just above the melting point. The hot wax is applied to fabrics with brushes, a *tjanting needle,* or wood blocks or linoleum blocks. After the dye is applied and set, the wax

is removed from the fabric by washing in boiling water. The fabric is washed three times, each time in fresh water. (This water should not be poured down a sink since the wax, as it cooled, would coat the drain pipe.)

bed The bed of a printing press is the surface against which the type is clamped. A publication is said to be "put to bed" when all type is in the press and is ready to be printed.

bentonite A powdered clay that gels when added to water. It is sometimes used in the manufacture of pastel chalks to make them less brittle.

binders Binders hold together particles of pigment in a continuous film. Typical paint binders include oil, glue, gum, resin, casein, and various plastic materials.

biting-in An etching term referring to the action of dilute nitric acid, or other mordant, upon the bare parts of a steel or copper plate. Plates are prepared by coating them with etching ground or varnish, portions of which are later removed with an etching needle. These bared portions are acted upon by the acid and constitute the printing portions of the plate.

black mirror A small, black glass that was once used by landscape artists. It both reduces the view of the subject and eliminates color, making composition somewhat easier for the artist. It is also called a *Claude Lorraine glass,* after the seventeenth-century French painter.

blanket (1) In engraving, the name given to the piece of cloth wrapped around the roller of the press when line engravings are made. It allows a greater uniformity of pressure and forces the paper more firmly against the plate. (2) In offset lithography, the rubber-surfaced sheet, bound around a cylinder, that transfers the image from the plate to the paper.

bleach-out process *See* DRAWINGS FROM PHOTOGRAPHS.

bleed If a photograph, or other artwork, extends to the very edge of a printed page it is said to bleed. To accomplish this, the page is first printed and then trimmed along the edge of the picture. Plates planned to bleed must extend $\frac{1}{8}$ inch or more beyond the trim edge of the sheet.

bleeding (1) The tendency of some pigments to work through coats of paint that have been applied over them. Certain dyes are inclined

to bleed through subsequent paint layers. (2) Color bleeding in photography may be due to such problems as defective processing, excessive exposure, subject reflections, underacidity of print transfer dyes, or improper mordant on the transfer support.

blending In painting, any system of merging two colors together so that they intermingle, rather than maintaining a sharp, hard-edged line of demarcation.

bloom Bloom is a milky or foggy defect that sometimes appears on the surface of a varnished painting. It is caused by moisture, either contained in the varnish or introduced during the drying period by condensation on the surface. Bloom can also be a surface effect, the same as that formed on furniture by moisture.

A superficial bloom can be removed by polishing the surface of the dry varnished painting with a paper tissue folded flat, on which has been placed a drop of household lubricating oil. This should be applied sparingly, without getting the surface oily. Changing the tissue frequently will absorb the surplus oil.

Varnishing is best done in a cool, dry atmosphere, such as an air-conditioned room. Dammar and acrylic varnishes are less apt to bloom than mastic or copal varnishes.

blue pencils Pale blue pencils are used to mark up artwork, photographs, and photostats. Light blue does not reproduce on line film or other ortho materials.

bole Bole is the ground laid for gold leaf. It is usually a dull red in color and is sometimes called *gold size*. Bole must be a very finely divided material in order to provide a smooth and nonabrasive foundation for the gold leaf.

bordering wax *See* WALLING WAX.

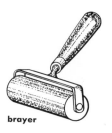
brayer

brayer A brayer consists of a soft rubber roller attached to a wooden or metal handle. It is used to ink wood blocks, linoleum blocks, lithographic stones, and printing plates. It should be kept as clean as possible and should be free of dents and scratches. In use, a small amount of ink is squeezed from its tube onto a piece of flat plate glass. The ink is rolled back and forth with the brayer until the ink is evenly distributed on the glass. The brayer is then rolled onto the block or stone.

brazing Soldering with relatively infusible alloys such as hard solder or brass. Higher temperatures than ordinary soldering are required. *See also* SOLDERING.

breathing tube A small tube of cane, paper, or metal about 6 or 7 inches long and $\frac{1}{2}$ inch in diameter. It is used to moisten bole grounds before gold leaf is laid on. The breath, when blown through the tube, carries enough moisture to make the ground sticky.

brilliant watercolors Transparent watercolors made from extremely vivid organic dyes. They are used in commercial art either alone or with other watercolor paints to achieve special effects. Many of the pigments are of doubtful permanence, but useful in the preparation of artwork that is to be photographed for printing plates.

bristle A material used in certain brushes. It is usually hog hair.

bronze powders These powders are made in a variety of shades, many of which imitate gold. They should not be used, however, in work that is intended to be permanent. They eventually darken, discolor, or tarnish.

brush cleaning After a brush has been used for oil painting it should be cleaned with several rinsings in turpentine or mineral spirits. It should then be wiped with a cloth and washed with warm water and a mild soap. The soap serves to emulsify and carry away the residual oil in the brush. By working the soapy brush against the palm of the hand, all traces of pigment can be removed, even the stubborn part that collects in the ferrule. After cleaning, the brush should be washed in warm, running water.

Brushes caked with dried oil can sometimes be restored by soaking them in acetone. Care should be taken, however, since acetone will also dissolve the material holding the bristles in the ferrule. The brush should be worked briskly in the solution and wiped frequently with a cloth. After this is done, the brush should be washed with soap and water. It must be remembered that acetone is flammable, and that *no* solvent should be used without adequate ventilation.

Brushes stiffened with shellac can be washed in a solution of borax and water. Tempera-caked brushes can be soaked in an ammonia or detergent solution, and lacquer-stiffened brushes can be cleaned with a solution of acetone and water to which a small amount of trisodium phosphate has been added.

On oil painting outings it is sometimes useful to take along a small quantity of petroleum jelly. After painting, brushes can be coated with this material. It will prevent the paint from hardening until there is time to clean them properly.

Watercolor brushes should also be washed with soap and water after use. After washing they should be rinsed with plenty of cool water.

Before brushes are put away they should be molded into their proper shape by squeezing them between the thumb and forefinger. They should then be allowed to dry.

After brushes have dried they should be stored flat in a drawer or box to protect them from dust. A brush that is not absolutely dry can develop mildew. For long storage, a few moth crystals should be added to protect the brushes from insects.

brush restoration Small red sable brushes used for detail work in oil painting sometimes become frazzled with use. To rejuvenate one, the brush tip should be dipped into a solution of equal parts water and glycerin. After the brush has soaked for a minute or so, it should be wiped along the edge of the hand to bring the hairs to a point. The brush should then dry overnight with the bristles up, and then be stored flat. It is not necessary to wash out the glycerin before painting.

brush washer This simple device for cleaning oil painting brushes consists of a loose coil of wire suspended over a container of turpentine or mineral spirits. The handle of the brush is held between the coils, with the bristles suspended in the fluid. With this arrangement the brush ends never touch the bottom, where their points might be twisted or bent.

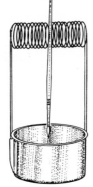

brush washer

brushes Brushes used by painters usually fall into two major categories: those made of coarse hair or bristle, and those made of a finer hair such as sable. The latter material is obtained from the tails of the kolinsky, an Asiatic mink. The so-called "camel hair" used in brushes is actually squirrel hair.

Following is an alphabetical listing of the more common brushes used for work in watercolor, oil, casein, sign painting, and other general applications.

angular liners. Also called *fresco liners,* usually made of white bristle and built with a slanted end. They are used for outlining and for running lines.

background brushes. Soft camel hair brushes used in lab work, photography, and photoengraving.

bamboo brushes. Pointed, brown ox hair brushes in bamboo handles. They can be used for a number of purposes, including ceramic painting.

blenders. Round brushes with square ends set in split quills and wired to handles. They are also called *badger blenders* because they are made of soft badger hair. They are used to obtain soft effects and blending in oil paintings, and for applying glazes on ceramic pieces. For more sweeping effects in painting, a fan blender should be used.

brights. Square-ended, short brushes used in oil painting, casein painting, and polymer painting. They afford good control in detail work and can be used with thick or heavy paint. They produce an

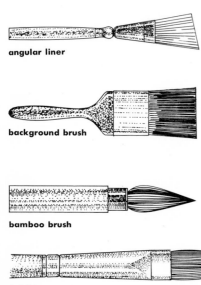

angular liner

background brush

bamboo brush

bright

effect similar to that of a painting knife, but with brush marks adding character to the strokes.

bulletin cutters. Flagged-tip brushes of pure white bristles used by sign painters. These brushes have flat handles and are of a chiseled construction. They are often used to outline (cut in) large letters, which are later filled in with a bigger brush.

camel hair brushes. Range in size from small, pointed brushes to large wash brushes. The name is inaccurate because the hair comes from the squirrel. The color may be gray, red, or black.

ceramic glaze brushes. Noted for the wide painting end and used for applying glaze to biscuit or greenware. A great many brushes of other types can also be used for this purpose and also for decorating. Red sable brushes can be used for shading effects, decorating, and design. Monogram or script brushes can be used for fine detail, and stipplers for pebbled effects.

color and size brushes. Large brushes which are made with brown camel hair and usually have short, flat handles. Color brushes are used for applying thin colors and dyes. They are widely used in painting and decorating theatrical sets. Size brushes are used for the application of glue or gelatin size.

cutters. *See* BULLETIN CUTTERS, *this section.*

dabbers. Large, round brushes used in stencil work. They are usually made of camel hair.

dagger stripers. Brushes made with long hair and thick bellies to hold a large quantity of paint. They are straight on one side and curved on the other to form a fine point. They are usually made of brown camel hair, and produce delicate, even-stroke lines and stripes on various surfaces.

easel brushes. Brushes which have square ends that are slightly flanged. They are set in metal ferrules on long, lacquered handles and are suitable for general easel work and tempera painting.

fan blenders. Soft brushes made in a flat fan shape and set in a metal ferrule. They are available in both bristle and red sable, with the more delicate effects produced by the latter. They can also be used for blending and to produce the wispy effects required when painting foliage or hair in oils.

filberts. Oval-shaped oil painting brushes that offer the same thin to thick strokes as the *round*. They are sometimes used instead of square-edged brushes when the effect of the brush edge does not need to be controlled so precisely.

fitch brushes. Similar to easel brushes, with a deep-cup chiseled tip. They are attached to a long, thin handle for ease of manipulation.

flats. Square-ended long brushes used in oil painting. They are more maneuverable than brights, which are shorter. They also leave brush marks that are less pronounced.

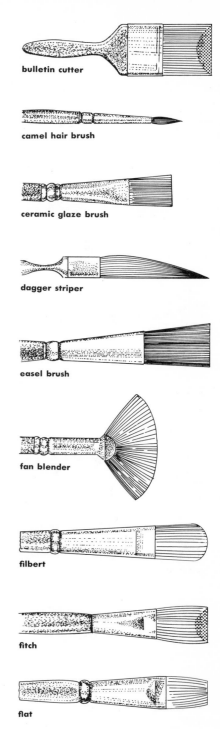

bulletin cutter

camel hair brush

ceramic glaze brush

dagger striper

easel brush

fan blender

filbert

fitch

flat

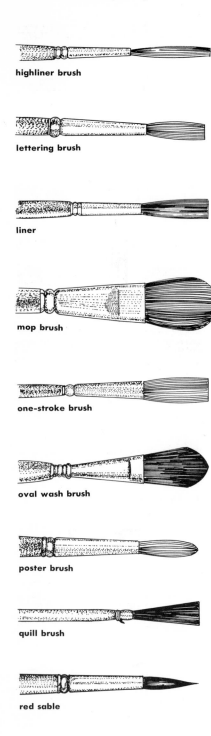

highliner brush

lettering brush

liner

mop brush

one-stroke brush

oval wash brush

poster brush

quill brush

red sable

highliners. Brushes made with square ends and long bristles. They are used principally for outlining letters and for striping. They are often made of red sable but are also available in brown and gray camel hair. *Script* and *monogram* brushes are similar in design, but are usually of red sable and mounted in smaller ferrules.

lettering brushes. Brushes made of red sable, camel hair, ox hair, and mixtures of camel and ox hair. They produce a clean, square edge for lettering. They are available in the same sizes as showcard brushes, but the hairs are longer. They handle easily and are useful for oil-base paints and synthetic colors.

limp brushes. Large, soft, floppy brushes used for special effects such as blending, mottling, and scumbling. In watercolor painting they are used for washes.

liners. A type of brush having a thick grouping of hair that tapers from the ferrule to a very fine point. Usually made of camel hair, they are used for creating fine lines in contours and scrolls.

mops. Large, round brushes made of camel hair. They are used in watercolor paintings for laying in washes.

one strokes. Brushes made in a large selection of hairs and hair mixtures, including sable, camel hair, and ox hair. They are set in flat ferrules with brush sizes ranging from $\frac{1}{8}$ to 1 inch. The tips have straight, square edges. They are widely used as lettering brushes.

oval wash brushes. Camel hair brushes in a flat oval shape used for large washes in watercolor painting.

photo retouching and spotting brushes. Red sable brushes of various sizes, including some that are very small.

poster brushes. Brushes usually made of black sable or camel hair. They are long-handled brushes that come to good points. Their large size also makes them useful for watercolor painting.

quill brushes. Long-haired lettering brushes set in nylon or natural quill ferrules. Some are square-ended and others are pointed. Brown camel hair quills are useful in lettering with oil paints, gold size, and colors ground in quick-drying varnish mediums. They can be used on smooth surfaces, such as glass, and are available in a variety of lengths. They can be used for china painting, outlining, and decorating. Gray camel hair quills are made of more resilient hair and can be used for heavier paints.

red sable brushes. Brushes used in oil painting, watercolor painting, commercial art, retouching, engraving, lithography, ceramics, and many other applications. For watercolor use they are made as pointed and flat brushes, also as oval-shaped and round wash brushes. For oil painting, where they are desirable for detail work, they are available as brights, which are short brushes with square ends, and rounds, which have a round shape and taper to a point.

rounds. Oil painting brushes that are about the same length as flats. They are round and have tapered points. They are useful for sketching, outlining, and for fine detail.

school art brushes. Include many kinds of artist and signwriter brushes and are used for general art instruction in schools. Easel brushes and easel fitches are also used.

script brushes. Used for ornate script, monogramming, and scroll applications. They are long, pointed brushes, usually made of red sable.

shaders. Brushes having squared ends. They are employed only in smudging, shadowing, and blending, and cannot be employed for any fine line or contour work. They are available in a range of thicknesses from approximately $\frac{1}{2}$ to $1\frac{1}{2}$ inches.

showcard brushes. Brushes usually made from a blend of red sable and ox hair, which produce a clean, square edge for showcard lettering. they are used mostly for water-base paints, particularly tempera, and are available in standard sizes.

signwriter brushes. Brushes usually made of ox hair and of a square-ended, chiseled construction. They are somewhat thicker than single strokes and hold more paint.

signwriter fitches. Brushes made with white bristles and cup-chiseled and square-ended. These brushes are used for bulletin painting and sign lettering, and are available in many thicknesses and lengths.

single stroke brushes. *See* ONE STROKES *in this section.*

sky brushes. *See* OVAL BRUSHES *in this section.*

spotting brushes. Fine red sable brushes used in photoengraving, photography, and offset lithography to retouch, spot, and opaque, and also to clean up lettering and type.

stenciling brushes. Short and stiff brushes, round in section, and flat across the end. They are made of stiff black or white bristle and are designed to press paint into the cut-out portions of stencils. *Stippling* brushes are somewhat similar in design, and are used with a tapping motion for decorative effects on a variety of surfaces.

stripers. Brushes used to produce delicate lines. The most familiar is the *dagger striper.* Another type has long hair with slightly fanned sides. It has a square, flat tip and is mounted in either a quill or nylon ferrule.

varnish brushes. Good-quality white bristle brushes used for general painting, varnishing, and lacquering.

wash brushes. Brushes usually made of camel hair and quite large. Mostly used for applying washes in watercolor painting, these brushes are set in fairly flat metal ferrules and are round at the end. *Limp brushes* and *mops* fall into this category.

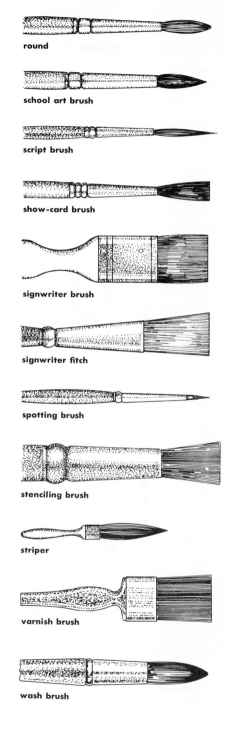

round

school art brush

script brush

show-card brush

signwriter brush

signwriter fitch

spotting brush

stenciling brush

striper

varnish brush

wash brush

brushing lacquer *See* WOOD FINISHING.

burin A burin is used for engraving on metal or wood, and is made in a variety of cutting faces *See also* ETCHING TOOLS.

burning A ceramics term to describe the firing of clay products in a kiln. *See also* CERAMICS TERMS. For the exposure or "burning" of plates, *see* PLATE BURNING.

burnisher (1) A tool used in etching. It consists of a round piece of smooth, highly polished steel. It is applied to plates to reduce shadings that are too dark and to remove scratches or other imperfections. (2) A tool, usually made of agate, for polishing gold leaf after it has been laid. *See also* AGATE BURNISHER. (3) A smooth wooden or plastic tool used in preparing artwork mechanicals to press down paste-up material or adhesive-backed lettering and patterns.

burnt plate oil A material used to thin etching ink that is too heavy in body. It is produced by boiling linseed oil and, at a certain temperature, igniting it.

C

calcimine A thin paint, white or colored, made of pigment, glue, and water. For information on other paints of this type, see DISTEMPER *and* SCENE PAINT.

calenders A stack of iron rollers used in paper making to smooth paper or give it a glossy surface.

calligraphy Calligraphy refers to elegant writing or penmanship, both as an art and as a profession. It is distinguished from ordinary handwriting by its fine quality. (*See illustration on following page.*) A typeface that resembles handwriting is called a "calligraphic" typeface. For more information see ENGROSSING.

camaïeu A technique of painting in monochrome in imitation of a cameo. Tints of the same color are used, without regard for realistic color, and effects are achieved entirely by differences in tone. *In camaïeu* paintings done in black, white, and shades of gray, in imitation of bas-reliefs, are also called *grisailles*. Engravings are said to be *in camaïeu* when they are printed in a single color of a uniform tint, with gradations of tone created by hatchings. (*See illustration on following page.*)

camera The basic tool of photography, the camera consists of a lightproof box with a lens at the forward end. The lens is equipped with a shutter and usually has some method of focusing. When the

Islamic (Turkish) calligraphy
OFFICIAL DOCUMENT.
(Eighteenth century.)
24 × 19⅞ inches. (*Fogg
Art Museum, Harvard
University.*)

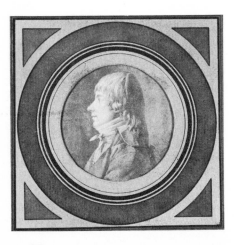

camaïeu drawing J. A. D. Ingres.
PROFILE PORTRAIT OF A MAN.
(Nineteenth century.) 2¹¹⁄₁₆-inch
diameter. (*Gift of J. S. Newberry in
memory of Meta P. Sachs. Fogg Art
Museum, Harvard University.*)

shutter is opened, the image of the subject being photographed falls on a surface called the film plane, located at the rear of the camera. The image is there recorded on sensitized film or plates.

camera lucida An optical device consisting of a prism of a special shape. The prism causes the image of an object to appear as if projected on a surface, such as a piece of paper, where it can be traced. It is often called a "lucy," and various degrees of enlargement or reduction can be achieved by altering the relative positions of the device and the subject matter to be copied.

camera obscura This apparatus, much larger than a camera lucida, is also used as a device to trace or draw the reflection of an object. It does not depend on a prism, but usually operates with a mirror and a double convex lens.

canvas Canvas is the standard material used for oil painting. Many textiles—such as hemp, jute, and cotton—have been employed by artists, but it is felt that linen fabric is best for painting. Linen is extremely durable, accepts sizing and priming films very well, has fewer problems with regard to moisture, and becomes brittle less rapidly than other fabrics. It can be obtained in a variety of weights and weaves.

Students' canvases are often made of cotton because it is a cheaper material. It does not, however, have the characteristic weave of linen, nor does it accept the glue size and oil priming as well. (*See* CANVAS SIZING AND PRIMING).

Jute, the material used in burlap bags, should not be used for permanent painting because it becomes weak and brittle with age.

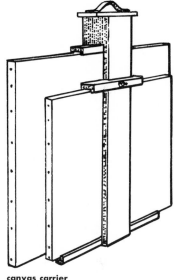

canvas carrier A wooden frame designed to carry either two or four stretched canvases in such a way that the surfaces do not come in contact with each other. Paintings that are still wet can be transported in it.

canvas carrier

canvas pins Steel pins having points at both ends and separators in the middle. They are used to keep wet canvases apart while they dry or when they must be transported.

canvas scraper A curved steel blade in a wooden handle used for removing oil and casein paint from canvas and other surfaces.

canvas pin

canvas sizing and priming Canvas will become brittle and disintegrate unless its fibers are protected from the action of linseed oil, the binder used in oil paints. A very thin solution of glue size is applied to raw canvas to reduce its absorbency and to protect the fibers.

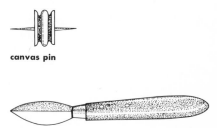

canvas scraper

Size is prepared by placing $1\frac{1}{2}$ to 2 ounces of rabbit skin glue in a quart of cold water and letting it soak overnight. The mixture is then heated in a double boiler until all the glue has been completely dissolved. The glue must never be boiled, as it will lose its strength.

The glue size should be applied to the stretched, clean canvas while still warm. A 2-inch bristle brush can be used, starting at the middle of the stretched canvas and applying as thin a coating as possible. Too heavy a coat is undesirable.

After it has been evenly sized, the canvas should dry under natural conditions. It should not be placed near radiators, heat lamps, or direct sunlight.

When dry, the canvas can be given a layer of paint called the ground. This layer consists of a white pigment with a binder of either a glue-water solution, casein, or a drying oil.

When painting with polymer paints on canvas it is not necessary to size the fabric. Polymer paints may be painted directly on the canvas without harm, although it is usually the practice to apply a coating of polymer gesso (polymer primer) to make the canvas less absorbent.

If a primed or sized canvas is accidentally dented, and the section cannot be flattened by restretching with pliers, the back of the canvas should be wetted at the point of the dent. Sometimes the moisture will tighten the fabric by shrinking it slightly. If this fails, the section should be moistened again and restretched.

canvas stretcher

canvas stretchers Wooden bars, usually made of pine, that comprise a frame over which canvas is stretched. They are mortised at the ends so that a piece of any length can be fitted with any other piece. The strips are normally $1\frac{3}{4}$ inches wide and sold in standard lengths from 8 to 28 inches (in 1-inch increments), and 28 to 60 inches (in 2-inch increments). Nonstandard lengths, and a $2\frac{1}{2}$-inch width, can be special ordered. Stretchers are provided with small wedges that will slightly enlarge the frame should the canvas ever become slack. These wedges, or keys, should not be inserted initially.

canvas-stretching pliers

canvas-stretching pliers Combination metal pliers and hammer used to stretch canvas securely over the stretcher bars when mounting. The gripping edges of the jaws are very wide and deeply corrugated.

Carborundum The brand name of the Carborundum Company for a silicon carbide. It is an abrasive, and available as a powder, a coated abrasive cloth, and in hones. It is also used as a textural additive to synthetic paints, and as a surface material for producing gray masses in collagraphic prints.

caret The caret ($_\wedge$) is a mark used in proofreading and writing that indicates where a word, or words, should be inserted.

cartoon colors *See* ACETATE COLORS.

cartoons (1) Animated figures in a motion picture format. (2) Full-scale drawings on paper that serve as the models for stained-glass windows, mosaics, tapestries, mural paintings, and, occasionally, easel paintings. Cartoons may be copied or actually transferred to the working surface by tracing or pouncing.

cartouche A decorative scroll or border executed with a pen or brush. (*See illustration on following page.*)

casein This material is a strong adhesive made by heating skimmed milk with hydrochloric acid. The curd is thrown out of suspension and, when dried, forms a white powder. With the addition of an alkaline substance, the powdered casein will dissolve in water. After the dissolved casein has dried, however, it is no longer water-soluble.

Casein by itself is too brittle for use as a binder for paint. For painting purposes, various oils and gums are added to it. Even at that, the dried film is not very flexible, so casein paintings are often executed on rigid panels or boards. Other surfaces, however, can be used—such as bristol board, illustration board, or stretched cotton or linen canvas not having an oil ground.

Casein is an opaque medium and, when used with a palette knife or bristle brushes, produces effects similar to oil painting. When dry, the colors have a matte finish that is very good for reproduction purposes.

Casein paints, and other water-based paints, eventually dry out in the tube. To prolong their life, be sure that caps are kept clean. It is also helpful to put a small amount of water in the ends of the tubes with an eye dropper before the caps are screwed on.

casting A technique in ceramics and metalworking of shaping ware by placing any hardening material in a mold.

celluloid Cellulose nitrate plasticized with camphor. Now replaced by cellulose acetate. *See* ACETATE MATERIALS.

cements *See* ADHESIVES. The term "cement" alone means a construction material, and the most commonly used one is portland cement. When cement is mixed with water, it forms a paste that dries by chemical action to a material as hard as stone. Cement is mixed with water, sand, and gravel to form concrete. *See* CONCRETE.

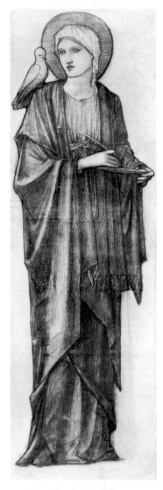

cartoon Sir Edward Burne-Jones. ST. THERESA. (Nineteenth century.) $66\frac{1}{2} \times 21\frac{3}{8}$ inches. (*Fogg Art Museum, Harvard University.*)

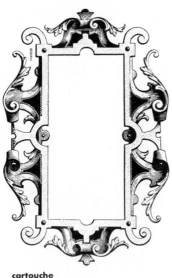

cartouche

ceramics Products made by the process of baking or firing. Ceramic wares are classified as earthenware, stoneware, china, and porcelain. Earthenware is often made of natural clay and fired at temperatures from about 1742 to 2129°F. It is nonvitreous, or comparatively porous, and will not hold liquid unless glazed. Stoneware is fired to temperatures higher than that of earthenware, up to 2300°F, is quite vitreous and hard, and will hold liquids even when unglazed. Pieces of sculpture made from natural clay and fired but not glazed are sometimes called *terra cotta,* a term meaning "baked earth." China is made from a clay body composed of kaolin and other materials and produced in two or more firings. The bisque is produced at firing temperatures of about 2381°F, then glazed at temperatures around 2129°F. Porcelain is made from specially prepared clay bodies and fired only once at about 2381°F. *See also* CERAMICS TERMS; ENAMELING; PORCELAIN; POTTERY; *and* TERRA COTTA.

ceramics terms The following are general terms used in ceramics.

archetto. A tool consisting of a wire stretched across a forked stick or rod and used for smoothing clay while molding.

ball clay. Also called *fat clay, plastic clay,* and *bond clay.* A widely used material with strong binding properties and excellent plasticity.

bat. A bat is a plaster disk that fits on the head of a potter's wheel. If a piece is thrown on the head itself, it must be cut off with a wire, and this sometimes ruins the work. If the piece is thrown on a plaster bat, it is possible to lift the ware by lifting the bat.

biscuit, bisque. A clay object that has been fired once prior to glazing. It also refers to pottery that is unglazed in its final form. The first firing converts the dry, fragile clay to a hard, more durable form.

blunger. A large tank in which clay is mixed with water. Revolving arms disintegrate and blend the clay.

body. A mixture of clays blended for certain characteristics.

building. Forming clay by rolling strips of clay and coiling them one on top of another.

casting slip. This material is used for casting in molds. A good casting slip must contain a deflocculant (a material that decreases the amount of water needed to make a pourable mixture). A combination of sodium carbonate and sodium silicate works very well. They may be purchased at a drug store and used in the following way. If 10 pounds (dry weight) of clay is to be made into slip, 5 grams of sodium carbonate and 10 cubic centimeters of sodium silicate are used. These chemicals are added to the water with which the clay is mixed, starting with about 40 percent of water based on the dry weight of the clay.

clays. Commercial clays are available in two ways, as natural clay from a particular deposit, and as compounded bodies, which are

blends of natural clays and sometimes other ceramic materials. Since there are over 2,000 standard clays, a great number of blends are possible. Blended bodies make possible any range of characteristics desired, with control over temperature requirements, plasticity, strength, craze-resistance, and shrinkage. General classifications for clays are earthenware, stoneware, whiteware, and porcelain.

dipping. A process in which pottery is completely immersed in glaze or slip. Other methods of application include spraying and brushing.

engobe. Colored slips applied to pottery to color or to decorate it.

filter press. A device in which slip is placed in the center of a series of flat, circular canvas bags in a press. When pressure is applied, excess water is removed and the clay acquires greater firmness and better molding characteristics.

firing. The application of intense heat in the baking of pottery, porcelain, or tiles. The process takes place in kilns, where temperatures can be controlled with reasonable precision.

glazes. Silicate coatings used for covering ceramic products. When subjected to high temperatures, glazes melt into glassy coatings. They are used both for decorative purposes and as a protection against moisture. They fall into such classes as lead glazes, alkaline glazes, borosilicate glazes, fritted glazes, salt glazes, ground glass, and slip glazes.

graffito, sgraffito. The technique of scratching a design through an overglaze to reveal a different color underneath.

greenware. Ware that has not yet been fired.

grog. A clay that has been burned and crushed. It is used in clay bodies to reduce shrinkage and warping. Ceramic sculpture can be done with mixtures of 30 to 40 parts grog (10 to 50 mesh), and 60 to 70 parts clay.

kick wheel. The weighted wheel at the bottom of the shaft on potter's wheels of a certain design. It is kicked with the foot to make the circular potter's wheel revolve.

kilns. Ovens in which clay is fired or baked.

potter's wheel. A revolving disk upon which pottery is formed. It can be foot-powered or motorized. As the wheel turns, a lump of soft clay can be worked evenly with the palms and fingers.

pottery tools. *See main heading* POTTERY TOOLS.

pulp. A name sometimes given to porcelain slip.

pyrometers. Devices to gauge temperatures in a kiln.

pyrometric seger cones. Small cones made of various clays that melt at certain temperatures. They are arranged in groups and melt in sequence. The temperature range of these cones is from 1094°F (cone 022) to 3362°F (cone 36). *See main heading* CONE TEMPERATURES.

saggers. Refractory clay boxes in which ware is placed to protect it from the open flame of the kiln.

slip. Liquid clay used for casting in molds, for decoration of ware, and as a cement for handles and other applied parts.

slip kiln. A kiln in which excess water is driven from slip to make it firmer.

stilts. Small metal devices used to elevate ware while it is fired.

throwing. The process of forming pottery on a potter's wheel.

ware. Ceramic products.

wedging. Kneading clay until it is uniformly soft and pliable.

cerography Painting in which wax is used as a binder for the pigments. *See* ENCAUSTIC.

chalcography The art of copper engraving.

chalk Two varieties of chalk are in common use: ordinary native chalk (also called whiting) and artificially prepared calcium carbonate in its whitest form. The latter is used as the basis for most pastels, and is mixed with glue or other mediums as a ground for oil and tempera paintings. Blackboard chalk is usually white but is also available in several colors.

chamois skin A soft, pliable leather that is often used in drawing to blend or remove charcoal or pastels. It is sometimes made from the skin of the chamois, but sheep and goat skins are also used.

charcoal Carbon made by roasting pieces of wood. It is cut into thin sticks and used as drawing instruments. It is commonly made from vine, beach, or willow. Charcoal pencils are available in several degrees of hardness.

chase A metal frame used to lock up type and plates so they will retain their positions while in the press.

chasing tools Generally speaking, chasing tools are used to ornament metal by cutting away, embossing, and so forth. Special chasing tools are used in repoussé work, where a relief design is created on a metal surface by hammering on the reverse side. The tools have heads that produce certain patterns such as ovals, squares, domes, and lines. They are struck with a chasing hammer, which has a metal head with a flat surface on one side and a metal ball on the other. *See also* REPOUSSÉ.

chasing hammer and tools, showing characteristic patterns made by them

chiaroscuro This Italian word means "light and dark" and refers to the art of distributing these elements in a painting, particularly as they tend to create the illusion that subjects are surrounded by space and standing free.

chih hua A style of Chinese painting that is executed by the fingers or fingernails instead of with brushes.

china clay So-called because it is used in the manufacture of chinaware. It is native hydrated aluminum silicate, and the very pure variety is called *kaolin.*

china marker A pencil with a colored wax center. It is used to mark glazed or shiny surfaces such as glass, plastics, and glossy photographs. Because it is too brittle to be sharpened, it is usually covered with spiral-wrapped paper which is peeled away as desired.

chinese ink Also known as *india ink.* It is an intensely black ink produced by combining carbon black (usually lamp black) with glue. It is often molded into sticks. To produce ink, the sticks are rubbed with water on a stone slab and the glue is dissolved.

chinkinbori A Japanese lacquer technique that consists of carefully sprinkling gold dust on plain black lacquer.

chromolithography Lithographic printing in several colors, requiring as many different stones as there are colors.

circle cutter A device that is similar in design to a compass except that a sharp cutting edge is used instead of a pen or pencil holder.

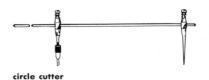

circle cutter

cire-perdue *See* LOST-WAX PROCESS.

cissing A defect in a paint film that is usually due to poor wetting of the surface when applied. It is characterized by ragged-edged fissures or crawling.

Claude Lorraine glass *See* BLACK MIRROR.

collage A composition pasted together and consisting of paper, cloth, wood, photographs and the like, usually of contrasting texture and pattern. (*See illustration on following page.*)

collagraph A print made from a plate produced by the collage method.

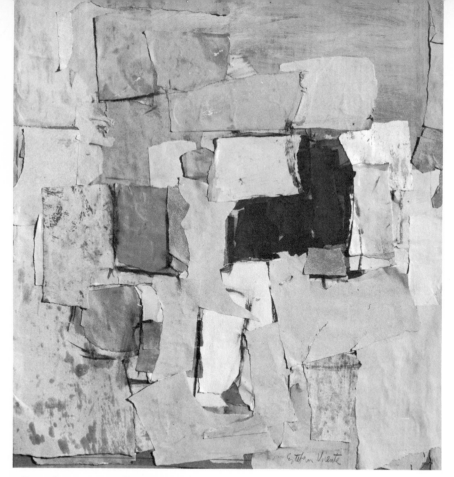

collage of paper mounted on corrugated paper Estaban Vicente. D-1957.
$22\frac{7}{8} \times 20$ inches. (*Gift of the Friends of the Whitney Museum of American Art. Collection Whitney Museum of American Art, New York.*)

collate To assemble in proper sequence all the sheets, signatures, or insertions for a printed piece.

collotype printing A planographic printing technique using gelatin-coated glass or metal plates. The gelatin coating contains a soluble bichromate salt, and the ability of water to swell the gelatin decreases with increasing exposure to light. When the coating is dampened, greasy ink is accepted in proportion to the light exposure received.

colophony This material is commonly known as *rosin* and is sometimes used as an ingredient in the wax-resin mixtures used to impregnate wood and reline paintings on canvas. Used by itself it produces a brittle film that is easily discolored and scarred.

color separation To reproduce a color photograph it is necessary to produce a separate plate for the red, blue, yellow, and black constituents of the original. Color separation is the process by which the colors of the original picture are sorted out so that all the reds

appear in the red plate, the blues in the blue plate, and so forth. Color separating is subtractive and it utilizes filters that are complementary to the colors that will be used in printing. A violet filter, therefore, transmits blue and red but stops yellow, and is used to produce the yellow printer. It works this way: the violet filter allows red and blue to affect the photographic plate, and when it is developed these areas in the negative will be the most dense. When a print (or plate) is made from this negative, the values will be reversed, the result being that the dense negative values of red and blue will be the lightest values in the print. For this reason the process is called "subtractive." The yellow areas absorbed by the filter will be the most transparent in the negative and subsequently most dense in the print. By subtracting the red and blue, the image of all the yellow areas has been isolated or *separated*. The red printer is made by using a green (yellow-blue) filter; the blue printer is made by using an orange (yellow-red) filter.

color sheets Special color overlay sheets that are made by several manufacturers. They consist of thin acetate sheets in a wide variety of colors and color tints. They have adhesive backs and can be used for making color layouts, posters, charts, and for altering the color values of paintings and transparencies.

color temperature A measure of the spectral range of a light source to measure the "whiteness" of the illumination used in color photography. The lower the color temperature of a light, the more red or yellow it appears. The higher the color temperature, the bluer it appears. Color films are sensitized to give a true color when exposed to light of a specific color temperature. This temperature is usually measured in degrees Kelvin, which is the temperature in degrees centigrade plus 273 (the temperature of an object emitting light of a characteristic color). Some films are balanced for daylight, or a color temperature of about 6,000°K, while others are balanced for tungsten ratings of 3,200 to 3,400°K.

Typical color temperatures are shown for the light sources below.

Clear blue northwest sky	20,000°K
Blue sky, thin white clouds	12,000°K
Blue sky	10,000°K
Overcast sky	6,000°K
Sunlight, average noon	5,400°K
Sunlight, one hour after sunrise	3,500°K
Incandescent tungsten lamp (average)	3,000°K
Candlelight	1,930°K

color transparencies Color transparencies consist of three different sensitized layers in one film. When light from the camera lens strikes the film, each of the three layers is exposed, with one primary color

recorded on each layer. The upper layer is blue sensitive and records yellow (yellow and blue being complementary colors); the middle layer is green sensitive and records magenta; the bottom layer is red sensitive and records cyan.

In processing, the three layers are first developed to black and white, with the negative image corresponding to the color intensity of the three primary colors in the subject matter. The film is then exposed to white light and developed in color developer. Certain chemicals, called color couplers, form dyes with the oxidation products of exposed silver deposits and special developers. With these substances, a colored image builds up next to the silver deposit and has the same gradation as the silver. Where the silver deposit is particularly dense, there will be more oxidation products and more dye will be formed. When the silver deposit is dissolved away, the dyes remain. The three layers, being superimposed, appear to the eye as one, and the combined color layers reproduce the range of colors seen in the original subject.

It is well to remember that in some transparencies the whites are 1,000 times brighter than blacks, but in actual printing the relation between inks and white paper is only on the order of 50 to 1. Certain appealing features of a transparency are, therefore, impossible to approximate in a printed piece.

colors Another word for "paints." *See* ACETATE COLORS; POSTER COLORS; etc.

combination (1) In photography, a combination of line and half-tone subjects on one piece of film. (2) In platemaking, two or more different printing forms combined on the same press plate.

Commercial Standard CS98-62, Artists' Oil Paints *See* OIL PAINTING PIGMENTS.

compass *See* MECHANICAL DRAWING.

comprehensive Also called *comp,* this is a very close representation of what final artwork is going to resemble.

concrete Concrete is a building material compounded of portland cement, aggregate, and water. The aggregate may consist of sand, gravel, crushed stone, blast-furnace slag, or other suitable material. When the water combines chemically with the cement, the material sets in a few hours and hardens to the strength of stone over a period of weeks or months.

A typical formula for concrete is the mixture of 1 part portland cement to 2 or 3 parts sand and 3 or 4 parts gravel. Control of the water content is essential to attain maximum strength.

When the size of the gravel is smaller than $\frac{1}{4}$ inch in diameter, the mixture is said to be mortar. A typical formula for mortar is the mixture of 1 part cement to 4 or 5 parts clean, sharp, clay-free sand. Lime is often added to mortar to make it white.

The addition of too much cement to a concrete or mortar can result in cracks due to shrinking.

concrete and cement pigments The following pigments can be used to color concrete or cement. The amount of pigment used should not exceed 10 percent of the volume of the material to be colored.

WHITE: White cement, marble dust, or small amounts of titanium oxide or zinc oxide
YELLOW: Mars yellow, raw sienna, or ocher
RED: Mars colors or red oxides
BLUE: Ultramarine or cobalt blue
GREEN: Chromium oxide or viridian
BROWN: Siennas or umbers
BLACK: Mars black

cone temperatures Pyrometric cones are made of clays that melt at certain specified temperatures. The cones are placed in kilns to provide visual indications of temperature. They are arranged in groups to sag in sequence. Following are cone numbers from 022 to 15 and their representative temperatures.

Cone 022	1,121°F (605°C)
Cone 021	1,139°F (615°C)
Cone 020	1,202°F (650°C)
Cone 019	1,220°F (660°C)
Cone 018	1,328°F (720°C)
Cone 017	1,418°F (770°C)
Cone 016	1,463°F (795°C)
Cone 015	1,481°F (805°C)
Cone 014	1,526°F (830°C)
Cone 013	1,580°F (860°C)
Cone 012	1,607°F (875°C)
Cone 011	1,643°F (895°C)
Cone 010	1,661°F (905°C)
Cone 09	1,706°F (930°C)
Cone 08	1,742°F (950°C)
Cone 07	1,814°F (990°C)
Cone 06	1,859°F (1,015°C)
Cone 05	1,904°F (1,040°C)
Cone 04	1,940°F (1,060°C)
Cone 03	2,039°F (1,115°C)
Cone 02	2,057°F (1,125°C)
Cone 01	2,093°F (1,145°C)
Cone 1	2,120°F (1,160°C)
Cone 2	2,129°F (1,165°C)
Cone 3	2,138°F (1,170°C)
Cone 4	2,174°F (1,190°C)
Cone 5	2,201°F (1,205°C)

Cone	6	. .	2,246°F (1,230°C)
Cone	7	. .	2,282°F (1,250°C)
Cone	8	. .	2,300°F (1,260°C)
Cone	9	. .	2,345°F (1,285°C)
Cone	10	. .	2,381°F (1,305°C)
Cone	11	. .	2,417°F (1,325°C)
Cone	12	. .	2,435°F (1,335°C)
Cone	13	. .	2,462°F (1,350°C)
Cone	14	. .	2,552°F (1,400°C)
Cone	15	. .	2,615°F (1,435°C)

contact screens *See* HALFTONE CONTACT SCREENS.

Conté crayons Popular crayons used in drawing and sketching. Conté is the name of a manufacturing company in Paris, France. The crayons are made in black, white, gray, sepia, and in four sanguine (blood red) colors: natural sanguine, sanguine XVIII Century, sanguine Medicus, and sanguine Watteau. Conté also makes a line of pencils, pastels, and chalks.

continuous-tone image A print or transparency that is composed of a range of densities from white through gray, to black. A continuous-tone image contrasts with a line image, which consists of only two tones, black and white.

continuous-tone image/drawing from photograph (see page 41)

copper engraving Fine-screen halftone engravings are made on copper, and coarse-screen halftones are usually made on zinc.

The term also refers to the plate that an artist has hand-engraved and to the print made from that plate.

copper wheel engraving The process whereby designs are engraved on the surface of glass objects. A small lathe is used, on which is fitted, one at a time, a variety of interchangeable copper wheels. The object to be engraved is pressed against the revolving wheel, which is fed with an abrasive of linseed oil and emery powder.

copper wheel engraving Glass design, George Thompson. Engraving design, Tom Vincent. ROMEO AND JULIET. 7½ × 11¾ inches. (*Courtesy of Steuben Glass, New York.*)

copy (1) Any written or printed matter that is given to the publisher to be reproduced in type. (2) Photographs, printed proofs, artwork, or paste-ups furnished for reproduction by printing. (3) A photographic duplicate.

copy scaling A determination of the ratio between copy and the final size to be reproduced.

copyboard The part of a process camera that holds copy in a flat plane so that it can be photographed. Some consist of glass sheets that hold the copy flat by pressure alone. Other systems use vacuum or suction devices.

The term may also refer to any simple board or easel on which photos or drawings are held while they are copied.

copying processes *See* DUPLICATING AND COPYING PROCESSES.

crackle glaze In ceramics, a type of glaze that produces a fine network of cracks covering the entire surface of the ware. It simulates the age of antique pieces.

crayon A small stick for drawing, usually made of a combination of pigments or dyes in a wax or oil medium. It is a smooth material and generally used on paper. Some crayons are water-soluble, and drawings made with them can be washed over with brush and water to extend tones. Lithographic crayons are made from extremely greasy materials and are used only on lithographic stones.

craze The cracking of a glaze on a piece of pottery. It is often caused by removing the pottery from the kiln too quickly.

crevé A condition in etching that results when the acid mordant has widened and broken down the areas between lines, yielding a print that has a gray appearance. Sometimes the condition can be rectified by using a scraper.

cropping A term used both in printing and photography. To crop means to eliminate unwanted details in a picture to emphasize a desired portion. It consists of removing portions on the edge, or edges, of the picture. Also, masking a picture to indicate such removal (crop marks).

cut This word is commonly used to mean a line or halftone engraving, or a picture printed from these. The term is a holdover from a time when all pictorial material appearing with type was produced from woodcuts.

In practice, only letterpress printing employs cuts. Other printing methods utilize a single plate containing both type and illustrations. Although the term may still be used, cuts are not actually required for offset, photogelatin, photogravure, or silk-screen printing.

The word "cut" is used another way when describing shellac and varnishes. Dammar varnish, for example, is said to be 5-pound cut when 5 pounds of dammar resin have been dissolved in a gallon of turpentine. Five-pound cut shellac means that 5 pounds of shellac have been dissolved in a gallon of alcohol. (*See also* MOTION PICTURE TERMS.)

cutting Paper may be trimmed or cut either before or after printing. Paper cutters can cut paper on the square or at angles, but special equipment is needed to provide die cutting, punching, and round-cornering.

Ink must be dry on paper before it is cut; otherwise one printed sheet may "offset" onto the back of the next sheet because of the pressure of the cutter.

cyclorama A cyclorama is a vertical surface, often curved or dished, used to form the background for theatrical settings—particularly for outdoor scenes. The illusion of great depth can be achieved by careful, even lighting of a cyclorama. It can be made of a solid material, and is then referred to as a *hard* cyclorama, or cyc. Usually, however, it is made of heavy cloth drawn taut to provide a smooth surface.

dabber A tool consisting of a mass of wool with a leather or cloth covering, attached to a wooden handle. It is used for inking blocks or plates.

The term is also used to describe a large, round camel hair brush used in stencil work.

dabber

dammar varnish *See* GUMS AND RESINS.

darkroom camera *See* PROCESS CAMERAS.

dead clay A term used to describe clay, or any other modeling material, that has become lifeless or unresponsive, often because of exposure to moisture.

dead metal The excess metal in areas not intended to be printed from a relief printing plate. Sometimes part of this metal is trimmed away or routed out.

Dead metal can also refer to "killed matter," which includes discarded type, or type that has been used for a job and is now set aside for remelting. It is placed in the "hell box."

decals (decalcomania) The system for transferring pictures, trademarks, emblems, and decorations from paper onto other materials such as glass, china, wood, or metal. The term also describes the piece

of paper itself. A decal consists of a film of one or more layers of color and varnish, lacquer, or adhesive printed on paper backing. This paper backing has been previously treated with a special adhesive which is water-soluble. The adhesive enables the decal to be removed from the paper and to adhere to whatever surface is being processed.

Decals are used on glazed ware in the following way: the printed paper is applied, face down, onto a surface that has been lightly varnished. The color is rubbed into this sized area with a stiff brush and the paper is washed away. When the object is fired, the binders used to print the decal are burned away, and the colors are fused directly into the glaze.

decoupage The art of making paper cutouts that are used in pictures or for the decoration of furniture or other ornamental objects. The cutouts may be from photographs or from printed matter of any kind, and are often embellished further with bits of plastic, glass, cloth, string, and so forth.

deep-etch (1) In offset lithography, the treatment of a plate for a long printing run. In this technique, the inked areas of the plate are recessed slightly below the surface. *See also* OFFSET LITHOGRAPHY. (2) In nameplate production, a method of deeply etching the letter portions of printing in a metal plate. The recessed areas are then filled with enamel.

designers' colors Opaque watercolor paints that dry flat without streaking. They are available in tubes and produced in a wide range of colors. They can be used in an airbrush, or with brush and pen. Since they are most often used for producing artwork that is to be photographed, the colors are not necessarily permanent.

Devonshire clay Another name for china clay.

diamond-point tool A tool in the shape of a ball-point pen, with an industrial diamond for a point. It will cut clean, even lines on plastics, glass, and metals.

diatomaceous earth Also called infusorial earth, this is a kind of silica that is light and absorbent. The individual particles are the silicified skeletons of microscopic plant life. It is an excellent inert filler for paints, and is also used as an abrasive and in metal polishes. It can be used with polymer paints to provide body and decrease gloss.

die cutting The process of cutting special shapes or cutouts in paper, cardboard, cloth, or other material. The dies somewhat resemble

cookie cutters and can cut through many layers of material at one time.

dipper A small cup that hooks onto the edge of a palette. It can be used to hold painting medium, or a thinner such as turpentine. It is made of metal and is sometimes equipped with a lid. *See also* PALETTE CUPS.

display letters Display letters, available in various heights, can be purchased for both interior and exterior use. Such letters, in a number of fonts, are made of cardboard, plastic, wood, aluminum, bronze, stainless steel, styrene, and Plexiglas.

distemper A term used to describe water-base paints using binders of glue size, and sometimes casein. Loosely applied to any paint that is used for flat wall decoration, murals, and large scene paintings. Calcimine and scene paint are glue-size paints.

doctor (1) A support in a lathe. (2) An electric brush used in electroplating. (3) A soldering implement. (4) A greasy fluid used for strengthening the work on a lithographic stone.

doctor blade A knife-edge blade used in gravure printing. It presses against the engraved printing cylinder and wipes off the excess ink from nonprinting areas.

dope A lacquer used most often for painting models of various kinds, especially those made of wood, cloth, or paper. It can also be used for painting toys. A different kind of paint is used for plastic models. It consists of an enamel that will adhere properly to the surface, and can also be used on china, glass, and metal.

drafting *See* MECHANICAL DRAWING.

drawings from photographs A bleach-out system for making pen or pencil drawings from photographs. First, a light enlargement is made on matte bromide paper. The artist then draws over the pale print with pencil or waterproof ink, following the lines of the image. When the drawing is completed, the underlying photographic image is bleached out. (*See illustrations on page 34.*)

One such bleach consists of two stock solutions. Stock solution A is made by mixing 32 ounces (1.0 liter) of water with $1\frac{3}{4}$ ounces (52.5 grams) of potassium permanganate. Stock solution B consists of 32 ounces of cold water and 1 fluid ounce (30.0 cubic centimeters) of sulfuric acid. (*Never* add water to the acid, because the solution could boil and splash on the hands and face, causing severe burns.)

For use, mix 1 part stock solution A, 2 parts stock solution B, and 64 parts water. When the image on the paper has been completely bleached, the paper should be fixed in hypo to remove the yellow stains, and then thoroughly washed. Care should be taken not to touch the ink lines while the paper is wet. They can easily smear.

dried lacquer work Dried lacquer work, or *kanshitsu,* is an old Japanese process of producing sculptural forms by covering armatures with lacquer-saturated cloth.

driers *See* SICCATIVES.

dry mounting This is the best method for mounting photographs and other paper materials on cardboard. It is a permanent method and one that eliminates wrinkles, bubbles, and stains. In use, a piece of specially processed dry-mounting tissue is cut to the size of the photograph or drawing and placed between it and the cardboard backing. The tissue is touched in a few places with a small hot iron called a *tacking iron.* This secures artwork and backing and keeps them registered. They are then placed in a dry-mounting press where the wax or shellac coating of the tissue melts slightly and binds the two materials together. Some kinds of dry-mounting tissue can be had that adhere at lower temperatures and can be easily removed from both artwork and mount.

tacking iron

dry offset An indirect *letterpress* system of printing in which ink is transferred from a relief plate to a blanket, and from there to the paper.

drying oils Any oil used in oil painting is called a drying oil. These oils are usually linseed oil, poppy-seed oil, or walnut oil, but others have appeared at different times on the commercial market.

A drying oil has the property of forming solid, elastic films when exposed to the air. The process of drying is mostly a chemical change, whereby oxygen is absorbed into the complex oil molecule. In some drying oils, the process of setting may take several years.

The following section describes linseed oil, in its several forms, and a few other commonly used oils.

castor oil. This oil is not recommended for artistic painting. Alone, it will not dry to a solid film, even after months of exposure to air. It has been used occasionally as an additive in efforts to impart flexibility to varnishes that produce hard and brittle films. If a few drops are added to a pint of lacquer, it will slow down the drying time.

linseed oil. This is the principal oil used in oil painting. It is processed from the seed of the flax plant and, unbleached, is of a

bright, golden color. It is refined by washing or by settling, and also by chemical methods. Bleaching is usually done by exposing the oil to sunlight.

As linseed oil dries, it oxidizes and polymerizes into a solid form called *linoxyn,* a substance that can never be transformed back into linseed oil.

Fresh linseed oil smells sweet. A rancid odor indicates the presence of free acid in the oil. The acid develops when the oil is exposed to air, or when it has been heated. Acid can be neutralized by adding a tablespoon of pulverized quicklime to each pint of oil and heating for a half an hour with frequent stirring. Calcium oxide will settle at the bottom of the container and be converted to a harmless calcium soap.

Following are a few of the ways in which linseed oil is processed.

Boiled oil, or *blown oil,* should not be used for painting purposes because it tends to darken badly. It is processed by heat and driers.

Cold-pressed linseed oil is produced by crushing linseed (unheated) in a press. A pale yellow oil is extracted and allowed to stand in tanks until the impurities settle to the bottom. The material is then filtered and bottled. It is the best of the linseed oils for grinding pigments for paints.

Raw linseed oil is made by steam heating the linseed before it is pressed. The oil is darker and generally inferior to cold-pressed oil. It has a different drying rate, and its film-forming quality is not as good. It is used in inexpensive house paints and for finishing wood.

Refined linseed oil is manufactured from steam-pressed oil that has been refined, bleached, and treated with chemical agents until it has the same general characteristics as cold-pressed oil.

Stand oil was once made by exposing raw linseed oil to sunlight in a shallow container. It is now manufactured by heating oil to high temperatures in an oxygen-free environment. It yellows less than other linseed oils and forms a tough, strong film. It produces a glossy smoothness in paints. It is often used as an ingredient in painting mediums, but seldom is used for grinding colors.

Sun-thickened oil is cold-pressed or refined linseed oil that has been partially oxidized by the action of sunlight and air. It is thicker, less yellow, and dries more rapidly than the original oil.

pine oil. A product of the distillation of wood turpentine, this oil is straw-colored, has an agreeable odor, and has a slow rate of evaporation. It is sometimes used as a preservative agent in casein emulsion paints and as a solvent for resins.

poppy-seed oil. This oil is often used in the grinding of white pigments and light colors because the dried film yellows less than linseed oil. It dries slowly, however, and forms films that are not as tough and flexible as linseed oil.

safflower oil. This material is pressed from the seeds of the safflower plant. It is somewhat slow-drying and is used for industrial

paints in combination with synthetic resins. This oil sees limited use in artists' paints.

tung oil. Also called *Chinese wood oil,* this material is seldom used for artistic painting. It is used in wood varnishes and floor sealers. If it dries in moist air, the resulting film is wrinkled and uneven.

walnut oil. This oil is made from walnuts and, when cold-pressed, is thin and clear. It dries more quickly than poppy-seed oil, and yellows less than linseed oil. It may be sun-thickened like linseed oil. It is not used a great deal because it easily turns rancid in storage.

dry-mounting presses Dry-mounting presses are used for mounting papers and cardboards, and also for permanently laminating other materials such as cloth and other pliable and rigid materials. These presses are built in a number of sizes, one of the largest having a platen measuring about 2 by 3 feet. All have thermostats to control temperature.

drypoint Drypoint is a form of engraving in which a copper plate is scratched with a sharp-pointed tool, raising a burr which holds the ink and yields a characteristic dark velvety effect when printed. It is called drypoint because no acid is used to eat out the lines.

Etching is quite different in that the sharp tool (an etching needle) scratches through only the etching ground that is placed on the surface of the copper plate. The plate is then placed in an acid bath, and the chemical action of the acid produces a line deep enough to hold ink.

Drypoint requires only a bare copper plate, a steel point, a scraper, a stone for sharpening the tools, and a burnisher. A small amount of ink mixed with petroleum jelly can be used to rub on the plate to show the progress of the work. It is easily removed.

dry-relief offset Also called *high etch,* this process refers to plates made for use on offset-lithographic presses, but printed without the use of dampeners and water. The plates are made photomechanically, and nonprinting areas are etched from 0.008 to 0.015 inch below the surface.

dummy A dummy is a page-by-page layout of a printed piece, made to the exact size of the proposed work and showing the location of display and body type and the positions of illustrations. Dummies that have been made from galley proofs are called paste-up dummies, or paste-ups. A cut dummy consists of illustration proofs mounted without relation to text, but in proper sequence, for checking purposes.

duotone In the duotone process, two halftone cuts are made from the same black-and-white photograph, and the picture is printed in

dry-mounting press

drypoint etching Rembrandt. CLUMP OF TREES WITH A VISTA. (1652) (*Gift of George Coe Graves. The Sylmaris Collection, The Metropolitan Museum of Art.*)

two colors—usually black and a color such as blue or green. To keep from overprinting exactly, the second shot is made with a screen angle 30 degrees different from the first. The process adds considerable depth to the picture because the grays in it are enhanced by the tints, tones, and shades of the added color.

duplicating and copying processes There is a basic difference between duplicating and copying systems. Duplicating processes depend on the use of unsensitized papers, with images being formed by transference from stencils, plates, or type. Copying processes use some form of an emulsion surface that is sensitive to light or some other form of radiation. Both systems are included in the following alphabetical list.

 anastatic process. This system is now obsolete, having been superseded by photolithography. It consists of reproducing a printed page, either type or pictures, by moistening it with dilute acid and pressing it against a zinc plate. The acid does not work on the printed portions of the page, but etches the zinc plate where it is in contact with unprinted portions. This leaves the printed portions slightly raised on the plate, and it can be inked and printed in the usual way.

blueprint. Copying an original drawing by placing it in contact with sensitized blueprint paper and exposing it to a strong light source. The blueprint paper is then washed, with the result that it turns blue where the light has struck it, but remains white where protected by the black lines of the original.

diazo. A copying process that utilizes a diazonium salt sensitive to ultraviolet, violet, or blue light. Materials using this system are also called dyeline materials. An original is placed in contact with the dyeline material and exposed to a light source. The radiation bleaches out all the diazonium salt that is not protected by a line or some other part of the image of the original. When the two are separated there is a positive copy of the original in the unbleached areas of the dyeline material. These areas are pale yellow and are still light sensitive. The diazo image is transformed into a colored, stable azo dye in the development stage. The transformation may depend on the presence of aqueous ammonia, heat, or a developing solution. Some diazo machines run as fast as 100 feet per minute. The cost of an $8\frac{1}{2}$- by 11-inch print is about a penny.

diffusion transfer. A photocopying process that produces a single positive copy of an original. Light is exposed through the original to a paper negative. The negative and a paper positive are passed through a developer, transferring the copy. The system can also be used to produce a kind of metal plate for offset printing and transparencies for overhead projection. Copies cost from about 6 to 8 cents and can be made at the rate of six per minute.

electrostatic copying. An electrostatic, or electrophotographic, system that projects a nonvisible electrostatic image of the original onto a piece of paper. Pigmented particles then cling to the charged areas of the paper and are fused to it. The cost ranges from 6 cents down to about $\frac{1}{2}$ cent per copy depending on the type of equipment and the number of run. Some machines run 40 copies per minute.

fluid (spirit) duplicating. A system in which a master is produced by placing a special aniline-dye carbon paper under a sheet of coated paper. The carbon is placed face up, so that when the coated paper is typed or written on, a reversed copy is produced on the back of the sheet. A certain amount of dye from the carbon paper is now transferred to the master, from which copies are printed directly. The master is moistened slightly with an alcohol-based solvent when copies are made. The solvent enables a very thin layer of the dye on the master to be picked up by the copies as they go through the machine. Dye carbons are available in purple, red, green, blue, and black, with purple providing the greatest number of copies. Copies cost about $\frac{1}{2}$ cent apiece. They can run up to 500 copies at 120 per minute.

gelatin duplicating. A gelatin process in which the item to be reproduced is typed or drawn on a hard-surfaced master with inks

containing aniline dyes. The master is then placed face down on a gelatin surface. The dye on the master is transferred to the gelatin within a few seconds. When blank paper is pressed against the gelatin, a small amount of the dye is released and a copy made. After about a day, the gelatin can be reused, since the dye will have sunk into it and will no longer print. This process is now little used. (Hectograph was an early system of this type.)

offset duplicating. An ink-receptive image is typed or drawn on a paper master, or produced photographically on a sensitized metal plate. The master or plate is then placed on the master cylinder of an offset press, and a series of rollers brings a combination of ink and water to the surface of the plate. The image area accepts ink but rejects water. At the same time, the master's nonimage area is moistened with water, causing it to reject ink. The inked image built up on the master is transferred onto a blanket cylinder. The paper picks up the inked image as it passes between the blanket cylinder and an impression cylinder. Inexpensive paper plates are designed for runs of 100 copies. Some metal plates can produce 1 million or more impressions, at rates of about 8,000 per hour.

stencil duplicating. In this system a stencil is typed or drawn upon and placed on a cylinder. The paper is fed between the stencil and an impression roller, which presses the paper against the stencil. Ink is fed from the inside of the cylinder through the image openings in the stencil, thus making copies. The stencil is good for runs up to about 15,000 at speeds of 200 per minute. The cost is about $2.50 for 1,000 copies.

thermal copying. This system operates on the principle that darker objects absorb more heat than do lighter ones. The paper on which copies are made is extremely sensitive to heat, and turns dark when exposed to it. When original materials and copy paper are exposed to infrared light in the copying unit, the dark portions of the original generate heat and darken the copy paper in the corresponding locations. The paper requires no further processing, but remains heat sensitive. Copies cost from 5 to 10 cents each and can be run at the rate of 15 per minute.

Verifax. Eastman Kodak's transfer method of copying in which a special paper, after exposure to the original and processing, produces a dyed gelatin matrix. When this matrix is pressed into a specially prepared paper, the image is transferred. About seven copies per minute can be run and the cost for the first copy is 8 cents.

whiteprint. A diazotype printing process used in equipment made by a number of companies. Unlike blueprinting, it makes a positive from a positive and uses a system of dry developing. The image appears as a dark line on a bluish or slightly purple background. Costs run about 1 cent per square foot.

duramen In woodworking, the heartwood of a tree.

dusting brush

dusting brushes Used for cleaning and dusting artwork and drawings, these brushes are long and flat, with a handle about 6 inches long.

dye Dyes are capable of being dissolved in liquids and are used in solution as stains. A pigment differs in that it is relatively granular, and consists of particles held in suspension by a binder. Dyes are used mostly for dyeing fabrics, but a few (called *lakes*) are precipitated on mineral bases and used as pigments in painting. Natural dyes may be from mineral, vegetable, or animal sources. Artificial dyes are derived mainly from coal-tar bases. The four most important classes are azo, anthroquinone, indigoid, and thioindigoid.

dye transfer The Eastman Kodak Dye Transfer system is a method of making color prints from color-separation negatives. These negatives are printed, by contact or projection, on Kodak Matrix film and processed to obtain a relief image in gelatin. The density of the image affects the relative thickness of the gelatin. When these relief films, called matrices, are soaked in appropriate dyes, the amount of dye absorbed by each matrix is proportional to the height of its relief image. The dyes are then transferred to a sheet of Kodak Dye Transfer paper by placing them, face down, in contact with the paper. The three dye images form the final color print.

E

easel A frame used to hold a painting during the time it is being painted. It is sometimes a three-legged structure with the two forward legs holding the painting. A studio easel rises vertically, with screw adjustments so the canvas can be raised up and down and tilted forward or backward.

efflorescence A change occurring on the surface or throughout a substance from loss of water or crystallization on exposure to air. It then becomes a powder, or is covered with a powdery whitish crust.

egg tempera *See* TEMPERA.

egg-oil emulsions Mixtures made by combining an equal amount of egg (both yolk and white) and oil. They are used in tempera painting as a binder. Egg tempera is normally a smooth paint, but when impasto effects are desired an egg-oil mixture is used. The oily ingredient may consist of stand oil, sun-thickened oil, dammar varnish, saponified wax, venice turpentine, or any combination of them. To the egg-oil mixture is added an equal amount of water, and the ingredients are well shaken in a jar or bottle to emulsify them. The emulsion is then ready for use as a binder for pigment, and the resulting paint can be thinned with water or with more emulsion.

easel

49

electro, electrotype A metal duplicate of a page of type, with or without cuts. Its use saves printing from the original type and cuts. This can be useful when a long run is anticipated, because the electrotype will wear longer than type. Also, if an electro is accidentally damaged on the press, another can easily be made. They are prepared by depositing a metal, such as copper or nickel, in a mold made from the original type. This is then backed up and finished for use on a flat-bed press, or curved for use on a rotary press.

electroplating A process in which a layer of metal is deposited on an object. It is usually done in a tank that contains a salt solution of the metal to be plated.

electrum An alloy of gold and silver. A pale yellow in color, it is sometimes used for casting purposes, and also for finely detailed sculpture.

elephant-ear sponges Fine-grained sponges used for finishing pottery.

embossing To emboss is to produce raised letters or designs on paper or other material. It is done with a set of matched dies. A relief die strikes from beneath the paper into a hollow die above.

emery A grinding agent consisting of finely pulverized corundum. It is usually affixed to wheels, but it is also available on cloth and paper. It is generally used for hand-polishing operations on metal.

emulsion In painting, a medium in which drops of one kind of liquid are suspended in another, without forming a really stable mixture. Typical of the emulsions used in painting are egg-oil and certain combinations of gums or glues and oil or varnish.

In photography this term refers to the sensitized material on film, plates, and photo papers.

enamel (paint) A liquid paint consisting of glossy varnishes mixed with pigments. It dries to a high gloss, but is generally not heavy-bodied and often requires an undercoat. Enamels are formulated in a number of ways. Oleoresinous enamels use a base of linseed oil. Alkyd enamels use alkyd resin as a base. Epoxy ester paints contain vegetable oils reacted with epoxy resin and generally have more durability than alkyd and oleoresinous enamels, but not as much as epoxy-polymide. The latter are sold in kit form with two equal parts that are mixed before use. They dry to an extremely hard surface that is resistant to such things as moisture, alcohol, and oil.

Japan is a name applied to black baking enamels. Quick-drying enamels are made by adding pigments to cellulose lacquers.

For a discussion of vitreous enamels, see ENAMELING.

enamel (paper) The term applied to a coating material on paper, or to paper so treated.

enameling The process of applying a vitreous glaze to metal or pottery objects, and then fusing it to a smooth, hard surface in a kiln or furnace. The base of enamel is a clear, colorless transparent compound called flux, which may be composed of silica, minium, and potash. The higher the percentage of silica, the harder the enamel.

The fine vitreous glaze of enameling will adhere to metals such as gold, silver, copper, and bronze, but will not adhere to nickel, zinc, or brass. For best results it is advisable to use gold, silver, or pure copper.

The flux is a glass (called *fondant* in French) that can be colored in endless ways with the addition of small amounts of metal oxides.

Metal used for enamel work must be free from grease, oil, dust, pencil marks, and fingerprints. It will otherwise be prone to chipping, pinholing, and cracking. Copper can be cleaned with a kitchen cleanser, rinsed in water, and dipped in a mild acid such as vinegar. It can also be cleaned satisfactorily in a solution of 2 parts commercial nitric acid to 1 part water. Copper is a pink color when absolutely clean. After cleaning it is rubbed with steel wool and then moistened with saliva. This provides a weak alkaline solution and ensures a neutral surface on which to work.

The piece may then be enameled and fired.

Following are a few examples of various enameling techniques.

basse-taille. A process that combines engraving, carving, and enameling. Either gold or silver is used and it is engraved with a design. It is then carved into a bas-relief so that when the enamel is melted it flows to a level even with that of the uncarved parts of the metal. The design then shows through the transparent enamel.

champlevé. Enameling that is accomplished by carving away troughs or cells in the metal, leaving a raised line that forms the outline of the design. The enamel is laid in the cells and the whole fired. Afterward it is filed with a corundum file and polished.

cloisonné. Enameling that consists of soldering narrow strips of metal to produce a raised outline of the design. These strips form cells, much as in the case of champlevé work. The cells are filled with enamel and fired.

plique-a-jour. A process of enameling similar to that of cloisonné, except that the narrow wires or strips of metal are not soldered to

gilded copper and champlevé enamel
FRENCH GOTHIC EUCHARISTIC DOVE. (Thirteenth century.) (*Courtesy of the Denver Art Museum, Denver, Colorado.*)

cloisonné TWIN CYLINDER VASES. (China, Ching Dynasty.) (*Courtesy of the Denver Art Museum, Denver, Colorado.*)

a metal base, but are soldered only to each other. These are then placed on a sheet of copper, silver, or gold. After the enamel is fused and sufficiently annealed and cooled, it can be easily removed.

encaustic An ancient method of painting, it is named after the Greek word meaning to "burn in." It is applied to a system in which the pigment is carried in hot wax. Heated tools are needed to control the effects in this medium.

For rigid supports, such as gesso-covered Masonite or plywood, a mixture of two parts pure (bleached) beeswax and one part dammar crystals can be used. The two are melted and mixed together under low heat, then cut into cakes when cooled. For use, the cakes are melted and dry pigments added. For lighter supports, such as canvas, the addition of 10 percent linseed oil is recommended.

Since the wax will not blend during application, the blending of edges takes place in the "burning in" operation. This takes place after the painting, or portion of the painting, is completed, and is accomplished with an electric element in an asbestos handle or by a heat lamp or blow torch.

Tools are cleaned up in turpentine.

encaustic on canvas Karl Zerbe. HARLEQUIN. (1943) 44 × 34 inches. (*Collection Whitney Museum of American Art, New York.*)

engraving (1) *See* CUT. (2) *See* ETCHING. (3) **A** photomechanical process whereby lines and borders are scribed on line negatives with an engraving needle. This tool produces an even, transparent printing line by removing a thin layer of blackened emulsion.

engrossing The work done on diplomas and citations by an artist who specializes in decorative lettering and illuminating. The words "engrosser" and "calligrapher" both apply to a person skilled in penmanship.

engrossing ink A kind of jet-black waterproof ink used for the lettering of diplomas, citations, and other documents.

epoxies Epoxy resins provide excellent strength and toughness, and have good resistance to acids, alkalies, and solvents. With the addition of a hardener, the material will cure at room temperatures to make solid castings. Epoxies can also be combined with glass cloth to make lightweight structural laminates. They have very good adhesion to metal or glass, as well as to the more porous materials like leather, wood, and paper.

eraser Rubber—the term "rubber" reflects the material's original application, still relevant here, as a tool to "rub out" incorrect or unwanted lines or strokes—is available with a variety of abrasives, forming erasers with a wide range of cleansing properties. Some are extremely soft, pliable materials and others act almost like sandpaper. For general drafting work a fairly hard eraser is recommended because it can be used for both ink and pencil. Gritty ink erasers should not be used because they damage the surface of the paper. For general cleaning of larger areas in a drawing, artgum erasers are advised.

Vinyl erasers are useful when working on various polyester drawing films.

Electric erasers are often used in drafting operations and consist of a motor-driven shaft that spins an eraser at high speed.

Air erasers resemble an airbrush and propel a fine abrasive in a controlled spray. It can erase paint and ink, and can also be used for etching glass and cleaning machine parts.

erasing knife *See* KNIVES.

etch A photoengraving term that means to produce an image on a printing plate by chemical or electrolytic action. When this term is used in offset lithography, it refers to an acidified gum solution used to desensitize the nonprinting areas on the plate, or to an acid solution added to the fountain water to keep nonprinting areas of the plate from accepting ink.

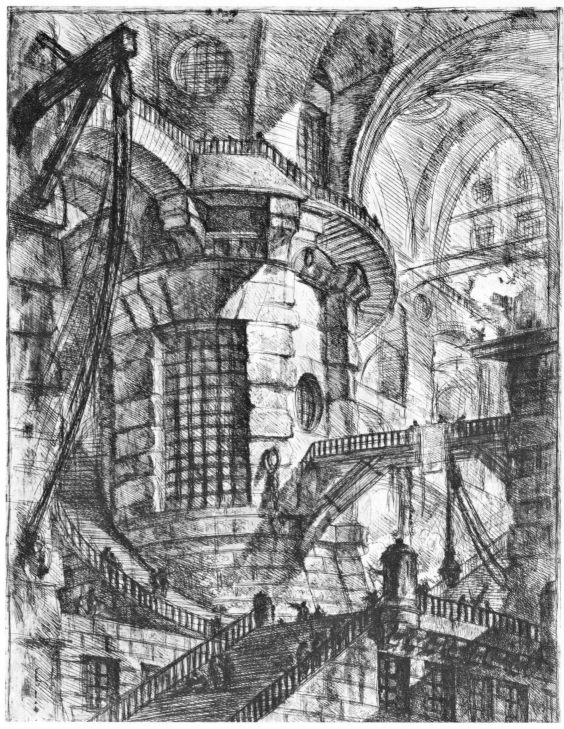

etching G. B. Piranesi. THE PRISONS.
(Eighteenth century.) (*Harris Brisbane Dick
Fund, 1937. The Metropolitan Museum of
Art.*)

54

etching This word comes from the Dutch *etsen*, "to eat," and denotes an eating-away process of an acid on a metal. An etching is produced by drawing with an etching needle on a metal plate that has been coated with a thin layer of acid-resisting material called the ground. The needle lays bare the metal without actually scratching it. The plate is then put in an acid bath, called a mordant, which bites, or etches, the lines into furrows of a depth desired by the artist. The plate is then inked and wiped, and the ink stays in the depressions or lines of the plate, not on the surface. The action of the powerful etching press forces the paper to pick up the ink from the incised lines. This system of printing is called *intaglio*, and includes line etching, aquatint soft ground, stylotint, pen process aquatint, and other types of bitten graphic work. In drypoint etching, the plate is scratched directly with a sharp tool, causing an incised line that requires no etching to make it deeper.

etching acids There are a number of acids used for biting plates. *Copper etching acid*, also known as *iron chloride* or *perchloride*, is a neutral solution and safest for biting plates. *Dutch mordant*, also called *Smielie's bath*, is a buffered acid that is stronger than copper etching acid, but much safer than nitric acid. *Nitric acid*, or *aquafortis*, is a corrosive, dangerous material that must be handled very carefully. Generally speaking, weaker acid solutions produce clean, smooth lines, while strong solutions make coarse, rough lines

etching grounds There are various commercially available liquid grounds that can be used in etching. If they are used, they eliminate the need for smoking plates and are more easily applied and removed. There are "hard" and "soft" grounds, both opaque and transparent. Rosin is used in aquatint grounds, as is powdered asphaltum.

etching tools Common etching tools fall into the following categories: points, burnishers, scrapers, and burins. Pointed tools include diamond points, etching points, litho needles, and carbide-tipped points. Burnishers consist of curved and straight blades in wooden handles. Scrapers are either flat or hollow in design, and burins are classified as bent, straight, knife, lining, chisel, flats, and elliptical. *Spitztucker* or *onglette* are other names for the elliptical burin.

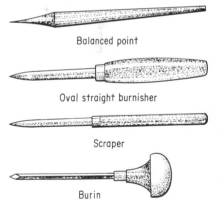

Balanced point

Oval straight burnisher

Scraper

Burin

etching tools

ethyl silicate A colorless, clear, volitile liquid that is used for making acidproof cement and for preserving stone. It is also sometimes used as a mural painting medium, being resistant to chemical and atmospheric attacks. When used as a binder for paint, it is mixed with alcohol and small amounts of water. A chemical reaction then takes place that changes the liquid to pure silica. For the best working

properties and adhesion of this material, the artist must be extremely careful in his formulation and handling of it.

extender A substance added to a pigment to make it longer wearing or to diffuse or dilute the color. Extenders are usually inert, translucent substances and are either colorless or white.

F

facsimile A process used by news services and newspapers in which graphic material such as photographs or drawings are scanned and converted into electrical signals. These signals are then transmitted, sometimes over very long distances, to a receiver that reconstructs a likeness, or facsimile, of the original copy. The likeness is often coarse-grained, something like a television picture.

fat and lean oil paints *See* LEAN TO FAT PAINTING.

felt- and fiber-tip pens These pens find wide application in the graphic arts, and are used for making dummies, layouts, color sketches, and signs. Some varieties are transparent and can be used to color transparencies and overlays. These pens contain a variety of instant-drying inks, many of which are formulated with dyes. The manufacturers of these pens make no claims for the permanency of the dyes used. Some felt-tip pens have replaceable tips in different shapes and sizes.

ferrule A tube made of metal, quill, or some other material that securely holds the bristles or hairs of a brush. It also serves to join the brush to the handle.

fettling knife A sharp instrument with a flexible blade tapering to a point. It is used in ceramics for the carving of clay models, sgraffito, removing mold marks, and for miscellaneous other uses.

fettling knives

filler A material used in woodworking, lacquering, and finishing. It is an inert, pastelike material used for smoothing out imperfections on wood surfaces. It is white and transparent, and particularly useful for filling coarse-grained woods prior to varnishing or polishing.

film opaques Large quantities of line film are used in the graphic arts. Much of it, after processing, must be treated for the elimination of pinholes, very small transparent dots in an otherwise black emulsion area. These pinholes are covered or "spotted" with small red sable brushes and film opaque. Red opaque is the most commonly used because it is easily seen against the black of negatives. It is flat, absolutely opaque, dries rapidly, and is water-resistant. It can be scraped, scribed, and, if necessary, can be washed off. Black opaque meets the same requirements as red, but some brands are waterproof when dry.

filmstrip *Filmstrip* and *slide film* are synonymous terms used to describe a continuous length of 35-millimeter film containing any number of still photographs, drawings, or charts. These pictures are projected on a screen one at a time.

Some filmstrips bear captions on the slides themselves; others are accompanied by narration and sound effects provided either by records or tapes.

finger paints Creamy, nontoxic, and washable paints used for fingerpainting on smooth-finish papers and boards. They are also used in crafts to decorate such things as boxes, waste baskets, and lamp shades. Designs in finger paints can be made permanent by varnishing them.

fire-gilt process A gilding technique in which an amalgam of mercury and gold is washed onto a metal base. The base is then heated to vaporize the mercury, after which the gold is burnished. This is an extremely dangerous operation, and one that is not recommended. The mercury vapors produced are very poisonous.

fixative A thin varnish material, now usually in spray cans, that is used to bind the loose particles of charcoal, pastel, or chalk in a drawing. Also, it is sprayed on pencil drawings and reproduction proofs to prevent their smudging.

flash point The temperature at which the vapors of flammable materials such as solvents will ignite if exposed to a spark or an open flame. Standard requirements of safety in industrial painting call for a thinner with a flash point above 80°F. The higher the flash point, the safer the product.

flat Also called a *stripping flat*, this is an assembly of film negatives or positives that are stripped or taped in alignment on a sheet of glass, plastic, or goldenrod paper, and used for making printing plates. *See also* FLATS, THEATRICAL.

flat-bed press There are two major kinds of presses: flat-bed and rotary. For flat-bed presses the printing plates for type and cuts are flat. For rotary presses the printing surface is cylindrical.

flat black varnish An acceptable flat black varnish can be made by dissolving 1 ounce of shellac in 3 fluid ounces of wood alcohol, and adding 2 ounces of lampblack. This mixture must be kept away from excessive heat or open flame.

flat color There are two main kinds of color printing: flat color and process color. Flat color is the use of broad areas of single colors, not meant to mingle or blend on the page to produce other colors. The use of colored headlines, borders, or blocks characterizes flat color. Color photographs, on the other hand, must be printed as *process* color to reproduce all their shades and tones.

flats, theatrical Stage constructions, used in series, to produce a painted background—usually architectural details. They are canvas-covered frames and are used for all flat surfaces on the stage: room interiors, exterior walls of buildings, and so forth. For simplicity in storing, handling, and shipping, the greatest width of a flat is usually 5 feet 9 inches.

To create a smooth wall surface with a number of flats, it is necessary to mask the cracks between them. This is done with a glued and tacked strip of canvas called a "dutchman." *See also* SCENE PAINT *and* SCENE PAINTING.

flexography This printing system is a form of rotary letterpress that uses flexible rubber plates and fast-drying fluid inks. Only two rollers are required, one running partially immersed in the fountain, and the other transferring the ink to the plate. Like the plate, these rollers are made of rubber. Extremely fast-drying solvent inks are used in this process. Almost anything that can be run through a web press can be printed by flexography, including hard-surfaced materials like acetate, cellophane, polypropylene, polyethylene, and other plastic films. Prior to 1952, flexography was known as *aniline* printing.

flock Short fibers of cloth sprayed onto a tacky adhesive surface, creating a velour or suedelike finish. Fibers of nylon and other materials are available in a number of colors.

flong A printing term referring to a special kind of paper used in stereotype making. It is made by pasting strong tissue paper to thick blotting paper.

flowers of tin A material with valuable fusing qualities, used in the making of enamels and glazes.

fluorescent colors Paints in several colors which glow under black light (ultraviolet light).

flush A printing term that means "even with." Headings are often run flush left, meaning even with the left margin. If the term is used alone, it is taken to mean flush left. When a line is flush with both margins (as this one is), it is said to run "full measure." *See also* TYPOGRAPHIC TERMS AND EQUIPMENT, JUSTIFICATION.

flux (1) In enamel work, flux, or *fondant,* is a substance composed of silicates and other materials that forms a colorless, transparent glass when fired. (2) In welding and soldering, a substance to promote the fusion of metal. When added to molten metal, it tends to clean it and bring the dross to the top. Fluxes are typically made of combinations of tallow, charcoal, rosin, sal ammoniac, etc.

font This word refers to a particular typeface and size, including all the capitals, small letters, punctutation marks, numerals, and so forth.

fountain In printing, a container or reservoir on a press that contains an ink supply, or, as in the case of offset lithography, a fountain solution (usually a water-alcohol mixture) that wets the nonprinting areas of the plate.

four-color printing *See* COLOR SEPARATION *and* PROCESS COLOR.

french chalk A common name for talc. *See* TALC.

fresco There are two methods of fresco painting: *buon fresco* and *fresco secco.* In *buon fresco,* dry pigments are ground with water only and applied on a wet lime plaster wall. As the plaster dries, the pigment is permanently bound to it. *Fresco secco* is a method of painting with pigments ground in glue, casein, or polymer emulsions on a dry plaster wall that has been wetted with lime water.

fresco pigments Permanent pigments for fresco painting must be light-fast, and also able to resist the acid action of polluted air and the alkaline action of the lime plaster. The following pigments are acceptable:

fresco Domenico Ghirlandaio. SAINT CHRISTOPHER AND THE INFANT CHRIST. (Fifteenth century.) 112 x 59 inches. (*The Metropolitan Museum of Art, Gift of Cornelius Vanderbilt, 1880.*)

WHITE: Slaked lime putty, bianco sangiovanni, and neutral blanc fixe
YELLOW: French ocher, mars yellow, and italian raw sienna
RED: Pure artificial red oxides, mars red, light red, and indian red
VIOLET: Cobalt violet and mars violet
BLUE: True cobalt blue and cerulean blue
GREEN: Chromium oxide, cobalt green, green earth, and viridian
BROWN: Burnt turkey umber, raw turkey umber, and verona brown
BLACK: Mars black and lampblack

frisket cement A special cement used to glue down frisket paper or film to make a protective mask.

frisket paper A thin paper that will not wrinkle or curl when wet. It is placed over areas of photographs or drawings to be masked during an airbrush or painting operation. The appropriate shapes

are cut in the material with a frisket knife. Liquid frisket is also available which is applied directly to the artwork with brush or pen. It dries quickly and is easily removed. It lifts off like a sheet of rubber.

A similar material is sometimes used in fine art. It consists of a removable adhesive, and is used to mask certain areas that are not supposed to receive paint.

frit A silicate compound used in ceramics as a strengthening agent in porcelain and as an ingredient in enamels and glazes.

The term also refers to calcined, or partly fused, materials used in glassmaking, particularly medieval glassmaking.

frottage The French word for "rubbing." A technique in which a material, such as paper, is placed on a rough or irregular surface and is rubbed with a pencil or paint. The approximate image of the peaks and valleys results. The method is used to copy bas-reliefs, tombstones, and bronzes. The resulting image is also known as *frottage.*

fugitive colors Any colors that have a tendency to fade, particularly because of light, dampness, or heat.

fuller's earth A form of diatomaceous earth. It is used as an abrasive.

rubbing MEN WITH SHIELDS AND SPEARS. (Cambodia, eleventh–twelfth century.) 2 feet × 4 feet. (*Fogg Art Museum, Harvard University.*)

G

gallery camera *See* PROCESS CAMERA.

garnet paper A material similar to sandpaper, except that finely crushed garnets are used as the abrasive instead of sand.

gather A term used in the making of stained glass. It refers to the small amount of glass affixed to the end of the blowpipe. This *gather* of glass, which is clear and transparent, is dipped into molten glass of another color. When blown, the colored glass forms a film on the clear glass, forming *flashed* glass. This technique is used to prevent colors from becoming too dark for use in stained-glass windows.

In bookbinding, *gather* is a term describing the process of arranging folded sheets or signatures in sequence.

gelatin A material made from the bones and skins of animals, it is used to make photographic emulsion, as sizing, as an adhesive, and for many other applications. For its use in molds, see SCULPTURE.

gels Transparent sheets of colored gelatin used in spotlight tinting, overlays, and light diffusion. A great many colors are available. *See also* MATERIALS FOR COLORING LIGHT.

gesso Traditional gesso is a material made from chalk and gelatin or casein glue, and painted on panels to furnish a painting surface for tempera work. It is often highly polished (sometimes with an abrasive material as fine as alumina) before the paint is applied, and gives brilliance to pigments placed on it. A gesso ground is not flexible and can only be used on solid surfaces.

Polymer gesso, or synthetic gesso, provides a flexible ground that can be used on canvas and other fabrics, as well as on many other materials.

gesso sizing Traditional gesso may be sized to reduce its absorbancy. A typical size consists of white shellac diluted with 4 or more parts denatured alcohol. It should be brushed or sprayed very lightly.

Shellac must never be used on the *surface* of a painting because it has the tendency to darken and crack.

gilder's cushion When gilding, the extremely thin gold leaf must be laid out where it can be flattened and cut. A gilder's cushion provides this support. It consists of soft calfskin stretched over a thin padding on a rectangular panel of wood. The panel may be 5 or 6 inches wide by 8 or 10 inches long. The leather should not be oily, and is frequently dusted with red ocher or hematite to keep the gold leaf from sticking to it.

gilder's knife A fairly heavy steel knife that is about 8 inches long. It is used for cutting gold leaf after it has been thoroughly flattened on a gilder's cushion.

gilder's tip

gilder's tip A very thin, flat brush, the hairs of which are held in a light cardboard handle. In use it is brushed through the artist's hair. This gives the brush a small charge of static electricity that enables it to pick up the delicate sheets of gold leaf from the gilder's cushion. The leaf is then positioned on the working surface.

gilding The art of applying gold, either in leaf form with the aforementioned tools or in dust form. Gold leaf, as the term implies, consists of thin leaves of real gold which are applied to a surface as sheets. Gold leaf retains its brilliance and luster almost indefinitely even in outdoor applications. Bronze powders and paints, however, tend to tarnish and discolor.

Gold leaf is purchased in books consisting of 25 leaves measuring about 3 inches square. A book will cover an area of about $1\frac{1}{2}$ square feet. There are two types: loose leaf and patent leaf. The loose leaf is separated by rouged tissue paper and must be removed with the use of a gilder's tip. Patent leaf is usually marked "for gilding in

the wind," and each leaf is mounted on a larger-sized tissue-paper backing. It is applied by pressing the leaf face down, then rubbing against the paper backing.

Leaf must be placed on smooth, sealed, clean surfaces to which gold size has been applied and allowed to become tacky. A slow size becomes tacky in from 12 to 24 hours; a quick size from $1\frac{1}{2}$ to $2\frac{1}{2}$ hours. The leaves are pressed against the surface, with each sheet overlapping the next by about $\frac{1}{8}$ inch. No attempt should be made to trim or remove excess sheets. After allowing the work to dry overnight, it should be rubbed with clean absorbent cotton. This burnishing will remove all excess leaf and will also polish the metal to a high luster. No protective coating is required unless the object receives frequent handling. In this case, a coat of clear varnish may be applied.

Gold can also be electroplated, and shell gold is a finely powdered gold mixed with a medium and applied as a paint. (*See also* FIRE-GILT PROCESS.)

glacure A thin glazing on fine pottery.

glass Glass is a hard, rigid material that is resistant to weathering and to most chemicals except hydrofluoric acid.

The simplest kind of glass is made by melting together silica and soda ash. Bottle glass is a mixture of soda, lime, and silica. Added sparkle is imparted to glass by the addition of a small amount of barium. Metallic oxides are used to color glass and give it special properties.

glass etching methods The most common commercial method for etching glass utilizes hydrofluoric acid. This is a potentially dangerous operation because the fumes given off are highly injurious.

A less hazardous solution for frosting or engraving glass can be made in the following two-part recipe.

Solution A consists of 2 ounces (60.0 grams) of sodium flouride, 180 grains (12.0 grams) of potassium sulfate, and water to make 16 ounces (500 cubic centimeters).

Solution B consists of 196 grains (14.0 grams) of zinc chloride, 2 fluid ounces (65.0 cubic centimeters) of hydrochloric acid, and water to make 16 ounces (500 cubic centimeters).

For use, mix the two solutions in a plastic or hard rubber container and apply with a quill pen or a brush. A fine matte finish is obtained on glass in about thirty minutes.

The vapors from the mixed solutions should not be breathed. Use rubber gloves when handling. Remember that acid is always added slowly to water, not the other way around.

glassine A thin, transparent paper used for making protective envelopes and sleeves for photographic negatives. It is also widely used as a wrapping material.

glazes *See* CERAMICS TERMS.

glazing In oil painting, glazing consists of laying an almost transparent film of color over a paint surface that has already dried. This is done to modify the tone of the area covered. Almost any color can be used as a glaze if it is thinned enough with a glazing medium and placed over a lighter tone.

glazing medium formula *See* PAINTING AND GLAZING MEDIUMS.

glitter Bright metallic particles that sparkle by reflected light. It is used for signs, displays, and decorations.

glue An adhesive material used for various joining purposes. It is also a binding medium in paints. In the orient, glue is the traditional binder for paints and inks.
 Glue is prepared from various animals and fish, the bones and skins of which are ordinarily used. With the exception of fish glues, most dry to a hard gel. The dried gel can be softened by cold water, but dissolved only by heating. Glue should never be boiled, because it loses its strength. Glues made from decomposed materials are weak. Pungent odors indicate defective glues.

glycerin A colorless, syrupy liquid that is soluble in water and in alcohol. It is useful as an antifreeze and has numerous applications in the graphic arts because it does not evaporate easily. It keeps stamp-pad inks, for example, from drying out.

glycerin sandwich If a badly scratched photographic negative is placed between glass plates coated with glycerin, the scratches will be temporarily filled in and a print can be made.

gold *See* GILDING.

gold leaf Gold is the most malleable of all metals and can be beaten into sheets, or leaves, 254,000 thicknesses to the inch. Beaten leaves are placed in books, the paper of which is rubbed with chalk to keep the leaves from sticking. A book consists of 25 leaves, a quantity that will cover about $1\frac{1}{2}$ square feet. *See also* GILDING.

gold point A drawing made on a slightly abrasive ground using a gold wire or point as a drawing instrument. *See also* SILVERPOINT.

gold watercolor It is possible to purchase genuine 23 karat gold in tablet form or on a small shell (shell gold). This gold is soluble in water and can be used for watercolor painting, lettering, and illuminating.

gouache A type of watercolor painting that uses opaque, rather than transparent, colors. Since it is opaque, the white of the paper plays no part. A pliable adhesive is usually added to the binder to give the dried surface a soft, semimatte sheen. The word is pronounced "gwash," rhyming with "wash."

grain (1) In lithography, the surface texture applied to offset-lithographic plates. This texture helps the nonprinting portion of the plate retain water and improves the durability of the printing image. (2) As applied to paper, the grain direction taken by a majority of the fibers in any sheet. This is also called *machine direction* and refers to the movement of the paper on a papermaking machine. (3) In photography, the distribution of silver particles in emulsions and images. If the particles are quite small and capable of reproducing good detail, the film is referred to as "fine grain."

graver An engraving tool with the handle cut off flat on one side so that it can be held close to the copper plate. It may have a square point or a lozenge-shaped point. The furrows cut with a square-pointed graver are broad and not very deep. The resulting print is gray because the furrows do not hold much ink.

gouache David Park. TWO HEADS. (1960) 12½ × 12¼ inches. (*Gift of Mrs. Volney F. Righter. Collection Whitney Museum of American Art.*)

gravure Instead of using a raised surface to print from, as letterpress does, gravure is an intaglio process and prints from sunken or depressed surfaces or cups. The depth (and the area) of the depressed areas varies, thus yielding more or less ink on the paper. In rotogravure, a copper cylinder with the image etched below its surface rotates in a bath of ink. The excess ink on the surface is wiped off by a doctor blade, and the ink remaining in the recessed cups forms the image by transfer to the paper as it passes between the plate and impression cylinders. It is considered to be the finest method of reproducing pictures, but its expense limits its use to long runs.

Sheet-fed gravure is a system of printing which yields excellent results in the reproduction of artwork, such as paintings and etchings, and photography. The screens used in this system are very fine, varying from between 120 to 250 lines. The latter produces the etching of 62,500 cups per square inch on the plate. The cells are so close that the ink coverage tends to fuse and obscure the pattern of the screen, and this is one of the reasons for its unusual effectiveness.

grisaille A technique of monochrome painting in two or three shades of gray, as in imitation of a bas-relief. It also refers to all methods of painting in which full modeling is done in black and white, or other contrasting tones, and then finished by the application of many transparent glazes. *See also* CAMAÏEU.

Grisaille is also a term denoting a pigment used in stained glass. It consists of a mixture of burnt umber, red lead, and quartz.

grog *See* CERAMICS TERMS.

ground The ground of a painting is the preparation laid over the support, providing a smooth, even-textured surface. Oil painting grounds are often a lead-oil mixture painted on a sized canvas. The traditional ground for tempera is gesso placed on wooden panels.

The term is also used in etching to describe the acid-resistant coating on a copper plate.

ground laying A ceramics term that is also known as bossing and grounding. It consists of applying a coat of boiled oil to porcelain ware, to receive the colored enamel.

ground-glass substitute Ordinary clear glass can be treated to resemble ground glass by the following method. Carefully mix 292 grains (20.0 grams) of rice starch with $6\frac{1}{2}$ fluid ounces (200.0 cubic centimeters) of water. To this add $3\frac{1}{4}$ fluid ounces (100.0 cubic centimeters) of water glass (sodium silicate).

Level the sheet of glass and pour on enough of the liquid to cover

it, then allow it to dry. The coating is fragile and is affected by water. To make it more permanent, the coating can be sprayed with fixative, or some other lacquer coating. (For true etching of glass, see GLASS ETCHING METHODS.)

grout A liquid mortar used to fill the cracks left between the tesserae in mosaic work. As it hardens it becomes waterproof. As sold, it is a fine white cement powder available by the pint or pound. A pound of cement will be required for every 2 or 3 feet of mosaic surface to be grouted. To mix, the powder is placed in a bowl and water added a little at a time until a thick, creamy paste is formed.

guides *See* MECHANICAL DRAWING, TEMPLATES.

guillotine A heavy steel cutting knife used for cutting printing plates made of copper, zinc, or magnesium, and for trimming excess metal from electrotype or stereotype casts.

gum eraser A soft, crumbly eraser that wears itself away but does not mar or scratch paper surfaces. It is also known as an *art gum eraser.*

gums and resins Following are some of the more common gums and resins used in fine art and the graphic arts.
 acaroid gum. A gum extracted from the Xanthorrhoea tree found in Australia. It is used in wax, as a sizing for paper, and occasionally as a surface film on paintings and sculpture.
 benzoin. A dark gum harvested from trees in Siam and Indonesia. It is sometimes used in varnishes and lacquers to make them less brittle.
 canada balsam. A product of coniferous trees. An exudate of these trees is distilled to produce a transparent resin that is used to cement photographic lens elements.
 cherry gum. Sometimes used in tempera paints as a binder. It is soaked in water and strained to obtain a usable solution. It produces brittle, glassy films.
 copaiva balsam. Sometimes used in the restoration of old oil paintings that are dried and cracked. It should not be used in a painting medium because of its tendency to dissolve linseed oil films.
 copal resin. A term applied to a group of hard and soft resins. The hard variety is a fossilized resin that is insoluble until fused at high temperatures and melted in hot linseed oil. A softer variety can be dissolved cold in alcohol.
 Dried copal varnish films are very glossy and hard, and are not easily redissolved by turpentine or alcohol.
 dammar resin. A product of a family of trees found in Indonesia

and is a favorite among the resins used for varnish making. It can be purchased already dissolved or can be bought in crystal form and dissolved in turpentine. It is a soft resin, as opposed to copal, and is widely used as a protective film on oil paintings.

The usual concentration of dammar varnish is a "5-pound cut," that is, 5 pounds of resin dissolved in 1 gallon of turpentine. In this concentration it is added to painting mediums. For picture varnish, this is reduced to 4-pound cut (simply by adding 4 parts 5-pound cut to 1 part turpentine). Retouch varnish is further diluted with turpentine to produce a 1-pound cut.

The resin is dissolved by placing the dammar crystals in a cheese-cloth bag and suspending them in turpentine. At no time should moisture be introduced, since water in the varnish will make it bloom.

dragon's blood. A dark-red resin used as an etching resist in photoengraving. It protects certain areas of the plate while in an acid bath. It is first brushed on the plate, then subjected to heat which actually melts the resin of the surface.

gum arabic. A gum obtained from acacia trees in Africa and Australia. It is also called *gum Kordofan* or *gum Senegal* and is purchased as a white powder. It dissolves in hot water and yields a sizing that is the principal binder used in watercolor and gouache. Sometimes a little honey or other substance is added to it to prevent its scaling when dry.

gum tragacanth. A gum produced from a shrub. The gum swells in cold water but does not dissolve. The adhesive is obtained by squeezing the water-softened mass through a fine cloth. The principal use of the gum is as a binder in the manufacture of pastels.

mastic resin. A resin exuded from certain trees growing in the Mediterranean area. It can be dissolved in turpentine or alcohol, but not in mineral spirits. It may be prepared in the same manner as dammar varnish, but is often used with the addition of drying oil or other plasticizer.

sandarac resin. A resin obtained from plants growing in the Mediterranean area and in Australia. It is no longer popular because it produces a brittle surface film that has a tendency to craze. It is soluble in alcohol and hot turpentine.

shellac. *See* SHELLAC.

gutter The gutter of a magazine or book constitutes the inside margins where the facing pages join. *See also* MARGINS.

gyotaku Gyotaku is the art of Japanese fish printing, a modern application of the ancient art of stone rubbing. Two methods are used: one in which the fish is coated with india ink and pressed on paper; the other where the fish is covered with a layer of light paper,

gyotaku print (*Courtesy of the Ecusta Paper Division, Olin Mathieson Chemical Corporation.*)

over which is placed heavier paper and the whole rubbed with watercolors.

gypsum A native calcium sulfate sometimes used in the finishing (surface treatment) of paper and textiles. When burned it can be mixed with water and will set rapidly as a firm plaster. This form of gypsum is called *plaster of paris,* and is one of the most common casting materials. *See also* PLASTER OF PARIS.

H

halftone There are two kinds of cuts or engravings used in printing: line cuts and halftones. Line cuts are used to reproduce artwork containing lines and patterns in which all the elements are either black or white. Halftones are used to reproduce photographs and drawings that contain grays (middle tones or halftones) in addition to black and white.

A halftone is produced by photographing the artwork through a screen. This produces an effect in which tone values are represented by a series of tiny, evenly spaced dots of varying size and shape. The dot areas vary in direct proportion to the intensity of the tones they represent, and will pick up ink accordingly. Any gray tone can be produced out of tiny black dots with white spaces between them.

Prior to the introduction of halftone screens, the effect of gray was produced by engraving fine lines closely spaced; the closer the spacing, the darker the gray.

A *dropout halftone,* also called a *highlight halftone,* is produced by eliminating the residual dot formation in the pure highlights. This is done either by spotting the highlight areas on the negative with opaque or by etching the printing plate.

An *outline halftone* is one in which the background outside the subject is entirely cut away, leaving a definite edge.

halftone contact screens These screens consist of a regular pattern of dots and are used for making halftone negatives in a camera. A

65-line screen is one that contains 65 fine dots to the linear inch. Screens are available in rulings ranging from 32 to 250 lines per inch.

In letterpress printing, the lower screens are used for printing on coarse paper (such as newsprint), and the fine screens require smoother finishes. Ordinary English finish or supercalendered paper will take a 110-line screen, but coated stocks are needed for 120- and 133-line screens. In offset lithography it is possible to use fairly fine screens on uncoated paper.

45 65 100 133

halftone contact screens
(*Photograph by Charles D. Hamilton.*)

Gravure processes always use fine screens, not less than 150 lines and frequently 175 and 200.

Gray contact screens are ones in which the dots are of a regular silver emulsion. *Magenta* screens have a dye image and can be used for contrast control through the use of filters.

hardening on A ceramics term to describe the process of low firing an underglaze decoration to remove the oils that bind the pigments. Hardening on takes place before the final glazing operation.

haricot A red copper oxide used as a background color in decorative ceramics work.

high etch *See* DRY-RELIEF OFFSET.

honey This material is sometimes added to various paint binders. When mixed with tempera, it imparts a true matte finish.

hot stamping A method of printing in which heated type or stamping dies are pressed against a thin leaf of gold or other metal, or pigment upon a surface such as paper, board, plastic, or leather. The thin leaf contains a sizing agent that is set by heat. This system, sometimes used for making movie titles and artwork for slides, is also called *hot-press titling*.

humidity effect Changes of relative humidity that affect the size and register of films, paper, flats, and press sheets. Paper and film expand slightly in size when they absorb moisture.

hyalography The art of engraving on glass, with diamond or emery cutting tools, or with hydrofluoric acid or other etching solutions. *See also* COPPER WHEEL ENGRAVING *and* GLASS ETCHING METHODS.

hydrofluoric acid A compound of hydrogen and fluorine, this is a corrosive acid with a pungent, suffocating odor. It readily attacks silica and is used in commercial glass etching operations.

impasto Hans Hofmann. UNTITLED. (1949) Oil on canvas. 29¾ × 24¾ inches. (*Gift of Mrs. Sidney Gerber and the late Mr. Gerber. Seattle Art Museum.*)

illuminated sheet (Italian, fifteenth century.) 21¼ × 14¾ inches. (*Fogg Art Museum, Harvard University.*)

ichonography Brian Fisher. COLLAGE "GEMINI." (1966) Ink on board and collage. 28⅛ × 18 inches. (*Eugene Fuller Memorial Collection, Seattle Art Museum.*)

ichnography The art of making decorative drawings by the use of compass and rule, in a sense revived in "op" art techniques. It also refers to the art of tracing plans and illustrations.

illuminating The hand decoration of books, as done in medieval times, with drawings and miniature paintings. Also, ornamentation and embellishments, usually in red, blue, and gold, that were sometimes added to initial letters and borders.

impasto The thick, heavy application of oil paint to a canvas, often through the use of a palette knife. These sections stand out in considerable relief. (The term also refers to the thick application of polymer, or other paint, to any painting surface.)

impression A print struck off from an engraved plate. Also, a press run or printing of a book. Successive impressions of books differ very little if at all from each other. Content is revised or rewritten between successive *editions.*

imprimatura Most painting grounds are white, but when a very thin glaze of color is put on over it, it is called an imprimatura. The old masters often used variously colored grounds.

india ink Also called *Chinese ink* and *sumi ink,* a permanent black ink made of lampblack and glue binder. Some varieties of india ink are waterproof.

ink-grinding stone An ink-grinding stone, called *suzuri* in Japanese, consists of a small (about $2\frac{1}{2}$-by 5-inch) flat stone with an indentation at one end to hold water. Ink sticks (*sumi*) are ground with water on the surface of the stone to make ink of any desired consistency.

ink knife An instrument resembling a large spatula. It has a handle and a blade with square or rounded end. It is used for handling paste inks, and is sometimes referred to as an ink slice.

inks Inks are colored liquids or pastes used for writing, drawing, marking, and printing. Traditional writing inks usually contain ferrous sulfate in the gallotannic acid derived from nutgalls. This iron-gall ink turns black when exposed to air. Good writing ink is a clear, filterable solution, not a suspension such as those used in drawing inks. Following are a few classes of inks.

ball-point inks. Inks of high tinctorial strength and free of particles that might tend to clog the ball-point tip as it passes along the paper. The ink dries on the paper by rapid penetration. Strong dye solutions are used as pigments, with vehicles such as oleic acid and castor oil.

black waterproof drawing ink. Made of carbon black, shellac dissolved in a thin borax solution, preserving agents, and sometimes glue. Since drawing inks contain a high proportion of solids and special binders, crusts of ink can build up on screw caps, pens, and brushes

ink drawing Philip Pearlstein. UPROOTED TREE. (1956) $17\frac{3}{4} \times 21\frac{3}{8}$ inches. (*Gift of John Preston in memory of Morgan O. Preston, 1918–1944. Collection Whitney Museum of American Art, New York.*)

unless care is taken. Drawing inks (which are alkaline) and writing inks (normally acid) should not be mixed because they may coagulate. Drawing inks should be mixed only with distilled water.

drawing inks, colored. Inks that contain soluble dyes and alkaline shellac. They are transparent and waterproof when dry. They have limited color-fastness, however, and should not be used in permanent drawing or painting.

drawing inks, colored pigment. Inks that contain permanent pigments and alkaline shellac thinned in water. They are waterproof when dry and are suitable for artistic purposes because the colors do not fade. They dry to a dull finish.

inks for writing on glass. Inks made very easily in the following ways. Black ink can be made by mixing 1 part india ink with 2 parts water glass (sodium silicate). White ink is made by mixing 1 part Chinese white or barium sulfate with 3 to 4 parts water glass. They can be applied with brush or ordinary steel pens and dry to a water-resistant finish in about fifteen minutes. For greater permanence, a coat of lacquer can be applied.

printing inks. Mixtures of coloring matter dispersed or dissolved in a vehicle or a carrier. The colorants may be pigments, toners, or dyes. There are several major classes of printing inks. There are letterpress and lithographic inks, commonly called *oil inks* or *paste inks,* and flexographic and rotogravure inks, referred to as *solvent inks.* Vehicles used in printing inks range from mineral oils to vegetable oils, such as linseed, but can be modified by the addition of materials such as alcohols, resins, waxes, and gums. Colors are finely powdered organic or inorganic substances. Typical pigments for printing inks include carbon black, titanium dioxide white, lithopone, chrome yellow, benzidine yellows, molybdate orange, dianisidine orange, cadmium red, para reds, lithol reds, phloxine and eosine lakes, iron blue, prussian blue, methyl violet, phthalocyanine green, and various powdered metals.

Flexographic inks are made as both alcohol-base and water-base materials. They consist of colorants that are either pigments or dyes, together with one or more resins. They must be very fast-drying, and are usually dried by heat.

Gravure inks are also quick-drying, with enough body to be pulled from the engraved wells in the cylinder or plate. They dry almost instantaneously under heat, but most of them are extremely volatile and can be a fire hazard if not handled carefully.

Letterpress inks are usually made in a paste form and consist mainly of pigments and drier ground in a drying oil. They may also have other materials in them to promote scuff-resistance, gloss, or some other special characteristic. In high-speed letterpress printing, the ink dries by absorption into the paper. In magazine printing, the inks usually dry by evaporation. For medium- and slow-speed printing,

the ink film dries mainly by oxidation or polymerization, a hardening or stiffening process that changes the ink from a fluid to a solid body.

Offset-lithographic inks are similar to some of the letterpress inks, but they do not contain materials that bleed, or that are not water-resistant. They dry mainly by oxidation.

screen-process inks. Also called silk-screen inks, used in a technique essentially that of stencil, where a heavy film of ink is applied through an open mesh pattern to form a design. All of the inks must be short and buttery to print sharp, and squeegee with little resistance.

specialty inks. Numerous inks made for special applications. These include metallic inks, fluorescent inks, magnetic inks, and scuff-resistant inks.

stamp-pad inks. Inks used to impregnate cloth or foam-rubber pads. They must be quite nondrying in the pad, yet dry by rapid penetration when applied to paper. Dyes, rather than pigments, are used. The vehicles are usually glycols.

intaglio crayon aquatint A technique in which a copper plate is cleaned and a porous aquatint ground laid on. A drawing is then made with a wax crayon, the wax protecting portions of the plate during the etching operation. This produces a coarse, white, crayon-

intarsia Design and carving attributed to McIntire. MAHOGANY CARD TABLE. (1790–1800, Salem.) (*M. and M. Karolik Collection. Museum of Fine Arts, Boston.*)

textured print, an effect that is sometimes used by itself or in combination with other intaglio processes, such as soft ground etching.

intaglio printing In the intaglio process, the printing elements are all below the plate surface, having been cut, scratched, engraved, or etched into the metal to form ink-retaining grooves or cups. Surplus ink on the surface must be wiped or scraped off after each inking and before each printing impression. Intaglio printing processes include copper and steel engraving, mezzotint, aquatint, etching and stipple engraving, rotogravure, sheet-fed gravure, photogravure, and offset gravure.

intarsia Decorative designs of inlaid wood in a background of wood. Often used in furniture making, and also known as *tarsia*.

ivory A material used extensively for carving and occasionally as a ground for paintings. Unlike bone, it can be worked as soon as it is cut. Ivory usually refers to the tusk material of elephants, but can also refer to that of the walrus and the hippopotamus.

Ivory carvings can be made with steel cutting tools, and the final product may be polished by the gentle application of fine pumice powder on a soft cloth. If a final polish is required, whiting or tooth powder can be used.

For miniature painting on ivory, the bluish-white variety should be used. If ivory has turned yellow, it can be treated with hydrogen peroxide and placed in the sun. To prepare it for painting, the surface should be rubbed with emery paper and then with pumice and cuttlebone. The surface must be clean and free from fingerprints before it is painted upon.

half of ivory plaque DEATH OF ST. AEMILIANUS. (Spanish, c. 1070) (*Courtesy of Museum of Fine Arts, Boston.*)

J

japan Japan refers to varnishes composed of resins and solvents. They are too brittle to be used alone, but are mixed with paints in order to impart gloss.

The term also refers to a class of cheap enamels that are usually black and almost always contain asphaltum. Some of these japans dry in the air, and others require a baking operation.

japan colors Quick-drying colors ground in japan varnish and used by sign painters for window lettering and paper or cloth signs. These colors are soluble in turpentine and dry to a matte finish.

japan driers Varnish materials that are not recommended for permanent painting because when they are mixed with oil colors they cause cracking and are apt to darken pigments.

K

kaolin A pure white clay used in the manufacture of porcelain. It is also sometimes used as a filler.

Keene's cement One of the whitest finish plasters available. It has extreme durability.

Kelvin temperature *See* COLOR TEMPERATURE.

key In copy preparation and stripping, an outline drawing used to position various printing elements.

kiln An oven or furnace heated by electricity, gas, oil, or wood, and used in ceramics for baking pottery. It is also used in enamel work and glass staining.

kneaded eraser A soft, pliable eraser used for erasing pastel, pencil, and charcoal. It is made of rubber and can be molded into any shape.

knife file A file used in woodworking, with a cross section resembling the blade of a knife.

erasing knife

mat knife

stencil knife

swivel knife

knives A great variety of knives and cutters are employed in the arts and the graphic arts. Some have rather specialized uses while others may be used for a number of purposes. Following are some of these knives, most of which have replaceable blades.

erasing knives. Long-bladed steel knives used for erasing india ink and other hard-to-remove materials.

etching knives. Knives equipped with small triangular blades and used in film work to remove pinholes from negatives. If the pinhole is roughened with this blade, light no longer passes directly through it.

film-cutting knives. Tools to cut film, make lines, and cut circles. Bicutters are used to cut parallel lines and are either adjustable or use interchangeable heads.

frisket knives. Tools consisting of a small sharp blade in a wooden or plastic handle. They are used for fine, often very detailed, outline work in frisket cutting.

mat knives. Heavy-duty cutting knives used for general studio applications. Some mat knives have additional blades which are stored in the handle. Others have adjustable blades so that the blade can be extended as it is sharpened down.

scraper knives. Knives used for cutting and scraping. Some use single-edge razor blades as a cutting edge.

scratch and sgraffito knives. Sharp points used in regular penholders and used for scratchboard and sgraffito work.

stencil knives. Knives in several sizes used for cutting stencils. The smaller blades can also be used for cutting friskets.

swivel knives. Knives with blades mounted so they are free to rotate 360 degrees. They are used for cutting irregular curves.

X-Acto knives. The trademarked name of products from the X-Acto Precision Tool Company, Long Island City, New York. This line includes a considerable number of knives and blades, also gouges, routers, and other tools.

See also WOOD-CARVING TOOLS.

kutch Also spelled "cutch," this term refers to the package of vellum leaves into which sheets of gold are placed for the first beating in the preparation of gold leaf.

L

lacquer This term now refers to a number of materials, including synthetic resins. Traditionally it meant a natural resin harvested from trees native to the orient. The lacquer is extracted as a sap. The processed material hardens even in the presence of moisture, does not become brittle, and takes a high polish. When thoroughly dry, it is quite resistant to acids, alkalis, and alcohol, and also to heat up to temperatures of 160°C. It is very fast-drying and can be used successfully on wood, metals, and glass, but is not suitable for use in permanent painting.

lake pigments A class of coloring materials made from dyes. Lakes are transparent and only become usable as pigments when they are combined with a solution of a metal and precipitated on a base of blanc fixe or alumina hydrate. In this process they achieve a certain amount of body and hiding power.

lateral reversal The inversion of the reading direction of printed material. It is accomplished by an optical attachment to the lens; by contact printing through the back of the film; or by "flopping" a film when it is stripped in.

layout A layout is the design for the job to be printed. It consists of drawings that provide a page-by-page outline of the whole job,

showing margins, areas of type, illustrations, headings, captions, and suggested colors. It is drawn to exact size, with every item specified or identified.

A layout having a page-by-page correspondence with the finished job is called a dummy. *See* COMPREHENSIVE *and* DUMMY.

lead caming Lead wire, grooved on both sides to hold the glass sections of a stained-glass window.

leading The process of making stained-glass windows. Lead caming is placed between the various pieces of glass, and entire sections are soldered together. To make a window waterproof, cement is worked under the strips of caming. *See also* TYPOGRAPHIC TERMS, LEADING.

lean to fat painting "Fat" is the term applied to paint that contains a good deal of oil, while "lean" refers to paint that has little or none. Since paints contract when they dry, painting should proceed from "lean" to "fat." Paints with very little oil vehicle should be placed on the canvas first, followed by paints containing a larger amount of oil. If this process is reversed, the slower-drying fatty paints will be sealed under the fast-drying lean paints. When the fat paints underneath finally dry and contract, they will crack the surface of the dry surface layer. For this reason, a painting should not be varnished until all contraction due to drying has taken place.

leather rollers Leather-covered rollers and brayers are sometimes used in lithography for spreading ink evenly on the stone surface.

leather-working tools Common tools used in working leather include a general modeler with a pointed end for line work and a flattened end for general modeling. A ball-end modeler is used for embossing and repoussé work, and a deer-foot modeler for fine work and for depressing outlines. A combination thonging chisel and lacing awl is used for making slits for leather lacing. Spoons are used for smoothing and burnishing operations, and a revolving punch is used for punching various-sized holes. The knife used for cutting leather is called a skiving knife.

letterpress A method of printing from a raised surface which carries the ink. It is the oldest printing process, the name having derived from the fact that the letters of type stand up above the general surface. It employs type or plates cast or engraved in relief on materials such as metal, wood, or rubber. Ink is applied to the printing surface and pressure is applied in one of the following ways. On a *platen press,* impressions are made by pressure against a flat area of type or plate. On a *flat-bed cylinder press,* pressure is produced

General modeler

Ball-end modeler

Deer-foot modeler

Thonging chisel and lacing awl

Revolving punch

leather-working tools

by a cylinder rolling across the flat area of type. In *rotary web printing*, the flat printing area is molded into a curved form against which an impression cyclinder revolves.

letterset (dry offset) A method of printing that uses a blanket for transferring an image from plate to paper. Unlike offset lithography, however, it uses a relief plate, and requires no dampening system.

light tables (light boxes) Also called *tracing* tables or boxes, these are simply wooden or metal frames with a ground-glass surface. Fluorescent tubes or light bulbs are placed underneath to provide the illumination needed to trace drawings, spot negatives, or assemble film materials.

lighting, lighting equipment The need for illumination, the basic principles of lighting, and basic items of lighting equipment are common to still photography, motion picture production, television, and the theatre stage. Following are a few of the specialized names applied to items of lighting equipment and lighting practices.

 baby spot. A spotlight of 500 watts or less.

 back light. A light, usually a spotlight, that illuminates a subject from behind, serving to separate it from the background.

 barn doors. Shutters or flaps on the front of a lighting unit that control the shape of the beam.

 base light. The total, uniform light needed on a television or motion picture set to satisfy the high light levels needed for television cameras and for motion picture film.

 beam projector. A lighting unit with a paraboloidal reflector that produces a narrow, almost parallel, beam of light.

 borderlight. A light mounted above the acting area on a stage and used for general lighting. Borderlights are also used to light scenery, backdrops, and other areas. They consist of a number of lights in a line, often in separate compartments. They usually have rondels or gels to color the light and are often wired in three or four circuits.

borderlight

 broad. A kind of open, box-shaped reflector that contains one or more large incandescent lamps.

 catchlights. Reflections of light sources in a subject's eyes or eyeglasses. Lights designed to do this deliberately are called *kickers* or *eyelights*.

 color frame. The metal frame used to hold color media (gels, etc.) at the front of a lighting unit.

 color media. Any colored, transparent material that is placed in front of a lighting unit to color the light it transmits. These are often referred to as "gels" or gelatin, but glass and plastic materials are also used. *See* MATERIALS FOR COLORING LIGHT.

ellipsoidal spotlight

fresnel spotlight

concert border. A borderlight mounted immediately behind the proscenium arch on a stage.

cucoloris. Also called "cuke" or "cookie." Material having a cutout that allows light to pass through it and project a form.

cyclorama strip lights. Strip lights mounted at the top and bottom of a cyclorama to light it evenly. Also called *cyc strips.*

dimmer. A device to control the intensity of light from lighting units.

ellipsoidal floodlight. *See* SCOOP *in this section.*

ellipsoidal spotlight. A lighting unit that consists of a lamp, reflector, framing device, and a single or multiple lens system. It also accommodates a pattern holder and patterns that can be sharply and uniformly projected. Models range from 250 to 2,000 watts.

eyelights. Low-intensity light sources used to add sparkle to the eyes or teeth and to reduce shadows on the face. They are usually placed at eye level. This is a television term; in motion picture production they are called *kickers.*

fill light. The secondary illumination used to reduce shadow intensity and to balance the effects of the key light.

flag. *See* GOBO *in this section.*

floodlight. Generally speaking, any lighting unit that produces a broad beam, or flood, of light. *See also* SCOOP *in this section.*

follow spot. A high-intensity spotlight used to follow action in arenas and stadiums and on large stages. It is equipped with adjustable iris and shutter controls, and its light source is either carbon arc or incandescent bulb.

fresnel spotlight. A lighting instrument that is comprised of a lamp and a fresnel (stepped plano-convex) lens. The unit can be made with or without reflectors, and has a system to adjust the spacing between the lamp and the lens so as to control the light beam. Models range from 100 to 5,000 watts.

funnels. Metal tubes mounted on the front of spotlights to control the spread of their beams.

gobo. Also called a *flag,* this is an opaque material hung a short distance from a lighting unit to mask off light from a certain portion of a subject or setting.

junior. A 1,000- or 2,000-watt fresnel spotlight.

key light. The main source of light that establishes the character of the subject and the atmosphere and mood of a scene.

kicker. *See* EYELIGHTS *in this section.*

Klieglight. A trademarked name of Kliegl Brothers Company that at one time referred to a large arc light used in motion picture photography. Since 1932, it refers to an ellipsoidal spotlight with an incandescent lamp.

limelight. An obsolete light source once used in spotlights. It consisted of a block of lime heated to incandescence by means of

an oxyhydrogen flame torch. It is the source of the popular term for fame or prominence.

linnebach projector. A light resembling a large floodlight and used in the theatre for projecting scenery on rear curtains or other large flat areas. It employs no lenses and uses very short throws. The scene to be projected is painted in transparent colors on a piece of glass 2 feet square or larger.

lobsterscope. A device on a spotlight to make it flicker. This creates a silent-film effect on a stage.

modeling lights. Also called *balance lights, counter lights,* and *cross-lights.* The main function of these lights is to balance the effects of key lighting on the face of the actor. If the key light is used on one side of the face, a modeling light is used on the other. It is not so intense as the key light.

olivettes. Standing floodlights used in the wings for lighting stage entrances and acting areas at fairly close range. Bulb wattage ranges from 500 to 1,500 watts.

plano-convex spotlights. Versatile lights that can be used as sharply defined spotlights or for soft-edged light. They range in power from 100 to 2,000 watts.

roundels. Circular pieces of colored glass, often used to color the light from striplights.

sciopticon. A scenic-effect projector used in theatre work, usually as an attachment to a regular spotlight. It employs single or multiple hand-painted disks. In use it creates the effect of moving clouds, falling snow, rippling water, and so forth.

scoop. A floodlight consisting of a lamp and an ellipsoidal reflector with fixed spacing. It has a reflector diameter ranging from 10 inches to almost 2 feet, with power requirements of from 250 to 5,000 watts.

scrim. A *flag* made of translucent material used to diffuse or soften light. The term is also used to describe large, gauzelike theatrical curtains. When lighted from the front, these curtains appear opaque. If lighted from behind, they appear transparent.

senior. A large fresnel spotlight using a 5,000-watt lamp.

set lights. Lighting instruments used to illuminate scenery and props on a stage. They are used to accent, model, highlight, and to create effects on the background or set. Other lights are used for the actors and acting areas.

snoot. *See* FUNNELS *in this section.*

striplight. A lighting unit similar to a borderlight that consists of a number of lamps in a line, usually on a single circuit.

olivette

plano-convex spotlight

scoop

striplight

lime The principal ingredient of plaster and an important factor in the technique of fresco painting. When pigments mixed with water are applied to fresh lime plaster, they are held securely in place as the lime becomes a hydroxide, and later a carbonate.

line conversion Line conversions are made by rephotographing continuous-tone photographs with line film, thus reducing all the values in the picture to tones of either black or white.

line copy A document, drawing, or other artwork consisting of only two tones, such as black and white, with no intermediate tones.

line cuts Line cuts are also referred to as *line etchings, line engravings, line blocks,* and *line plates.* They are used exclusively for the reproduction of materials executed in black (or a color) and white, with no intermediate shades of gray (or tones). Photographs, for example, must be reproduced as halftones.

line film Film that produces images of high density and contrast, used in the graphic arts and in some phototypesetting systems.

linen tester

linen This material is made from the fibers of the flax plant and can be made into a strong thread capable of being bleached. It is the principal painting support for oil paintings when used in the form of heavy canvas.

linen tester A small magnifying glass in a folding brass frame. It was originally designed for counting threads in linen cloth, but is now widely used for examining negatives, plates, and printed materials.

linoleum Linoleum is a floor covering made from finely ground cork, coloring materials, and boiled linseed oil which acts as a binder.

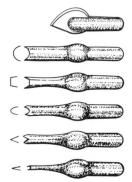

linoleum-block cutting tools

linoleum-block cutting tools All sorts of knives and other tools can be used to carve linoleum, since it is an easily worked material. Special linoleum knives and gouges are marketed, however, and generally consist of wooden handles with a series of interchangeable heads.

linoleum-block printing If a relief design is cut into linoleum, it can be printed with special inks and pressure, the latter provided either manually or with a press. Linoleum-block printing and wood-block printing are much the same process, but linoleum is much easier to work.

linseed oil *See* DRYING OILS.

lithography In lithography, or "writing on stone," a design is sketched with an oily ink called *tusche* or a litho crayon on a flat, smooth stone. The greasy substance is absorbed by the stone. The surface is then covered with a solution of gum arabic which contains a little nitric acid. This solution "fixes" the grease in the stone. When dry, the stone is washed off, removing the surplus gum. In printing, the entire surface of the stone is wetted and the design areas will repel the water, but will accept a greasy ink. A clean impression is then made by pressing a sheet of paper against the surface of the stone and running the whole through a press.

Color lithography (chromolithography) is practiced by the use of multiple stones or plates, one for each of the colors employed.

Lithography is a planographic, or flat-surface, printing process, as opposed to *relief* printing, which prints from raised surfaces, and *intaglio,* which prints from ink-filled wells or lines recessed below the surface of the plate. (*See also* OFFSET LITHOGRAPHY.)

livering Oil paint is said to "liver" if it turns into an insoluble, rubbery mass in the tube or can. This is the result of the action of poorly formulated materials or of impure pigments or mediums. Pure pigments ground in the proper oils will not liver.

logo, logotype A single slug, or line of type cast in one piece, that carries one or more words, such as the name of a firm or a product. Many firms adopt a special style of type for their name, and have logotypes made so that this style may be printed whether the printer has that particular type or not. Sometimes a firm's logo will include a trademark or other artwork with the type.

long clay A clay used in ceramics that has a high degree of plasticity.

lost-wax process A technique, also called *cire perdue,* for casting bronze statues and other forms, and also used extensively in jewelry casting. The original figure is modeled in wax over a core and covered with plaster. The wax is then melted out and replaced by molten metal.

Lucite A product of E. I. du Pont de Nemours & Company, this is a versatile methyl methacrylate plastic material marketed as a molding powder, rods, tubes, and sheets. It is a crystal-clear material and can be sawed, carved, machined, and cemented.

lumber markers Hard-pressed wax crayons used for writing on rough surfaces such as boards or wooden boxes. Available in red, blue, and black.

luminous paint *See* PHOSPHORESCENT PAINT.

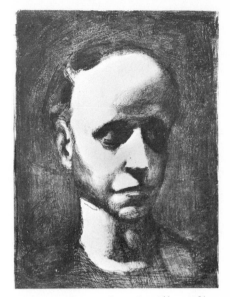

lithograph Georges Rouault. 13½ × 10¾ inches. (*Seattle Art Museum.*)

M

mahlstick A mahlstick is held in the palette hand of a painter and used as a support for his painting hand. It is a light rod of wood, often with a leather-covered ball at one end. Another name for this device is *rest stick*.

mahlstick

make-ready The careful leveling of relief printing plates on the bed of the press so that they yield the best possible impression.

manikin A correctly proportioned doll-like figure that is jointed and will assume any human position and hold it. A manikin is useful when drawing a human figure in action.

marble A limestone rock of great hardness and a favorite material of sculptors. It is variously colored and, after being cut and polished, has very strong resistance to weather. Most marbles are responsive to carving, take a high polish, and do not fracture under the sculptor's tools.

The weight of marble is about 170 pounds per cubic foot. A few of the more common varieties of marble used in sculpture and architecture are as follows.

bardiglio cappella. An Italian marble, medium gray in color, with darker gray and black streaks throughout.

benou jaune. A French marble that is a mottled gold, yellow, and violet.

breche rose. An Italian marble that is a mottled brown, white, and lavender.

campan griotte. A mottled brown French marble.

campan mélange rouge. A mottled pinkish-brown French marble.

carrara. An Italian marble quarried in Luna, and popular for centuries as a sculpture material. It is white, with occasional streaks of gray.

compage mélange vert. A green French marble.

escalette. A French marble that is a yellowish-green mixed with pink.

French grand antique. A mottled black and white marble from France.

giallo antico. (Antique yellow.) A yellow marble often used by the ancient Greeks and Romans.

languedoc. A French marble that is a bright red or scarlet color, blotched occasionally with white.

loredo chiaro. An Italian marble that is a mottled brown and yellow.

lumachelle. A mottled green French marble.

madrepore. A marble found in a number of places, consisting of a fossil-bearing variety of limestone. It occurs in many colors and is easily carved and polished.

Napolean gray. A gray marble found in the New England area of the United States.

pavonazza. An Italian marble also known as *Phrygian marble.* It is a variety of colored limestone with markings resembling those of a peacock.

Petworth marble. A variously colored type of limestone containing the fossil remains of freshwater shells. It is also known as *Sussex marble,* because it is quarried at Petworth in Sussex, England.

piastraccia. A lightly veined Italian marble.

porto marble. An Italian marble that is dense black traversed with gold-colored veins.

purbeck marble. A brown-colored marble, prized for its structural qualities.

rance. Also called *Belgian marble* because of its place of origin. It is a dull red marble with blue and white streaks or veins.

river marble. A marble that shows riverlike patterns when cut along certain planes and highly polished. These markings are caused by an infiltration of iron oxide.

Roman breche. A French marble that is comprised of mottled pinks and blues.

rosso magnaboschi. An Italian marble that is a rich red with an orange cast, containing lighter and darker spots or veins of color.

royal jersey green. A green, serpentine marble from the eastern United States.

saccharoidal marble. Also known as statuary marble, any variety of marble having a granular crystalline structure.

Saint Anne marble. A Belgian marble that is a deep blue-black with white veins.

Saint Baume marble. A French marble that is yellow with brown and red veins.

Saint-Beat. A pure white French marble often used in large statuary works because it occurs in abundant quantities.

sienna marble. Found mostly in France, a rich yellow marble, often with white and purple veins.

sienna travertine. A German marble that is a mottled brown.

marble dust Native calcium or magnesium carbonate.

marble paper A decorated paper used as end leaves in blank books and often in printed books. It is usually prepared one sheet at a time by the following process. A large tray of gum or size solution is prepared. Colors are sprinkled or flowed on this surface and patterns are made by combing or some other means of regulating the design, usually in a regular pattern. The colors are often tube oil paints thinned with turpentine, or waterproof drawing inks. The paper to be marbled is placed carefully on the bath, the colors adhere to the paper, and the sheet is hung to dry.

Similar papers are prepared by intaglio printing using a copper roll.

marble paper

marble polishing After a marble sculpture is completed, it is washed with sand and rubbed with a rough-textured cloth such as burlap. If a high polish is desired, the marble is rubbed with pumice stone and water. After this is done, the marble is washed with oxalic acid reduced to the consistency of table salt, and rubbed vigorously. After this is done, the acid must be removed completely because it injures marble.

marbling *See* MARBLE PAPER.

margins The parts of a page outside of the main body of type. A printed page will have a head (top) margin, an inside margin, an outside margin, and a foot (bottom) margin.

marouflage *See* ADHESIVES.

mask (1) To cover or block out areas of negatives or stripped-up flats with black paper, tapes, or foil so that they do not reproduce in plate making. (2) A cutout of black or red film or paper that is attached as a *window* on artwork. When photographed, it shows

up as a clear film area in the otherwise black negative. This aids in stripping in halftones and other printed material.

masking inks Opaque black ink for use on masks and overlays made on acetate, vinyl, mylar, and other plastic materials. It dries with a clean, sharp edge and without pinholes. A red, transparent variety can be used to follow outlines for masks. It photographs a dense black on ortho films.

Masonite, Presdwood Trademarked materials made by the Masonite Corporation. They are hardboards produced by reducing wood chips to their basic cellulose fibers under high steam pressure. The resulting pulp, containing long fibers and the natural lignin adhesive of the wood, is pressed into boards.

These materials are often used for painting grounds. They can be prepared with a size coat, with gesso, and with casein or polymer gesso to form an excellent surface for all kinds of painting. To obtain perfect adhesion, all traces of grease must be removed. When large sheets are used, they should be glued down to wooden frames to keep them flat.

mat cutters A range of knives and other devices for making straight or beveled cuts in picture mats.

materials for coloring light When colored light is required for theatrical, motion picture, or television productions, the following standard materials are used.

gelatins or gels. Fragile, transparent sheets of gelatin produced in many colors. They melt if water comes in contact with them, scratch easily, become brittle with heat, and fade rather quickly because of the intensity of the spotlights and floodlights they cover. They must be stored in a cool, dry place, separated by sheets of wrapping paper. They are available in 20- by 24-inch sheets.

lacquers. Containing dyes of various colors, produced as solutions for dipping or painting sheets of glass or light bulbs. They fade after exposure to light.

plastic color filters. Available in the same size and range of colors as gels, but a heavier material, waterproof, more resistant to heat, and retain their color several times longer than gels. (Gels, however, are much less expensive.)

roundels. Circular pieces of heat-resistant glass that can be placed in front of lights. They are available in red, blue, green, canary, amber, and pink, and in diameters ranging from about 4 to 11 inches. The colors do not fade.

mechanical A mechanical is a layout prepared for the offset printer and contains the actual material to be reproduced. It may also

contain instructions for copy that must be stripped in, and all pertinent handling information. Also called *camera ready.*

mechanical drawing Also called *drafting, precision drawing,* or *engineering drawing,* this is a precisely controlled method of drawing that endeavors to communicate specific information to the reader or viewer. Following are some of the more common materials and tools.

bow pen. A drafting compass that carries a pen or pencil at the end of one leg, and a point at the end of the other. The position of the two legs is regulated by means of a setscrew.

compass. An instrument used for describing arcs or circles with pencil or pen. Like the *bow pen* above it has two legs that are hinged together at the top.

divider. An instrument similar in appearance to a compass, except that both legs have points. It is used to transfer measurements to or from drawings and to divide lines into equal parts.

divider spacer. A precision instrument used for dividing a given size into any number of subdivisions up to 10 spaces.

drafting machine. A machine which mounts on a drafting table and is a combination of T square, protractor, and various scales and triangles.

drawing boards. Boards, of various sizes, used for drawing upon. Generally, the board is approximately $\frac{3}{4}$ inch thick and about 2 inches longer and wider than the size of paper to be used. The board should be made of well-seasoned wood, and the edges should be square to each other so that a T square can be used with it.

drawing cloth. A linen cloth that is specially treated to be smooth and translucent so that it may be used for ink tracings. Prior to use, the surface is lightly treated with powdered chalk or soapstone. This material, called *pounce,* is also applied after each erasure and provides a better working surface for the pen.

ellipsograph. A machine with which it is possible to draw mathematically true ellipses.

french curves. Guides, usually made of clear plastic, used for making regular, irregular, and reverse curves in mechanical drawings and illustrations. There are special sets of curves for such specialized uses as aircraft and ship design work.

geometric pen. A mechanism for drawing lines and ornaments in geometric patterns, such as those used on the borders of stocks and bonds, currency, and other certificates.

lead holder. A mechanical pencil for holding drafting leads of different thicknesses and degrees of hardness. The lead is sharpened on sandpaper.

lettering guides. Guides used for making letters and numerals. Some work on the principle of a stencil. Others operate by having

bow pen

reversible pen/pencil
combination compass

divider

divider spacer

french curves

lead holder

a scriber with a tracer point that follows engraved letters on a guide. Numerous alphabets, numerals, and symbols are available.

parallel rules. Two rules connected so they are always parallel to each other. Adjustable, they are used for drawing lines parallel to each other.

pounce. A dry cleaning powder applied to drawing papers and cloths to absorb oils and dirt and to provide a more satisfactory working surface for pencil or pen.

proportional dividers. Instruments similar to compasses, but with movable axis points scaled so that the opposite ends can be kept at a certain ratio. They are commonly used for reducing or enlarging drawings.

protractor. An instrument used in drawing and plotting for laying down and measuring angles on paper.

ruling pen. A type of pen that has two parallel blades for a point. These are mounted in a handle and provided with a setscrew that regulates the distance between the blades, thus varying the width of the lines that are drawn.

spline. A flexible device for drawing long curves. It is bent to form the desired curve, and this shape is held by weights attached to it.

straight edge. A blade, usually of stainless steel, made in lengths up to 120 inches and used for drawing and cutting operations.

templates. Plastic or metal guides for drawing uniform and well-defined circles, squares, ellipses, and countless shapes that constantly reoccur in different areas of mechanical drawing. Templates are available with the symbols most often used by such workers as architects, mathematicians, sheetmetal fabricators, engineers of all kinds, and designers. Specialized templates can be made to order.

tracing cloth. A thin, translucent cotton fabric sized with starch to provide a good working surface. It is used mainly by architects for making permanent ink drawings.

triangles. Plastic or metal triangles, 30° and 60° or 45°, made in sizes from 4 to 18 inches. Some triangles are marked with scales such as rules.

parallel rules

proportional divider

protractor

ruling pen

ellipse template

triangles

T square. An instrument for drawing straight lines squared up with other parts of the drawing. It is composed of a long strip called the blade, fastened rigidly at right angles to a shorter piece called the head. Some models have adjustable heads with protractors on them.

T square

medium (1) The liquid constituent of a paint, the fluid in which the pigment is suspended. (2) The mode of expression chosen by an artist, such as oil painting, sculpture, or etching. Also the tools or materials used, such as an etching needle, a camera, or a certain kind of paint. (3) *See* PAINTING AND GLAZING MEDIUMS.

megilp A material comprised of mastic varnish and linseed oil. It was widely used in the nineteenth century but discontinued when the material was found to cause cracking, discoloration, and other defects in oil paintings.

The term is still used in England to describe a mixture of oils used to thin pigments in the bromoil photographic process.

metal-coloring formulas Following are methods for chemically coloring aluminum, brass, bronze, copper, iron, steel, and silver.

aluminum. *Near-white, matte* effects on aluminum are achieved by agitating the metal part in a solution of 1 or more tablespoons of lye to a pint of water. For an effect that resembles tinted, anodized aluminum, place the part in household dye after treating it in the lye mixture. The material must be clean before the treatment is started. It is also well to remember that lye is caustic, and must be kept away from the skin and eyes.

brass. For *black* colors on brass, immerse the metal in a solution of 1 part copper nitrate and 3 parts water. The addition of a small amount of silver nitrate may improve the color.

For a *gray* color, immerse the part in a solution of 1 part ammonium sulfite and 4 parts water. Considerable time may be needed to achieve the desired depth of color.

For *golden-matte* colors, the part should be covered with a solution of 1 part commercial-grade nitric acid and 3 parts water, and rocked gently. Always pour the acid slowly into the water, never the other way around. After the soaking operation, the part should be wiped clean under running water, then the surface should be protected with a plastic spray.

A *blue-green* color is achieved by painting the metal daily with a mixture of 3 parts copper carbonate, 1 part sal ammoniac, 1 part copper acetate, 1 part cream of tarter, and 8 parts vinegar (measurements by volume). The treatment should continue for three or four days.

Yellow-orange, blue, and *red-brown* tones can be achieved in the following ways. For yellow through blue tones, the part should be

immersed in a solution consisting of 1 teaspoon of lye, 2 teaspoons of copper carbonate, and 1 cup of hot water. For more bluish tones increase the concentrations of the chemicals. Red-brown colors can be had by briefly dipping the part in 1 teaspoon of copper carbonate, 10 teaspoons of household ammonia, 1 teaspoon of sodium carbonate (sal soda), all mixed in 1 quart of near boiling water. After this treatment, the part should be rinsed in water and dipped in diluted sulfuric acid. Various shades can be created by experimentation.

For any of the above treatments, the brass must be absolutely clean. Grease can be removed with a strong detergent, followed by a hot-water rinse. Use care where lye or acid is an ingredient. Lye is caustic, and the fumes from acid are dangerous. Work outdoors where possible, and protect hands and eyes.

bronze coloring. *Yellow-green* is imparted to bronze with a mixture of $3\frac{1}{2}$ pounds of ammonium chloride, 2 pounds of copper acetate, and 1 gallon of water.

Apple green requires a solution of 20 ounces of sodium chloride, 16 fluid ounces of ammonia, 20 ounces of ammonium chloride, and 1 gallon of vinegar.

Bluish-green colors are achieved by a solution of 1 ounce of sodium thiosulfate, 8 ounces of nitrate of iron, and 1 gallon of water. (Sodium thiosulfate is the common photographic "hypo.")

Antique green effects are imparted by a mixture of 5 ounces of copper nitrate, 5 ounces of ammonium chloride, 5 ounces of chlorinated lime, and 1 gallon of water.

Red colors are imparted by the application of the following solution, heated for use: $6\frac{1}{4}$ ounces of copper sulfate (blue vitriol), 1 ounce of copper acetate, $2\frac{1}{2}$ ounces of alum, and 1 gallon of water to which a few drops of acetic acid have been added.

Brown shades are achieved by a mixture of 2 ounces of potassium sulfide, 4 ounces of barium sulfide, 8 fluid ounces of ammonia, and 3 to 5 gallons of water.

Dark brown to black colors are imparted by first heating the bronze and applying a solution of $1\frac{1}{2}$ ounces of potassium sulfide, $2\frac{1}{2}$ ounces of lye, and 1 gallon of water. Over this use a paint brush to stipple a solution of 8 ounces of copper nitrate, 4 ounces of ammonium chloride, 4 fluid ounces of acetic acid, 1 fluid ounce of chromic acid, and 1 gallon of water.

copper. For *light-matte* effects on copper, the metal is covered with a solution of 1 part nitric acid and 3 parts water. (Add the acid slowly to the water.) A ceramic or glass tray should be used and the part agitated in the solution. The part should then be wiped clean under running water, dried, and sprayed with lacquer. (Acid fumes are dangerous, so use the acid outdoors.)

Blue-green patinas are achieved by painting the metal daily with a solution of 3 parts copper carbonate, 1 part sal ammoniac, 1 part

copper acetate, 1 part cream of tartar, and 8 parts vinegar. Continue the application for three or four days.

Yellow-green colors are imparted by painting the part daily for a few days with a mixture of equal parts of sugar, salt, and strong vinegar. Do not immerse the metal in the solution.

Reddish-bronze to *dark brown* colors are achieved by dipping the object in a solution of 2 teaspoons of sulfurated potash, 3 teaspoons of lye, and 1 quart of hot water. Changes in temperature, amount of chemicals, and time immersed will vary the colors.

As with other metal-treating processes, the bronze or copper part must be clean before it is treated. Otherwise, results will not be uniform or permanent.

iron and steel. *Black* or *near-black* colors are achieved if the metal is heated red hot and then dipped in linseed oil or heavy engine oil. Most cast irons, if etched or sand-blasted, will turn a blue-brown color if dipped in a solution of 6 tablespoons of tannic acid and 1 pint of water.

Blue-black colors are imparted by immersing the metal in a strong photographic hypo solution (sodium thiosulfate). After this treatment, the part should be coated with linseed oil. Gun bluing solutions can also be used.

Gray colors are achieved by boiling the part in a solution of iron sulfite until the metal turns the desired shade of gray.

silver. Silver can be oxidized by placing it in a solution of 40 fluid ounces of ammonium sulfide and 1 gallon of water.

mezzotint This engraving process is the reverse of line engraving and etching. In the latter two processes the engraver works on a polished plate. In mezzotint, the copper or steel plate is roughened

mezzotint; first state David Lucus. WEYMOUTH BAY, DORSETSHIRE. (Nineteenth century.) 5¾ × 7¼ inches. (*Manson F. Backus Collection, Seattle Art Museum.*)

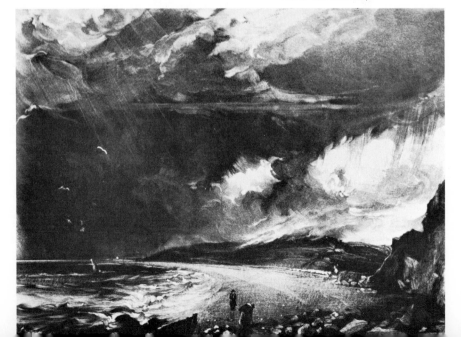

by rubbing Carborundum between two plates and by using a "rocker," a sort of steel chisel with an edge set with minute teeth. It is curved so that the teeth rock into the plate at various angles. The rough grain thus produced would print a deep black if inked and printed. The engraver then burnishes the plate with a steel instrument to produce the white areas of his design. The less he burnishes or polishes an area, the darker a gray it will print. As in most engraving processes, plates are printed on a hand press in limited editions.

mica An inert mineral that is sometimes used as an agent to improve the structural properties of paint. It is a complex silicate that occurs in transparent laminated form. It can be split into thin layers or sheets.

microfiche A microfilm card or sheet used in some information storage systems. It consists of a film format about 4 by 6 inches containing micro images of type and other information, with a title heading large enough to be read by the unaided eye. Standard microfiche has a capacity of 98 images of $8\frac{1}{2}$- by 11-inch book or magazine pages. It is limited—as is all microfilm—to black-and-white reproduction of color originals.

microfilm Greatly reduced film records of such things as books, newspapers, engineering drawings, reports, and manuscripts. These fine-grain, black-and-white copies are made on 16, 35, 70, and 105-millimeter film format permitting easy storage and handling. Reductions are on the order of 20:1 and 40:1. The film is used in microfilm viewers which provide sufficient magnification to read the originals without difficulty. Some viewers have copy-making equipment attached to them.

mildew prevention (1) *For leather:* Prepare a solution of 4 percent copper sulfate and soak a soft towel in it. Wring out the cloth and let it dry. It can then be used to rub leather articles, such as leather-bound books. One treatment is sufficient and the leather will not be marked in any way. (2) *For paper and canvas:* A 4 percent solution of formaldehyde sprayed on the surface will protect it from mildew, and will also harden it. It is a useful material for toughening glue surfaces and protecting them from mildew and mold. Formaldehyde solutions are normally sold in 37 percent strengths in drugstores. A 4 percent solution is made by mixing one part of that strength with 10 parts water. (3) *For watercolor paints:* If mildew develops on watercolor paints, a small amount of phenol should be added to the water used in mixing. About 1 percent of a 10 percent phenol solution will suffice; this amounts to about 2 teaspoons to 1 pint of water.

mobile A decorative three-dimensional art object constructed of metal, glass, wood, plastic, or other materials. It is mounted in a hanging position and is free to move in any of its planes.

modeling clay, modeling materials *See* SCULPTURE.

moiré This term is used to describe the undesirable patterns that occur when a halftone is made from a previously printed halftone or a steel engraving. They are caused by the conflict between the dots in the halftone screen and the dots or lines of the original. Careful rotation of the halftone screen by the engraver or photographer may minimize or eliminate moiré patterns.

monotype A printing technique in which a picture is painted on a sheet of glass or metal. The picture is transferred to a sheet of paper by pressure. Additional copies require that the subject be repainted on the plate. For another definition, see TYPOGRAPHIC TERMS, MONOTYPE.

montage A collection of photos pasted on a common background, or a composite picture made by printing two or more negatives on a single sheet of photographic paper.

mordant (1) In gilding, an adhesive film that holds the gold leaf applied to it. (2) In engraving, the etching solution used in the production of plates. (3) In the manufacture of dyes, any substance that adsorbs dyes and prevents their washing out. (4) In photography, materials used for dye-toning, and in certain color printing processes.

mosaic The art of decorating surfaces with small pieces of stone, tile, glass, or shell. These pieces are called *tesserae* and are held by an adhesive of some kind. The interstices between the tesserae are filled with a thin mortar called grout (*see* GROUT).

Tiles are most often used in mosaic work. They are easily cut or broken to the desired size, then mounted on a backing of wood, masonry, plastic, or other material. Special adhesives are sold for mosaic work, but ordinary white glue is good for working on wood and some other materials. When the individual pieces are set as desired, the grout is applied evenly across the face of the mosaic. It is spread with the hands or a stiff brush and carefully pressed into all the cracks. The excess is removed with damp cloths. When the grout has dried, there will be a film of cement on the face of the tiles. This is removed with fine steel wool, then the entire mosaic face is coated with liquid wax or silicone polish.

Mosaic does not include work done in enamel or in wood. Wood inlay work is called *intarsia*.

mobile Alexander Calder. POMEGRANATE. (1949) Sheet aluminum and steel, steel wire, and rods. About 72 inches high, and about 68 inches in diameter. (*Collection Whitney Museum of American Art, New York.*)

mosaic Aleksandra Kasuba. RELIEF MOSAIC. $40\frac{1}{4} \times 35\frac{3}{4}$ inches. (*Courtesy of the artist. Photograph from the Worcester Art Museum, Worcester, Mass.*)

Mosaic is also a term used in photography to denote aerial photographs pieced together from many separate exposures.

mosaic gold A metallic powder containing a large percentage of bisulfide of tin. It was once used as a cheap substitute for powdered gold, but is now replaced by bronze powders.

motion picture terms There are many terms employed in motion picture production that refer to specialized methods or objects. Following is a brief sample of such terms.

answer print. The first print of a completely edited motion picture that combines sound, picture, and effects.

barney. A blanket, or quilted cover, that is placed over a camera to muffle its sound. Normally, a *blimp* is used. A *heater barney* is a

cover with a heating element in it. It is used to encase cameras that must be outdoors during cold weather.

blimp. A soundproof housing that covers a motion picture camera. It must be used in situations when photography and sound recording take place at the same time, as it keeps the noise of the camera from being picked up by the microphones.

cinematography. Motion picture photography.

close-up (CU). A motion picture shot taken at close range. A close-up of a person might include only his head, or head and shoulders.

cut. An abrupt change from one shot to another, without an effect such as a fade or a dissolve. It is also a term meaning to *edit* a picture. In a third definition, it is a command to stop the action of a scene.

cutting room. The room, or area, in which motion pictures are edited.

daily. A rush print made from the film shot on any given day. It is screened by the director on the morning after. It may be used later as a work print.

dissolve. An effect in which one scene melts into another. It is a simultaneous *fade out* (from one scene) and *fade in* (to another scene). It is also called a *lap dissolve.*

dolly. A wheeled platform for moving a motion picture camera during a shot. It allows smooth, jitter-free movement when used on the smooth floor of a studio. When used outdoors, special tracks are built.

dolly-in, dolly-out. Shots in which the camera (on a dolly) moves directly toward, or away from, the subject being photographed. *See also* TRUCK *in this section.*

extreme close-up (ECU). A motion picture shot that is taken at extremely close range. An extreme close-up of a person might include only an eye, or a very small portion of his face.

fade. The gradual disappearance of the screen image into black is called a *fade out.* An image that emerges slowly from black is called a *fade in.*

high hat. A very low tripod head resembling a formal top hat in shape.

interlock. The simultaneous screening of a motion picture work print and a magnetic or optical track, both running at precisely the same speed. If the interlock screening is satisfactory, the next production step is the preparation of the *first answer print,* the motion picture composite print with mixed sound track and optical effects.

long shot (LS). A shot in which the scene is a considerable distance from the camera.

match-action. The joining of two shots at a point in which the action in the first coincides with the action in the second, preserving the illusion of continuous action.

pan. This term describes the movement of a camera in a horizontal plane. *See* TILT *in this section.*

panorama. A term describing a wide scene viewed slowly from one side to the other.

tilt. The movement of a camera vertically. A camera *tilts* up and down, and *pans* right and left.

truck. The movement of a camera on a dolly in which the camera stays parallel with the action of the subject. A *trucking shot* is one that moves alongside the subject; a *dolly shot* moves toward the subject or away from it.

wipe. A transition from one shot to another in which one scene is pushed off the screen with another scene.

work print. The first print from the original, used for preliminary screening and editing purposes.

moulage The technique of making a mold; also the material itself. The material is extremely delicate and can be used on human hair or skin, or on antiques or other objects that are too fragile to be molded in rubber, gelatin, or plaster. It is applied warm with brushes or palette knives, and can be reused.

mounting large photographs The best method for mounting photographs is the *dry mounting* method, *which see.* It is sometimes impossible, however, to dry mount larger prints, and in this case it is best to paste them to a piece of Masonite or plywood. A good wallpaper paste may be used, as can the material described under ADHESIVES, PASTE.

Mounting is accomplished by taking the washed print, still wet, and removing the excess water with a squeegee. The face of the mount and the back of the print are then coated with paste (being certain that no lumps are present). The two are then placed together and the squeegee again used to remove any excess paste. Plain brown wrapping paper is then pasted on the back of the mount. It will counteract the tendency of the front to curl or warp as the paste dries.

muller The muller is used for grinding pigments on a slab. Traditionally, porphyry was used for both muller and slab, but now glass is the material most often used.

N

needle The sharply pointed steel instrument used on copper plates in etching and drypoint techniques.

needle files Needle files are made in a number of shapes and are useful for many applications in woodworking, jewelry making, and other uses requiring fine detail. They are slender, steel tools about 5 inches in length. The following names of needle files indicate their description and usage: barrette, crossing, entering, equaling, half-round, knife, marking, round, slitting, square, and three-square.

nitric acid A highly corrosive yellowish acid, colorless when pure, that mixes with water in all proportions. Also called *aquafortis,* Latin for "strong water." It is often diluted with various proportions of water and used as a mordant in etching.

nitrocellulose Cellulose fiber treated with nitric acid. The material is soluble in certain organic solvents. When plasticizers and resins are added, it makes nitrocellulose (pyroxylin) lacquers. These lacquers are durable for only moderate lengths of time.

needle files

Barrette

Crossing

Entering

Equaling

Half-round

Knife

Marking

Round

Square

Slitting

Three-square

O

obliterate To cover a plate from which engravings have been made with deep and irregular incisions. This destroys the plate and prevents further prints from being struck from it. The artist determines the number of prints to be made from a given plate. This "edition" of prints is made under his supervision, numbered, and signed by him.

offset lithography This system of printing, like lithography from stones (*see* LITHOGRAPHY), depends on the principle of the printing area accepting greasy ink while the nonprinting area is dampened with water and repels the ink. In practice, the image from a plate is "offset" onto the rubber blanket of an impression cylinder, and transferred to a sheet of paper. Offset plates are made from such materials as paper, paper-backed metal foil, zinc, and aluminum, and the image is produced on them mostly by photographic means.

 Deep-etch plates are used in offset lithography for long runs. Simply stated, the printing portions of the plate are etched slightly below the surface and treated with an ink-receptive substance. The nonprinting areas, meanwhile, are treated chemically to make them more water-receptive. (*See also* DRY OFFSET *and* DRY-RELIEF OFFSET *printing systems.*)

oil painting A method of painting in which pigments are bound together, and to the canvas, by a drying oil. The oil, usually linseed,

oil on canvas Willem de Kooning. DOOR TO THE RIVER. (1960) 80 × 70 inches. (*Gift of the Friends of the Whitney Museum of American Art. Collection Whitney Museum of American Art, New York.*)

is thinned with solvents such as turpentine and mineral spirits. The pigments used in oil painting should dry in linseed oil to form an acceptably strong paint film. (*See also* BRUSHES; CANVAS; CANVAS SIZING AND PRIMING; OIL PAINTING PIGMENTS; *etc.*)

oil painting pigments The following pigments conform to *Commercial Standard CS98-62, Artists' Oil Paints,* published by the U.S. Government Printing Office, Washington, D.C. These Commercial Standards serve to establish quality criteria, standard methods of test, rating, certification, and labeling of manufactured commodities, and to provide uniform bases for fair competition. The pigments below have been shown to resist fading satisfactorily when used in oil painting and under normal conditions of exposure. They resisted fading in full concentration when exposed to direct sunlight at southern exposure under glass at a 45-degree angle for two months, a minimum of 600 hours of sunlight.

WHITE: Flake white, mixed white (zinc white and white lead), titanium white, and zinc white

YELLOW: Cadmium yellow (light, medium, and deep), cadmium-barium yellow (light, medium, and deep), hansa yellow, mars yellow, naples yellow, and yellow ocher

ORANGE: Cadmium orange, cadmium-barium orange, and mars orange

RED: Alizarin crimson, cadmium red (light, medium, and deep), cadmium-barium red (light, medium, and deep), indian red (bluish shade), light red (scarlet shade), mars red, rose madder, ultramarine red, and venetian red

VIOLET: Cobalt violet, manganese violet, and mars violet

BLUE: Cerulean blue, cobalt blue, manganese blue, phthalocyanine blue, prussian blue, and ultramarine blue

GREEN: Chromium oxide green, cobalt green, green earth, phthalocyanine green, and viridian

BROWN: Burnt sienna, burnt umber, mars brown, raw sienna, and raw umber

BLACK: Ivory black, lampblack, and mars black

The following four pigments were exposed to the same conditions as the above for a period of one month, or a minimum 300 hours of sunlight: cobalt yellow, strontium yellow, ultramarine green, and vermilion.

In addition to the exposure tests mentioned above, pigments and paints must meet the following requirements in order to conform to Commercial Standard CS98-62.

1. Pigments shall be of good grade. Organic lakes or toners shall not be used to fortify or sophisticate inorganic pigments. Substitution of similarly colored pigments is not permitted.

2. Vehicles shall consist of pure drying oils; linseed and/or poppy oil only.

3. Driers may be used in minimum amounts in paints that contain pigments which have a retarding effect on the drying of oils, to allow them to conform to drying-rate requirements. The maximum amount of drier, however, shall not exceed 0.1 percent of cobalt or 0.2 percent of manganese, calculated as metal, on the weight of oil.

4. Drying rate shall be determined by the sand- and pressure-testing devices. Paints shall dry to both tests within twenty-one days and not under three days at 23°C and 50 percent relative humidity.

5. Consistency of artists' oil paints shall be determined by use of a standard 2-kilogram Paste Paint Consistometer. Readings between 2 and 5 will be acceptable under this standard.

6. Brushing quality of artists' oil paints shall be determined by observing the handling quality of the paint when manipulated with a brush. All artists' oil paints shall brush out smoothly, evenly and easily, leaving a normal brush mark. They shall not be sticky, thick, or rubbery, nor too fluid. There shall be no free or excess oil. They shall not contain skin and shall be uniformly ground. They shall retain their form and shall not level out when applied with a palette knife.

7. Tinting strength of artists' oil paints shall not be less than that of the standard adopted for each pigment.

8. Composition of the paint, governed by the relative amounts of vehicle, pigment, and inert used, shall produce a paint of satisfactory working qualities, conforming to all requirements of this Commercial Standard.

9. Inerts and fillers shall not be used as extenders, reducers, or diluents.

10. Bodying agents, such as metallic soaps and/or refined beeswax, may be used only in minimum amounts to produce desirable working qualities, consistency, and to prevent settling of pigment.

oils *See* DRYING OILS *and* OIL PAINTING.

opaque *See* FILM OPAQUES.

overlay (1) A sheet attached to copy or artwork. It contains special instructions about reproduction or arrangement. (2) A transparent or translucent film attached to artwork carrying additional detail to be reproduced. In multicolor printing these overlays may represent the simple separation of the colors to be printed.

oxgall A wetting agent, such as those now commercially available in art and photo supply stores. It reduces the surface tension of water, and when a drop or two is added to water paints, they flow out and adhere better to smooth papers.

P

pad A silk-covered dabber for applying varnish to copper or steel plates.

paint Colors. A term to describe a suspension of pigment in water, oil, or solvent, used to cover a surface for purposes of protection or appearance. It consists of a coloring material, such as pigments or dyes, a liquid medium known as the vehicle, and sometimes binders. In water-base paints, mixtures of casein, glue, or polymer may serve as binders in the water vehicle.

Solutions of gums and resins, called varnishes, are not true paints, and neither are enamels and lacquers. Stain is a varnish that contains a coloring material, usually a dye.

painting and glazing mediums The purpose of a painting medium is to dilute oil colors and to give them good brushing properties, but without diminishing the strength or longevity of the paint film. It is not a good idea to use turpentine or other thinners with colors on canvas. Turpentine alone produces a weak paint film and weak colors.

A serviceable painting medium can be made by mixing 1 part stand oil, 1 part dammar varnish (5-pound cut), and 5 parts pure gum turpentine. For every 10 ounces of the above, a few drops of cobalt drier may be added.

painting knives

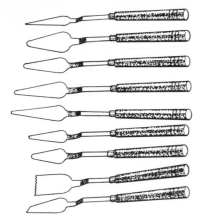

palettes

palette cups

A typical glazing medium contains less turpentine and drier. It is made by mixing 3 parts stand oil, 2 parts dammar varnish (5-pound cut), and 3 parts pure gum turpentine. Two or three drops of cobalt drier may be used for every pint.

painting knives Extremely flexible steel blades set in hardwood handles. They are made in a number of shapes and used in direct knife painting techniques.

palette The surface an artist uses for laying out and mixing his paints before applying them on the canvas. Sometimes the palette is a lightweight device, often of wood, that is carried in one hand. It can also consist of a sheet of marble or glass that rests on a table or taboret conveniently located near the easel.

palette cups Small containers designed to clip on the palette and hold a supply of linseed oil or painting medium. Some are designed with screw-on lids to prevent spilling.

palette knife A steel spatula, mounted in a wood handle, usually in a straight or trowel shape. It is used for mixing oil paint.

pantograph A device used for enlarging or reducing the scale of a drawing. One arm, equipped with a pencil that rests on a piece of paper, is connected through a series of levers to a pointer that the operator uses to trace the original drawing. Some will enlarge or reduce in 34 ratios.

paper cutters Hand-operated paper cutters and trimmers consist of a cutting blade bolted at one end to a ruled board. When the blade is drawn flush with the board, which has a metal strip at the cutting edge, a shearing action takes place which cuts paper and board very cleanly and evenly. Much larger, power-driven guillotine cutters are used for cutting larger quantities of paper at one time.

paper marbling *See* MARBLE PAPER.

Straight

Trowel

palette knives

pantograph

paper cutter

paper terms The following are standard terms used in the paper and printing industries.

antique finish. A finish obtained by operating wet presses and calender stacks at reduced pressures. It is a finish somewhat rougher than eggshell and is rough to both sight and touch. The term is used as a prefix to denote a slightly rougher texture on another surface. Antique-vellum, for instance, is not as smooth as vellum.

basic size. The sheet size recognized by buyers and sellers as the one from which its basis weight is determined. Formerly it was the size which printed, folded, and trimmed most advantageously.

basis weight. The weight in pounds of a ream of paper cut to a certain size. The basic size varies with different grades of paper. For fine papers a standard ream consists of 500 sheets of a size 17 by 22 inches, and is expressed as 17×22—500.

bulk. The thickness of a pile of a certain number of sheets of paper under a specific pressure. This is an important factor in calculating the thickness of a book or magazine.

calendered paper. Paper that has passed through the cast-iron rollers at the end of a paper machine. This process smooths the surface of the paper. Supercalendering makes the surface glossy. The more calendering a paper is subjected to, the better it will take halftones.

chemical pulp. Pulp made from wood by the sulfite, sulfate, or soda process. Paper made from chemical pulp is generally superior to that made from groundwood pulp, but inferior to paper made from rag pulp.

coated paper. Coated surfaces of clay and other materials are placed on paper to produce a smooth, shiny surface. Such a surface is necessary for fine, detailed, and blur-free reproductions in both color and black and white. There are various classifications such as glossy coated, dull coated, and brush coated. Different stocks may be coated on one or both sides.

cockle finish. An irregular surface usually produced on rag bonds and ledger papers. The effect is obtained by coating the paper with sizing and drying it in loop or festoon fashion in heated air.

cold-pressed finish. An extreme antique finish, usually applied to heavy ledger papers.

deckle, deckle edge. The unfinished edge of handmade paper has a characteristic appearance as a result of leakage under the frame (deckle) in which the paper is made. Handmade paper has a deckle edge on all four sides. Machine-made papers have it only on two sides. The same rough or irregular effect can be achieved in a special cutter.

eggshell finish. A paper or cardboard having a relatively rough surface, so-called because it resembles the surface texture of an eggshell. It describes the finish on papers used both for printing and drawing.

embossed (plated) finishes. Effects obtained by placing plain sheets of machine-finished paper between alternate sheets of zinc and plaster boards or cloths. This combination is then passed between two steel rolls under great pressure. The design of the board or cloth is pressed into the paper in this way. In another method, rotary plating, the paper passes between male and female steel-engraved design rolls.

enamel paper. Also called coated paper, it refers to paper with a coating of fine clay. It has a glossy appearance.

english finish. A finish with a smoothness somewhere between that of machine-finished and supercalendered.

felt finishes. Imitations of old handmade or mold-made papers. They are obtained on the paper machine with marking felts which transfer their weave or design onto the paper when it is still partly wet.

felt side, wire side. The felt side of a piece of paper is the upper side of the sheet as formed in a papermaking machine. The wire side is the lower side which is in contact with the screen of the machine and is slightly less perfect. On certain papers, the felt side of the sheet is smoother and better for printing. Critical work such as halftones should be done on that side.

finishes. Coated and uncoated papers are obtained in various finishes. This section lists a number of finishes, such as cockle finish, embossed finish, and so forth.

groundwood pulp. Also known as mechanical pulp. Newsprint is made from this material, and it discolors badly with age. Chemical pulps are used for papers of higher quality.

handmade finish. An embossed or plate finish that simulates the appearance of handmade paper.

laid finish. A watermark consisting of finely spaced parallel lines. They are produced by tiny wires in the papermaking machine which press into the sheet as it is being made. The effect occurs naturally in handmade papers because of the screen of the frames in which paper is made.

machine finishes. Finishes made directly on the paper machine with standard equipment, and obtained at the dry end of the machine by calendering or polishing. Typical finishes are antique, English finish, machine finish, and vellums.

quire. One-twentieth of a ream; 25 sheets if the ream has 500 sheets.

rag papers. The most expensive papers, made in whole or in part from cotton or linen rags. Rag content is expressed in percentage of 25, 50, 75, and 100 percent. Pure rag papers are the strongest and most resistant to the discoloration and deterioration that come with age.

ream. A standard ream consists of 500 sheets of paper. Some tissues, however, have 480 sheets to the ream.

sulfate paper. Paper made by the sulfate process cannot be bleached as white as soda or sulfite paper. Strong papers, such as kraft paper, are made from unbleached sulfate materials.

supercalendered finish. A shiny, smooth surface obtained by passing the paper between fiber-filled and steel rolls with the application of steam and pressure.

watermark. A localized modification of the structure and opacity of a sheet of paper so that a pattern or design can be seen when the sheet is held to the light.

papers and paperboards Paper is most often produced from the cellulose derived from plant sources. It is made into a paste that is rolled in sheets, dried, and variously processed to yield material for printing, writing, and wrapping. Some of the more common papers and paperboards used in fine art, graphic arts, and printing appear in the following alphabetical list. Where pertinent, basic sheet sizes and weights are given. (*See* PAPER TERMS, BASIC SIZE *and* BASIS WEIGHT.) Basic size is expressed as, e.g., 25 × 38—500, meaning size in inches and number of sheets per ream.

academy board. A light cardboard with a ground of white lead, oil, and other ingredients. So-called because it was once widely used in art schools instead of wood panels or canvas.

alabaster parchment. A translucent paper coated with lead acetate crystals and processed to imitate parchment. It is used for diplomas, certificates, and book covers.

animation paper. A two- or three-ply paper available in continuous rolls, used for making drawings for animated film work.

art parchment paper. A hard-sized, heavy paper with the color and appearance of old vellum. Like alabaster parchment it is used for diplomas and certificates.

background paper. *See* SEAMLESS DISPLAY PAPER *in this section.*

bible paper. A lightweight, thin printing paper of small bulk, having good properties of permanence, strength, and opacity. Some grades are made from flax fibers, others from sulfite and rag. It is principally used in books, Bibles, and encyclopedias where bulk is critical. Basis weights range from 13 to 30 pounds (25 × 38—500).

blanks. A kind of cardboard that can be coated or uncoated, pasted or unpasted, made with a white or colored liner, the middle being of different stock than that of the liner. They are stiff and used for such things as calendar backs and window displays. Basis weights range from 120 to 775 pounds (22 × 28—500).

blotting paper. An unsized paper used to absorb excess ink from penned letters or signatures. It is also used for other applications where a soft, spongy paper is required.

bond layout paper. Writing or printing paper with good characteristics of strength, permanence, and durability. It is used for general layout purposes.

bond paper. A paper used for writing paper, business forms, and typewriter paper. The name "bond" was originally applied because this paper was used for printing stock certificates and bonds. The less expensive bond papers are made from wood sulfite pulps. Rag-content bonds contain 25, 50, 75, or 100 percent of pulp made from rags, and offer greater permanence and strength. This paper is suitable for offset printing, and is available in white and various colors, weights, and finishes. It is usually made in basis weights of 13 to 24 pounds (17 × 22—500).

book paper. A wide range of papers used for trade and text books. They are less expensive than text papers and made in a greater assortment of weights (22 to 185 pounds). The basic size is 25 × 38—500.

bristol board. Papers of postcard weight or more, and used for general artwork and lettering. They can be used on both sides and are available in smooth and medium finishes. Index bristols are used for index cards and records and made to take ink well. Mill and wedding bristols have good surfaces for printing and are widely used for greeting cards, programs, tickets, and wedding announcements. *See also* PATENT OFFICE BRISTOL *in this section.*

cardboard. A good quality of chemical pulp or rag pasteboard used for signs, printed material, and high-quality boxes. It is produced by combining two or more webs of paper, either without paste while still wet or with paste. The term applies to papers 6/1,000 of an inch or more in thickness where stiffness is of prime importance.

charcoal drawing paper. A rough-finish paper specially suited for use with charcoal crayons and pencils. It has a high rag content and is easily erased. It has a basis weight of 60 to 70 pounds (25 × 38—500).

chestnut board. A brown-colored board once made from chestnut pulp but now made from other hardwood species as well. It is a very stiff and rigid board.

chipboard. A low-density board made from mixed waste paper and used where strength and quality are not needed.

cloth-lined paper. A paper backed with cloth and used for such things as maps, charts, and manuals where strength and wear-resistance are important.

construction paper. Similar to poster paper, but heavier. It is made from mechanical pulp and is available in a large range of colors, most of which are not lightfast. Usual basis weights are 40 to 80 pounds (24 × 36—500).

coquille paper. A drawing paper that has a surface consisting of raised dots. *See* ROSS DRAWING BOARDS *in this section.*

corrugated board. Corrugated sheet faced on both sides and used for packing, wrapping, and display work.

cover paper. A variety of paper used for outside covers on catalogs, pamphlets, magazines, and booklets. It is manufactured in many

surface textures. Papers of this sort must have good characteristics of dimensional stability and durability, and good folding qualities. They range in quality from chemical wood pulp to rag pulp, with mixtures of the two. The better grades are colorfast. Coated and uncoated stocks have basis weights of 50 to 100 pounds (20×26—500).

crepe paper. A lightweight, crinkled paper available in many colors and used for displays, floats, and decorations. Care must be taken to keep this material dry. It has no strength when wet, and the colors run badly.

cross-section paper. Usually a bond or ledger paper printed with various styles and colors of cross-section lines. On cross-section paper the inch line is accented. *See also* QUADRILLE PAPER *in this section.*

detail drawing paper. A paper used for sketching the details from which finished drawings are made. It usually has good strength and durability. It has a basis weight of 60 to 100 pounds (24×36—500).

drafting paper. A fine white, or cream-colored, paper that is hard-surfaced and has good erasing characteristics. It is used for drawing and is usually sized.

drawing bristol. A cardboard made of 100 percent cotton in the higher grades. It has good characteristics of permanence, strength, and erasability.

drawing paper. This term describes a wide variety of papers used for pen and pencil drawing by artists, architects, and draftsmen. The usual basis weights are 80 to 100 pounds (24×36—500).

duplex paper. Various papers having a smooth finish on one side and a rough finish on the other, or which have sides of different colors.

etching paper. Also called *steel plate* paper, this is a soft, but strong, paper made for printing etchings. It is a 100 percent rag-content paper with a smooth surface, and is made with a minimum of size. The basis weight is 120 pounds (22×28—500).

facing paper. Lightweight, decorative paper pasted on base stock or filler board and used for picture mounts, mat boards, and other purposes.

finger-painting paper. A paper, coated on one side, that takes finger paint easily.

foam core board. A lightweight board made of styrofoam faced on both sides with white paper. About $\frac{1}{4}$ inch thick, and very stiff without being heavy, this board is ideal for cutouts and for mounting.

glassine. A smooth, dense transparent or translucent paper made from wood pulp beaten to obtain a high degree of hydration of the paper stock. It is greaseproof, and used as a packaging material and for envelopes and windows for envelopes.

gummed paper. A variety of colored, patterned papers with an

adhesive on one side for easy application. Also coated or uncoated book paper, gummed on one side, used for stickers, labels, stamps, seals, and tapes.

illustration board. Boards made by mounting good drawing paper on a stiff backing, usually a filled pulp board of some kind. Surfaces vary from smooth to rough, and rag content varies. In the better grades, the face paper can be stripped from the backing. A *hot-pressed* surface is a very smooth surface for fine pen and ink work. *Cold-pressed* has enough texture for watercolor washes but is still smooth enough for pen and ink. *Medium surface* is used for pencil, watercolor, crayon, and other mediums. Single-thickness boards are about $\frac{1}{16}$ inch thick, while double thickness boards are about $\frac{1}{10}$ inch. The basis weight is 150 pounds (17 × 22—500).

index stock. A stiff paper receptive to writing ink and to printing. It is available in smooth and antique finishes and used for index records and business cards. Basis weights are from 180 to 440 pounds (25.5 × 30.5—1,000).

india paper. Also called *bible paper,* because it was originally used for printing Bibles, and also for making prints from fine engravings.

japan papers. Special papers made with an irregular mottled effect in the surface. It is used for greeting cards and other decorative applications. Basis weights are from 50 to 150 pounds (25 × 38—500).

kraft paper. A very strong paper made entirely from wood pulp and used as wrapping and packaging material. It is usually made in basis weights of from 25 to 60 pounds (24 × 36—500), although heavier weights may be made.

label paper. Various papers used for can and bottle labels. Made both for offset and letterpress printing, they have a smooth side for printing and a rough side to receive an adhesive.

lampshade papers. Papers that are translucent and either flame-resistant or flame-retardant. They are often made of woodpulps, vegetable parchment, or laminated glassine.

layout pads. Pads of fine-quality white paper, very good for pen and ink, wash drawings, layouts, and comprehensives.

ledger paper. A material made from rag pulp, chemical wood pulp, or a mixture of both. It is a heavy white paper well suited for ink and wash drawings. It is a strong, durable, and permanent paper, and the best varieties are fully opaque. Normally basis weights are from 24 to 36 pounds (17 × 22—500).

manila paper. The term originally referred to paper manufactured from manila hemp, the same material used for making rope. Such paper is now called *rope manila,* and manila refers to yellowish paper or bristol.

marble paper. A material which, like *granite paper,* has colored patterns that simulate the veined effect of certain stones.

mat board. Widely used in picture framing, and as a mounting

board for photos and artwork, a fairly heavy board lined with plain or colored cover paper.

mechanical drawing paper. *Same as* DETAIL DRAWING PAPER.

metal-foil paper. Paper backed with genuine metal foils in a number of vivid colors.

metallic paper. A paper coated with zinc white, or with clay and other materials. The surface is such that it can be marked on with metal points (silver, aluminum, and gold, for example), but it cannot be erased. It is one of the grounds used in the silverpoint method of drawing.

mounting board. A stiff, smooth finished board, used for the salon mounting of photographs, artwork, and drawings.

newsprint. The paper used in the publication of newspapers. It is an impermanent material made from mechanical wood pulp, with some chemical wood pulp. Artists use it as an inexpensive sketching paper for large drawings in soft pencil, charcoal, or pastel. Basis weights are from 30 to 35 pounds (24 × 36—500).

oatmeal paper. A paper in which fine sawdust is added to produce a sheet with a coarse texture. It is an inexpensive sketching paper for work in pastels and charcoal.

offset paper. Similar to the book paper used in letterpress printing, with the addition of a sizing used to resist the slight moisture present in offset printing.

onionskin. A lightweight, durable bond paper. It is usually quite translucent and is so named because it resembles the dry outer skin of an onion. It is usually employed for duplicate typewriter copies and in interleaving order books. It has a basis weight of 7 to 10 pounds (17 × 22—500).

parchment paper. Medium- to heavy-weight vellums with a parchmentlike appearance. Inomachi and Shizuoka No. 2 are typical handsome japanese vellums.

pasteboard. The heavier papers and cardboard that get their rigidity and thickness by being built up from two or more plies. These plies are pasted together or pressed together wet.

pastel paper. A paper with enough tooth to be used with chalk or pastel. It is available as either white or tinted stock, is fairly heavy in weight, and has a high rag content.

Patent Office Bristol. A high-grade bristol board made to meet exacting U.S. Patent Office specifications for trademark and patent applications. It is made of 100 percent cotton fiber and has good dimensional stability, high brightness, and a level surface.

photographic background paper. *See* SEAMLESS DISPLAY PAPER *in this section.*

plotting paper. Drawing paper laminated to both sides of an aluminum sheet or foil to ensure better dimensional stability. It is often used in drawing the color separations used in map making.

postcard paper. Lightweight bristol, made from soda and sulfite

quadrille

cross section

pulps, that has a smooth, firm surface for writing with pen or pencil or for ordinary printing.

poster board. A stiff cardboard used for show cards, posters, display advertising, and signs. It may be white or colored on one side, and is made in thicknesses up to 14-ply. It will take poster colors, watercolors, tempera, pen and ink, airbrush, and silk-screen process.

poster paper. A strong, waterproofed paper used for billboard poster work. It is white or colored with nonfading pigments. It does not curl when paste is applied to it. It has basis weights of from 32 to 63 pounds (24 × 35—500).

pouncing paper. Outlines are made in this paper with a tracing wheel, forming a pattern that can be used to make letters or figures on a large sign. Pouncing powder is then forced through the holes made by the wheel. Any grade of paper of basic weights from 16 to 24 pounds (17 × 22—500) can be used.

profile paper. *See* CROSS-SECTION PAPER *in this section.*

quadrille paper. Usually a good-quality white ledger paper with light blue lines ruled on it. Similar to cross-section paper but having lines of equal weight. The inch line is accented on cross-section paper.

railroad board. A clay-coated board in a wide range of colors. It is used for mailing cards, show cards, tickets, tags, and car signs. The basis weight ranges from 130 to 300 pounds (22 × 28—500).

"repro" boards. Like Ross boards, these are white boards with different textures on them. Drawings in tone values reproduce as line copy. Textures include rough stipple, stipple, dot, coarse and fine halftone, and bead.

rice paper. Not a true paper, nor is it made from rice. It is manufactured from the pith of a tree grown in Formosa. Tissue-thin sheets of the pith are peeled away as a cylindrical section of the wood rotates against a knife. Rice paper is also a term used to describe various Oriental papers used in block printing. These papers are of different weights, fiber patterns, and textures. Some are handmade. Common types are Chiri, Deberasu, Donnasai, Gasenshi Echizen, Hosho, Iyo glazed, Kinwashi, Kitakata, Natsume, Okawara, Sekishu, Tokugawa, and Unryu.

Ross drawing boards. Boards having a lightly pebbled surface, with some portions partly in relief and other portions depressed. If a pencil or crayon is drawn across the surface, the pigment is left mainly on the high spots. Gray tones, or middle tones, are actually made of minute black dots. Black is achieved by forcing pigment into the depressed portions, and pure white highlights are made by scratching away the coated surface with a scratchboard knife. The final effect is so similar to a halftone that inexpensive line shots of artwork done on these boards can be successfully made.

scraper board. The British term for scratchboard.

scratchboard. A plain white-coated drawing board coated with india ink. After it is dry, the surface can be scratched with a scratchboard knife to produce a snow-white line. Brilliant, contrasty black and white drawings are produced in this way. *See also the main heading* SCRATCHBOARD.

seamless display paper. A special grade of cover stock made in a wide assortment of colors. It has a basis weight of 50 to 55 pounds (20 × 26—500), but is usually made in rolls 107 inches wide by 12 feet long. They are used in window displays and television studios, but their widest use is probably in photography, where they are used to provide a large expanse of even-colored background.

show-card board. A board used for window and counter display signs. It is lined on one side with book paper.

sign paper. A paper used for sign and poster work indoors and out. It is usually made of bleached chemical wood pulp, and has good water-resistance and fair strength. It has basis weights of 90 to 110 pounds (24 × 36—500).

silhouette paper. A smooth-surface paper that is flat black on one side and white on the other. It is used for making silhouette cutouts.

stencil paper. A special heavily oiled paper made specifically for stencil work.

storyboard pads. Pads printed with white areas, shaped like television screens, on a dark gray background. Small drawings are made in the white screen-shaped areas and they are used to visualize the continuity of a film, a television production, or a slide presentation. Underneath the screen is a box in which copy can be written.

tag stock. A paper developed for general tag use that has good water-resistance, folds without cracking, and has a surface that easily takes printing, stamping, or writing. The basis weight is from 100 to 270 pounds (24 × 36—500).

text paper. The paper most frequently used for announcements, booklets, brochures, fine books, and annual reports. It is available in a variety of colors and textures. Common basis weights are 60, 70, and 80 pounds or heavier (25 × 38—500).

tissue paper. Extremely lightweight paper available in a great many colors. Widely used in craft projects, it is also used in collage painting. It is made in weights lighter than 18 pounds (24 × 36—500).

tracing paper. Paper used both for tracing and original drawings. Various types and surfaces are available, and it is an ideal paper for pencil work and pastels. It is made in weights from $7\frac{1}{4}$ to 16 pounds (17 × 22—500).

vellum. A high-grade paper made to resemble genuine parchment.

velour paper. A paper with a velvetlike finish, produced by flocking the surface with fine bits of rayon, nylon, cotton, or wool. It is then sometimes embossed in various patterns.

watercolor paper. A special drawing paper with a surface texture suitable to accept watercolors. The better grades can withstand the harsh scraping that is sometimes necessary to produce highlights. For permanent painting, the paper should be a 100 percent rag, not wood pulp. Paper of an inferior grade destroys depth of tone and turns yellow and brittle with age.

papier-mâché A substance originated in France in 1740. It consists chiefly of paper pulp mixed with glue. It dries to a hard finish that can be drilled, sanded, and painted.

In making papier-mâché construction over armatures, an effective method is to apply strips of paper soaked in polymer medium. This material is durable, waterproof, and quick-drying. Other acrylic materials, such as paints, can also be introduced and combined with the emulsion.

parchment Genuine parchment is made from the thin skin of calves, lambs, goats, and other animals. Vellum is a term describing finer skins, such as those of new-born calves, goats, or lambs.

Parchment is prepared by washing, treatment with lime, scraping, rubbing, dusting, and other operations, and is typically pale and smooth. To paint on parchment with watercolors, or to illuminate, the material should first be mounted on a stretcher. The surface must also be free of grease, or the colors will not adhere.

paste *See* ADHESIVES.

pastel Pastel colors are chalks or crayons made of a finely ground pigment and a minimum of nongreasy binder, such as gum tragacanth or methylcellulose. Since they are blended on the painting itself, a larger assortment of shades and tints is required than with oil or other color mediums. They provide a method of drawing in full color without having to wait for the color to dry. It addition to the wide range of vivid colors, a set of graduated grays is manufactured for layout work. Pastels are applied directly to the surface, and certain special papers have been developed for its use. They have a slight sandpaper texture to which pastels easily adhere.

There are hard and soft pastels. The hard ones can be sharpened to a fairly sharp point for detail work; the soft ones make broad strokes with good coverage. Pastels can be blended into each other with such materials as cotton swabs, sponges, stumps, and bits of cloth.

In commercial art, pastels are widely used for quick comprehensives and preliminary sketches. They are used in fine art to produce finished works. It is a permanent form of painting, but the pigment is only on the surface of the paper and must be protected by glass if it is not to be rubbed off.

Since a lot of pigment dust is raised during pastel application, poisonous pigments are eliminated from the palette since they could be inhaled by the artist. Sulfur-sensitive pigments are also excluded.

Special oil pastels are available that simulate the character of oil paint. They are in stick form and similar to crayons, but softer in consistency. The colors are easily blended with turpentine or mineral spirits.

There are also water-soluble pastels on the market.

pastel fixatives Thin varnish materials now usually packed in spray cans for the simple and even application to drawings. Only enough fixative should be used to keep the pastel particles from falling off the paper. The more fixative used, the darker the drawing becomes. The best way to protect pastel work is to frame it under glass with a mat thick enough to keep the particles from touching the glass. The frame should then be sealed to keep out air, dust, and moisture.

paste-up forms High-quality bristol printed in a grid of light blue, which will not reproduce on camera. It is used to maintain the alignment of copy pasted onto it. Corner and registration marks are printed in black.

patinas *See* METAL-COLORING FORMULAS.

peen The striking face of certain hammer heads. These hammers are termed ball peen, cross peen, straight peen, etc., depending on the shape of the striking face.

pencils There are three basic kinds of pencils: graphite, carbon, and colored. Ordinary lead pencils are made from graphite mixed with clay. The more clay that is added, the harder the material. Graphite, also called plumbago, is a form of carbon that occurs in flat plates and has a greasy feel. The use of a graphite pencil produces a shiny, gray effect. Drawing pencils are graded from 6B (the softest) through 5B, 4B, 3B, 2B, B, HB (medium soft), F, H (medium hard), 2H, 3H, 4H, 5H, 6H, 7H, 8H, and 9H (which is the hardest).

A carbon pencil is made with carbon black in a special binder and is available in several degrees of hardness. It produces a deep black matte-finish mark.

Colored pencils consist of colored chalk or crayon bound in the usual cylindrical or hexagonal case of wood. Watercolor pencils consist of watercolor pigments set in pencil form. After the marks are made a wash can be created by applying a water-saturated brush. There are also numerous other pencils designed for particular jobs such as making reproducing and nonreproducing marks in various duplicating and reproduction systems or leaving marks of high

electrical conductivity. The latter pencils are used with electronic computers, tabulators, and scoring machines.

Pencils are used in virtually any stage of artwork production, from rough layout to finished art. They can be used on almost any paper stock, but work best on the rougher textured papers.

pens Implements for writing and drawing, pens were once made from split or pointed quills, and also from reeds, bamboo, and coarse grass. Metal pens are now most often used. Pen points are available in a large assortment of designs, each of which produces a characteristic stroke or pattern. Pens are used for such things as drawing, mapping, lettering, engrossing, and for extremely fine work. In the latter instance, *crow quill* pens are employed. They produce an extremely fine line.

Some typical lines made by Speedball pen points, manufactured by Hunt Manufacturing Co., Philadelphia, Pa.

pentimento As linseed oil becomes transparent with age, an overpainted portion of a picture may be revealed. This condition is called *pentimento,* or "repentance."

perforating wheel *See* POUNCING.

perlite An expanded form of mica that is sometimes used as a textural additive in paint.

pernetti Small pins or tripods of iron that support ware while it is being fired in a kiln. The term also applies to the marks left on the baked pottery by these supporting pins.

petroleum jelly A jellylike substance, also called petrolatum, obtained in the fractional distillation of petroleum. It is insoluble in water, but readily soluble in turpentine. Vaseline is the trade name of petroleum jelly made by Chesebrough-Pond's, Inc.

phenol Carbolic acid.

phosphorescent paint A paint which glows in the dark after having been activated by artificial light or daylight.

photoengraving The technique of producing relief plates, such as halftones, zinc etchings, etc., by photography. In this method a metal plate is coated with a photosensitive emulsion and exposed to light under a reversed positive. The picture is developed by dissolving away the portion of the emulsion not acted upon by the light, and the plate is etched.

photogelatin printing A method of printing that produces extremely fine tones on uncoated papers. Its uses include the facsimile reproduction of photographs, pencil sketches, charcoal and pastel drawings, and other artwork where it is important to retain the fine shading and grain of every stroke.

The photogelatin plate consists of a thin film of photosensitive gelatin on a special metal plate. Continuous tone negatives are made of the artwork, placed on the plate in a vacuum frame, and exposed. No screens are necessary.

When light strikes the smooth, hard, uniformly absorbent plate, a chemical change takes place. The plate becomes moisture-repellant in proportion to the amount of light received at any given place. When printed, the moist portions of the plate repel the ink and dry portions accept it, through the entire range of tones. The finished print is thus an exact, continuous-tone duplication of the original subject matter.

photographic lens cleaning To remove dust from a lens, a soft brush should be used. A lens should never be touched with the fingers because the greasy prints may leave acid perspiration that can etch the surface of the glass. Fingerprints can be removed with lens tissue or a soft, lintless cotton rag. If lens cleaning solution is used, care must be taken to prevent its seeping between the cemented elements of the lens. The solution should be placed on the tissue, not on the lens.

Coated lenses should never be cleaned with silicon-impregnated tissue or cloth. They can leave a residue that can permanently discolor the coating.

photographic lenses The following entries describe the lenses, or lens types, commonly used in still and motion picture photography. *See also* ABERRATIONS.

achromatic lens. A lens which has no chromatic aberrations. About the only lenses lacking achromatization are those found in very cheap cameras.

anamorphic lens. The lens system used for wide-screen effects. It gives greater magnification in one meridian than in the other.

anastigmat lens. A lens corrected for astigmatism, so it brings both vertical and horizontal lines to a focus in the same plane. The field of this lens is essentially flat.

apochromatic lens. In this lens, all colors come to focus at a common point. Widely used in process and copying lenses.

convertible lens. A lens that consists of several elements. These elements can be used in various combinations to provide different focal lengths. They are also called *separable* lenses.

fixed-focus lens. Inexpensive cameras, which have no provision for focusing, use lenses of this type. The position of the lens is fixed, and all objects from a few feet away to infinity are tolerably in focus.

long-focus lens. A term used to describe any lens longer in focal length than the standard lens for a particular camera. Telephoto lenses are long-focus, but not all long-focus lenses are telephotos. Long-focus lenses give greater image magnification, but have narrower angles of view.

process lens. A highly corrected, apochromatic lens used for precise color-separation work.

standard lens. Usually the lens provided with the camera as standard equipment. In still cameras, the standard lens is one whose focal length is about equal to the length of the diagonal of the negative area normally provided by the camera. The normal field of view of a standard lens is about 53 degrees.

telephoto lens. A lens for photographing distant objects. It is designed in a compact manner so that the distance from the front of the lens to the film plane is less than the focal length of the lens.

wide-angle lens. A lens that covers a field of view of about 90 to 135 degrees.

zoom lens. Also called a *varifocal* lens, this is a lens the focal length of which can be varied continuously without disturbing the focus.

photographic papers The following terms are commonly used to describe photographic papers.

bromide paper. A paper made with silver bromide salts which provide high sensitivity and short exposures. It is the most popular type of paper used in enlarging.

chloride paper. A paper made with an emulsion of silver chloride. It is usually used as contact paper or for very slow enlarging papers.

chlorobromide paper. A paper with an emulsion that is composed of both silver bromide and silver chloride. Fast contact papers, and medium-speed enlarging papers, use this emulsion.

double weight. The heavier weight in which any photographic paper is supplied.

mural paper. Enlarging paper available in very large sizes, usually in rolls. It is used for making photomurals.

printout paper (POP). A paper used to make prints by light alone,

without any processing involved. They are a reddish color and are often used as proofs. They can be made permanent by toning.

single weight. The lighter weight in which any photographic paper is supplied.

photographic processes The following list of photographic processes includes several that are now obsolete, but are of academic interest nevertheless.

albertype. A process in which a photographic plate is covered by chromate of potash and exposed to light. It can then be inked like a lithographic stone to furnish prints.

ambrotype. An obsolete method of photography, invented in 1851, in which a negative is formed in a collodion emulsion of glass. When backed with black velvet or black varnish, it appears as a positive.

bromoil. A photographic process for making prints in permanent oil colors on a ground consisting of a bromide print.

calotype. A method of photography invented in 1841 by Fox Talbot, and also known as Talbotype. It utilized paper negatives and prints.

carbro process. A system of making carbon prints in which the tanning of the pigmented gelatin takes place in a special bleach bath and treats prints made on bromide paper. It is also known as the *ozobrome* process.

cliché-verre. A name given to prints made by a process in which a design or picture is drawn or painted on glass to form a negative. This negative is then printed in the usual way, using sensitized photographic paper. The design to be printed is sometimes scratched on an opaque coating of black varnish.

collodion process. This method was invented in 1851 by F. Scott Archer and was in general use for thirty years. It superseded the daguerrotype and calotype processes. Called also the *wet-plate process,* the negative consisted of a glass plate coated with collodian containing iodides. Just prior to exposure, it was immersed in a solution of silver nitrate. After it was exposed it was developed with pyrogallol or acidified ferrous sulfate.

collotype. A photomechanical process developed commercially by Joseph Albert in 1868. In this system, a hardened gelatin image is formed on a glass plate and printed with a greasy ink. It is still sometimes used for reproducing delicate monochrome work and for short runs of color.

daguerrotype. A photographic system developed by Daguerre in 1839. It consists of a positive image formed by mercury vapor on a surface of highly polished silver. The silver is plated on copper. The highlights of the photograph consist of a milky deposit of mercury amalgam, and the shadows are simply the polished silver.

doretype. A positive image on glass that is backed with gold paper.

dye transfer. A system of color printing in which three separately prepared images are transferred in register to one sheet of paper. *See also* DYE TRANSFER *as a major heading.*

kallitype. An early process using paper sensitized with ferrous oxalate and a silver salt.

photogram. A design or pattern produced on regular photographic paper without the use of a negative or a lens system. Opaque or transparent objects are assembled on the paper, and the paper is exposed to light and processed in the usual way.

wet-plate process. *See* COLLODION PROCESS *in this section.*

photographic terms (general) The following are standard photographic terms.

actinic light. That portion of the spectrum that can expose photographic materials.

adapter back. A supplementary back for view cameras which permits the use of a smaller film size than the one designed for the particular camera.

agitation. The movement of film in a developer (or the developer around the film) to maintain a continuous change of solution at the face of the emulsion layer.

antihalation. The treatment of films and plates to prevent halation. It usually consists of an opaque backing. *See* HALATION *in this section.*

aperture. The opening which controls the amount of light entering the camera through the lens.

autopositive. A film or paper that produces a positive image when exposed to a positive (or a negative image from a negative) and is processed in a single development stage. It is different from a *direct positive* method which employs reversal processing, with reexposure and redevelopment.

Autoscreen film. A brand name for a material made by the Eastman Kodak Company. With this film it is possible to make halftone negatives from continuous-tone copy without a ruled screen or a contact screen. The dot pattern has been built into the film, and halftone images are produced automatically.

B or bulb. A marking on a camera shutter that indicates that the shutter will remain open as long as the shutter release is depressed. At one time rubber bulbs, connected to the camera with rubber tubing, were used to operate shutters pneumatically in order to minimize jarring.

bath. Any solution, such as developer or fixer, used in photographic processing.

bellows. An accordion-pleated cloth or leather tube, used in

cameras and enlargers, that provides a lighttight enclosure between the lens and the sensitive material or the negative.

blocked up. A term that refers to overexposed or overdeveloped highlights in a negative. It means that no detail is visible.

blocking out. Painting out undesired areas or spots on a negative.

blow up. To enlarge a photograph. Also, the finished enlargement.

burned out, burned up. An overexposed negative or print.

burning in. A method used in exposing photographic paper so that certain parts of the image are given more light than other parts. *See* DODGING *in this section.*

cable release. A flexible, encased wire employed to actuate the shutter of a camera without inducing undesirable camera movement or vibration of the camera.

changing bag. An enclosure made of a lighttight material, usually two layers thick, that makes possible lightproof operations such as the loading of film holders or developing tanks in broad daylight. The holders are slipped into one end of the bag which is then zippered shut. The hands slip through sleeves having rubber wrist bands to keep out the light.

characteristic curve. A graph that shows how increases in exposure increase the density of the film.

circle of confusion. In theory, if a lens is focused at a certain distance, only objects at that distance are clearly in focus. Objects in front of, and behind, the focus point are more or less out of focus, and points outside of the plane focused on are imaged as blurred circles which are called circles of confusion.

clearing bath. A step in the processing of a negative or print. Clearing is the removal of veil, fog, scum, or stains, or the neutralization of chemicals from the previous bath.

contact print. A print made by putting paper and negative in contact and exposing them to light. A contact print is always the same size as the negative it was made from.

contact printer. A device that provides a light source and a means for holding negative and paper (or film) in close contact while the exposure is made.

contrast. This term describes the difference in tones of a photograph. If there is only a slight difference, the picture is said to be *soft;* if too great a difference, the picture is said to be *contrasty* and lacking in middle tones.

copper toning. The use of copper ferricyanide in toning bromide prints. It gives them a range of warm black to reddish-purple tones.

cut film. Negative material similar to roll film made in flat sheets of standard plate sizes.

darkroom. A laboratory in which photosensitive materials are

loaded, developed, or printed. It is so-called because some photographic processes require absolute darkness. At other times a darkroom may be illuminated with various safelights, depending upon the material being handled. *See* SAFELIGHTS *in this section.*

definition. The sharpness and clarity of a picture. A measure of the resolving power of a lens in terms of its ability to produce sharply defined photographic detail.

dense. A term applied to a negative or a transparency that is overexposed, overdeveloped, or both.

densitometer. An instrument used to measure the density of photographic materials, both black and white and color.

density. The relative opacity of a negative produced by the amount of silver deposited by exposure and development in a given area. The light-stopping capacity of the blackened emulsion. Density measurements are logarithmic in scale.

depth of field. When a lens yields a sharp image of a given object, there may be other objects, both farther away and closer, that are not equally sharp. *Depth of field* describes the zone between these points in which everything is acceptably sharp. It is generally greatest for the smallest apertures, and diminishes as the aperture increases in size.

depth of focus. The allowable error in the distance between the lens and the film within which a sharp image of the subject focused upon will still be obtained.

develop. To bring out the latent image of an exposed film or plate by chemical means.

developer. A developer converts the silver halides affected by light into black metallic silver. The visible silver of the latent image forms the final negative. All the unused silver halides are dissolved and washed away in fixing and washing baths.

diaphragm. Also called an *iris,* this is a continuously variable device that is usually placed between lens elements to control the amount of light passing into the camera.

diaphragm settings. A diaphragm should always be set by moving the leaves from the widest opening to the desired aperture. This method takes up any backlash that might be present and provides the most accurate setting. To open to the next larger stop, therefore, the lens should first be opened to its widest position and then "stopped down" to the desired opening.

dimensional stability. The ability of photographic materials to hold their size and shape before and after processing.

direct positive. A positive image obtained directly without processing through the negative stage.

dodging. A method of shading a portion of the photographic paper during exposure so that the tone of selected portions of the print is modified.

easel. A device used to keep paper flat while it is printed with an enlarger.

emulsion. The light-sensitive coating on photographic plates, films, and papers. It consists of finely divided silver halides in gelatin.

emulsion speed. A measure of the amount of light required, on a given emulsion, to produce a correctly exposed image. An emulsion which requires little light is said to be "fast."

enlargement. A print made in an enlarger, usually of a size larger than the negative.

enlarger. An enlarger is an optical projector that projects the image of the negative onto sensitized paper or film. By adjusting the distance between the lens and the sensitized material, almost any degree of enlargement is possible. There are two basic types: one uses a condenser system to collimate the light from a lamp and provide parallel light beams through the negative; the other is a diffusion system that scatters the light of the bulb. Condenser enlargers are used for most commercial applications. Portraits are commonly printed with a diffusion enlarger. Enlargers are built in a variety of sizes to accommodate different sizes of film. Special lamp heads, with color temperature controls, are used for color printing. With a special attachment, an enlarger can be used to make reduction prints.

exposure. The amount of time that the image of a subject is allowed to fall on the sensitized film or paper.

exposure latitude. The tolerance of a film to underexposure and overexposure.

exposure meter. Also called a *light meter,* this is a device used to measure light intensity and to gauge the exposure settings on a camera. A reflected light meter measures the amount of light coming from the scene to be photographed. An incident light meter measures the light falling on the scene, instead of that reflected from it.

extension tubes. Threaded tubes used to extend the lens from the camera to permit focusing on objects that are extremely close.

f-stops, f-numbers. The f-number represents the ratio of the diaphragm opening to the focal length of the lens. The usual f-numbers are 1.4, 2, 2.8, 4, 5.6, 8, 11, 16, 22, 32, 45. They represent successive decreases of one-half in light intensity. In other words $f/11$ gives twice as much exposure as $f/16$; $f/8$ gives twice as much exposure as $f/11$.

At one time US (Uniform System) numbers were used on lenses. These numbers, now obsolete and found only on very old lenses, were proportional to the exposure required, and compare with f-numbers as follows:

f	$f/8$	$f/11$	$f/16$	$f/22$	$f/32$	$f/45$
US	4	8	16	32	64	128

ferrotype. The method of producing a glossy surface on a photographic print by drying it with heat on a highly polished plate.

film. Film consists of a sensitized material, or emulsion, coated on a flexible support, usually a transparent plastic material.

film plane. Also called *focal plane,* this is the position in a camera occupied by the film or plate.

filter factor. When a filter is used on a camera, the exposure must be lengthened because the filter absorbs some of the light. The filter factor is the number of times the exposure must be increased.

filters. Devices that shut out light of some colors but not of others. Filters are used in black-and-white photography for the purpose of making certain colors dark, or black, on the final print. To do this, the color of the filter must be complementary to the color to be darkened. In other words, an orange filter will darken a blue sky. For a color to be rendered as white, or very light, the filter should be the *same* color as the subject to be lightened.

Filters are also used in color photography for correcting the color temperatures of light sources.

Filters are usually made of glass or gelatin. The latter must be handled with great care and protected from moisture, heat, and dust. They are cut to the required size by placing them between two sheets of paper and cutting them with scissors.

finder. Any attachment to a camera for showing, before the picture is taken, the scene that will be included in the picture. Also called *viewfinder.*

fixing. The process in which the unexposed and unreduced silver halide in a negative is removed. Hypo (sodium thiosulfate) is the chemical most often used.

focal length. When a lens is focused on infinity, the focal length is the distance from the optical center of the lens to the film plane.

fog. A dark, hazy deposit or veil of uniform density over all, or parts, of a piece of film or paper. It can be caused by light other than that forming the image, by lens flare, aged materials, chemical impurities, or other causes.

forcing. The attempt to bring out detail in an underexposed negative by extending the development time or by using an accelerator.

gamma. The numerical expression of the degree of contrast of a developed or printed-out picture.

glassine envelopes. Envelopes and sleeves made of glassine are made in all film sizes and used for the protection of negatives and transparencies.

glass plates. Film plates consisting of glass sheets coated with a sensitized emulsion. Sheet film has largely replaced them, but they are still used in some critical work because of the dimensional stability of the glass.

glossy. A term applied to a photograph dried on a ferrotype plate or drum. The glazed surface of these prints is not easily scratched or soiled in handling, and they have a wider range of tonal values than do matte prints.

ground glass. A sheet of matte-surfaced ground glass attached to the back of a view camera or process camera so that the image of the subject matter can be focused on it. It is exactly in the film plane.

guide number. A number that relates the output of a light source (such as a flashbulb) to the sensitivity of a particular film. When this number is divided by the distance in feet to the subject, it gives the *f*-stop at which the lens should be set.

halation. The tendency of light to form halos. It is caused by the reflection of light that has passed completely through the emulsion, and is most pronounced when street lights, or other bright sources, are photographed at night.

high key. A negative or print that has an overall light effect, with very few dark tones or shadows. High-key lighting produces tones that fall mostly between white and gray, with very few dark gray or black tones.

highlights. The bright parts of a subject that show up as the densest part of the negative and the lightest or whitest part of a print.

high-speed photography. Very often high-speed photography is employed to record movement or events that occur too quickly to be seen by usual visual or photographic means. When motion pictures are shot at high speeds and projected at normal rates the action of the subject is slowed to a point where it can be observed. High-speed operation is considered to be from 50 to 500 fps (frames per second). Very high speed is from 500 to 100,000 fps, ultrahigh speed is from 100,000 to 10 million fps, and superhigh speed is anything in excess of 10 million fps.

hold back. To hold back means to dodge or otherwise shade certain portions of the image while printing. It is the opposite of *burning in.*

hyperfocal distance. The distance from the camera lens to the nearest object in acceptable focus when the lens is focused on infinity.

hypo. The name "hypo" stems from an earlier, incorrect term, hyposulfate of soda. It is really the common fixing agent, sodium thiosulfate.

intensifier. An intensifier is used to strengthen the image of either

a negative or positive. In most methods, metal is added to the silver image, and the increase in density is proportional to the existing density. Because of this, when a negative is intensified, the highlights are always intensified more than the shadows.

light meter. *See* EXPOSURE METER *in this section.*

low key. A low-key photograph is one which has mostly dark tones and very few light or white areas.

M synchronization. *M* synchronization on a lens is used for flashbulb applications. It allows a 15-millisecond delay so that the bulb burns to its brightest point before the shutter opens. *See also* X SYNCHRONIZATION *in this section.*

negative. The image on film in which the dark tones of the original appear transparent, and the light tones appear black and opaque.

neutral density filter. When a lens cannot be stopped down sufficiently for use with a given film, a neutral density filter can be employed. It is a gray filter that does not affect the colors in a scene, but serves only to reduce exposure.

Newton's rings. When two polished or smooth transparent surfaces are in partial contact, irregular colored rings are sometimes seen. Called Newton's rings, these are caused by interference of light reflections from the two surfaces.

orthochromatic. A term used to designate sensitized materials that can be exposed by ultraviolet, blue, and green light, but not deep orange or red.

pan, panchromatic. Sensitized materials that can be exposed by ultraviolet light, and by all the colors in the visible spectrum, including red.

parallax. In twin-lens reflex cameras, there is a viewing lens and a taking lens. Parallax is the difference in the fields of view of these two parallel lenses. It is a factor to be considered in any camera system that does not employ through-the-lens viewing, but is generally negligible except for close-ups.

pH. The pH scale ranges from 0 to 14 and is a measure of relative acidity or alkalinity in liquids. A value of 7 is neutral. Lower values are acid, and higher ones are alkaline.

photomacrography. Making large pictures of small subjects by using a short-focal-length lens on a long-bellows camera.

photomicrography. Photography of extremely small subjects through a microscope.

pinholes. Very small transparent spots on developed negatives usually caused by dust, undissolved chemicals, or air bells.

Polaroid back. A supplementary back for 4- by 5-inch view or press cameras that makes possible the use of Polaroid materials.

positives. Prints or transparencies with light and dark areas corresponding to the light and dark shades of the original subject. Color positives contain the true colors of the original subject.

press camera. A folding camera, usually of 4- by 5-inch format, once widely used in newspaper photography.

projection printing. The production of photographic prints with the use of an enlarger.

proportional reducer. *See* REDUCER *in this section.*

range finder. A camera range finder is used to measure the distance from the camera to the subject and allow the proper focus setting.

reciprocity law. Generally, the idea that when the light falling on a subject is decreased, a proportionate increase in exposure time will produce a negative of comparable density. At very low intensity levels, most emulsions fail to follow this law, requiring a much greater than proportionate increase in time in order to achieve the same density.

reducer. Reducers are solutions capable of dissolving silver, and are used to cut down the contrast or density of a negative or positive image. A *proportional reducer* lowers density proportional to the silver present, with a certain amount of loss in shadow detail. A *superproportional reducer* removes more density from the highlights of a negative than from the shadows.

reflex printing. A contact-printing method in which light passes through the back of the sensitized film or paper sheet and is reflected back to the emulsion by the material being copied. The dark portions of the original reflect little or no light, and the light areas reflect most of the light.

reticulation. The contraction or wrinkling of a film emulsion because of sudden changes of temperature during processing.

retouch colors. Colors used to correct defects in black-and-white and color photographs. They adhere without crawling and can be used with brushes or air brush on matte and glossy prints.

reversal process. A method in which a positive is produced from the plate or film exposed in a camera. The negative and positive stages are often produced from the same emulsion layer with no separate printing material required. In this system, only one copy can be made at a time.

rinse. A washing or rinsing bath given a sensitive material in the course of processing. It neutralizes or removes chemicals from a preceding bath. In black-and-white photography, the principal rinse is given between development and fixing.

roll film. A long strip of plastic material with a sensitive emulsion on one side and a layer of gelatin on the other. The gelatin layer reduces the tendency of the base material to curl. The film is attached to opaque backing paper that protects the film from light before and after it is exposed in the camera. Thirty-five-millimeter roll film is wound in and out of a small metal container called a *cassette*.

roll-film adapter. This adapter permits the use of roll film in cameras designed for cut film or plates.

safelights. Lights used in darkrooms, and always of a color that will not affect the sensitive material being handled. Blue-sensitive materials require a safelight that is red, orange, or yellow. Ortho-chromatic materials require a dark red safelight. Panchromatic materials require complete darkness or an extremely limited use of a dark green safelight. X-ray materials and color papers require olive green or brown safelights. The film or paper box (or data sheet in the box) will contain information about the appropriate safelight to use with that material.

safety film. At one time, highly flammable nitrate materials were used as the support for films. They have since been replaced with cellulose acetate, polyester, and other plastics that are not readily flammable. When these materials were first introduced they were called *safety film.*

sheet film. Another term for cut film. It consists of a negative material with its emulsion coated on a base of plastic rather than glass.

shutter. A mechanical device in cameras that opens and closes, at different rates of speed, to expose film or plates. Shutters are placed in different positions in different cameras: in front of the lens, behind the lens, between elements of the lens, or near the focal plane directly in front of the film. The majority of shutters in modern lenses are located between elements of the lens.

spotting. The use of opaque in painting out pinholes and other unwanted portions on a negative, or the use of dyes to remove white spots on a print.

stop bath. When a negative or print is removed from the de-veloper, it is usually placed in a stop bath to halt the action of the developer immediately. A common stop bath is a solution of 2 to 5 percent acetic or citric acid, or potassium metabisulfite.

superproportional reducer. *See* REDUCER *in this section.*

toners. Toners are available in many colors and are used for changing the color of black-and-white prints.

transparency. *See* COLOR TRANSPARENCIES *as a major heading.*

tripod. An adjustable, three-legged support used to prevent moving a camera and thereby blurring the image during its exposure. Generally speaking, tripods should be used with 35-millimeter cameras if the exposure is longer than $\frac{1}{50}$th of a second, and with larger cameras if the exposure is longer than $\frac{1}{25}$th of a second.

view cameras. Useful in the wide range of commercial photog-raphy, these cameras are manufactured in plate sizes of 4 by 5, 5 by 7, 8 by 10, 11 by 14 inches, and sizes such as 8 by 20 inches for panorama and banquet work. A view camera can be focused at both the front and the back, and has adjustments for tilts, swings, shifts, and rise and fall—these to control the shape of the subject in the image. It has a ground glass on the back which enables the

photographer to view the exact image to be recorded. Film holders are inserted in the back of the camera.

washing. After sensitized materials have been chemically processed, it is important that they be washed thoroughly. If not, chemicals can attack the image and cause fading, spotting, or staining.

wash-off material. A substance that forms a water-insoluble image in the areas that have been exposed. The nonimage areas remain water-soluble and wash off during processing.

X synchronization. A setting on the lens that allows the ignition of electronic flash at precisely the instant the shutter is opened. *See also* M SYNCHRONIZATION *in this section.*

photographic-tray cleaning formula Stained trays and bottles can usually be cleaned with a mixture of 1 part hydrochloric acid and 3 to 4 parts water. (The acid must be added to the water.) This mixture must not come in contact with the hands.

Black deposits of silver often build up in developer and fixer trays. These may be removed with nitric acid, or by a strong solution of potassium permanganate, followed by a bath of a 5 to 10 percent solution of potassium metabisulfite.

photography The system of producing images on sensitized materials by the action of visible light or other forms of energy such as infrared or X-ray. Usually, a camera is placed in front of the object to be photographed and the object's image is focused by a lens onto a sensitized film or plate. After exposure, the film is developed and fixed.

photogravure A way of making intaglio engravings in copper from photographs in which a gelatin image is used as an acid resist. It is considered high quality for halftones, but not so good for type.

photostat *See* STATS.

pick-up A pick-up is a small lump of rubber cement used to pick up excess rubber cement used in mounting or frisket making. By using a pick-up there is no smearing or scratching as would be the case with an eraser.

picture protection Pictures such as watercolors and pastels must be protected by glass. In this way they are sealed off from moisture and dirt.

An oil painting is usually varnished. If the varnish surface becomes soiled or darkened it can be cleaned with solvents without endangering the upper paint films. Picture varnishes must remain transparent for long periods, be easily applied and removed, dry rapidly, and not darken severely with age.

Polymer paintings are either left unvarnished, or coated with polymer varnish.

pigments Pigments are finely divided, colored powders that are mixed with liquids to produce paints. They do not dissolve in the liquid, but remain suspended in it. Substances which dissolve are classified as dyes.

Pigments are available in all colors of the spectrum, and black and white. The following are the common names of a number of pigments, some of which are obsolete or seldom used in permanent painting.

white pigments

Antimony White. A pigment consisting of antimony oxide and a large percentage of blanc fixe. It is permanent but can be darkened by sulfur fumes.

Barium White. Blanc fixe, an artificial barium sulfate.

Baryta White. Blanc fixe, an artificial barium sulfate.

Barytes. A native barite or barium sulfate. It is a white powder with no coloring power used as an inert pigment and adulterant in cheap paints.

Biacca. The Italian name for white lead. It is used for painting in secco, but not in fresco.

Bianco Sangiovanni. A fresco white consisting of calcium hydroxide and calcium carbonate. It is made by exposing lime to the air where, after a few months, it becomes partially carbonated.

Bianco Secco. A white pigment made from slaked lime and water, and used in fresco painting.

Bismuth White. Bismuth nitrate, a material that is more prone to the darkening action of sulfur fumes than is white lead. Now obsolete, and superseded by zinc white. At one time it was also called spanish white and bougival white.

Blanc Fixe. Artificial barium sulfate, used as a base for certain lakes and as a white pigment in fresco and watercolor work. It is permanent, but not used in oil painting because it becomes almost transparent in linseed oil. It is also called barium white, baryta white, constant white, enamel white, mineral white, and permanent white.

Bologna Chalk. Slaked plaster of paris.

Bologna Stone. Barytes.

Bougival White. Bismuth white.

Caledonian White. Lead chloro-sulfite. This pigment is now obsolete.

Ceruse. From the Latin *cerussa,* white lead.

Chinese White. A preparation of zinc white for watercolor use, first produced by Winsor and Newton in 1834.

Constant White. Blanc fixe.

Cremnitz White. Also called kremnitz white, or krems white, this

is a special kind of corroded white lead produced by the action of acetic acid and carbon dioxide on litharge.

Dutch White. A term referring to Dutch process white lead. It is also another name for china clay.

Enamel White. Blanc fixe.

English White. Whiting.

Flake White. Basic lead carbonate. It is stable and permanent for oil painting uses if it is well protected by oil, varnish, or overpainting. It will turn brown if exposed to sulfur fumes. Also, oil films of white lead may yellow if they are kept in the dark. They regain their brightness, however, when exposed again to normal light. This pigment is poisonous if taken internally.

Flemish White. White lead.

French White. White lead.

Heavy Spar. Barytes.

Kremnitz White. Cremnitz white.

Krems White. Cremnitz white.

Lime White. Whiting.

Lithopone. A combination of zinc sulfide and barium sulfate (blanc fixe), this material is sometimes used in interior house paints. The material has the defect of turning dark in bright light but becoming white again in darkness. It is seldom used as an artists' pigment. It is also called oleum white and Orr's white.

Magnesia White. A term sometimes used to describe native magnesite, or artificial magnesium carbonate.

Magnesite. A permanent inert pigment, native magnesium carbonate.

Magnesium Carbonate. An artifically made inert pigment.

Mineral White. Blanc fixe.

Mixed White. A mixture of varying percentages of zinc white and white lead.

Oleum White. Lithopone.

Orr's White. Lithopone.

Paris White. Whiting.

Permanent White. Blanc fixe.

Satin White. A combination of calcium sulfate and calcium aluminate. It is used in the manufacture of coated papers and sometimes as a base for lakes.

Silver White. An unstandardized term, sometimes used to describe various mixed whites.

Snow White. Zinc oxide, zinc white.

Spanish White. This term once referred to bismuth white which is now obsolete. It now signifies whiting.

Strontium White. Strontium sulfates, artificial and natural, have the same properties as blanc fixe. For use as a pigment, this material was replaced by the less expensive blanc fixe (barium white).

Sublimed White Lead. Lead sulfate containing zinc. It has better opacity than flake white, but is inferior in other ways.

Terra Alba. A fine grade of ground gypsum or alabaster sometimes used in gesso grounds, also as a filler in paper and paint.

Tin White. Stannic (tin) oxide is used in ceramics to produce an opaque white. It is not used in painting.

Titanium White. A white pigment containing at least 30 percent of titanium dioxide and the balance usually of barium sulfate. It should have no trace of lead. Titanium white has greater hiding power than either white lead or zinc white.

Titanox. A trademarked name for titanium white.

Vienna White. Calcium carbonate made by air-slaking lime, as in the production of bianco sangiovanni.

White Earth. A white clay sometimes used as a base for lakes.

White Lead. Also called flake white and cremnitz white. It is the basic carbonate of lead. It usually contains about 70 percent of lead carbonate and 30 percent of lead hydrate.

Whiting. Chalk. One of the many natural forms of calcium carbonate. It was once used in gesso grounds and now sees use as a filler and adulterant in cheap paints. When mixed with linseed oil and white lead it is called glazier's putty.

Zinc Oxide. Zinc white.

Zinc White. A pigment made from zinc oxide. A pure, cold white that is not poisonous and does not darken on exposure to sulfur fumes. It has less hiding power than white lead. It is called chinese white when used in watercolors. Also called snow white.

Zircon White. Zirconium oxide. It is a pigment used in ceramic glazes, but not in paints.

yellow pigments

Alizarin Yellow. A brownish-yellow material with the same pigment characteristics of alizarin crimson. It is little used.

American Yellow. A variety of chrome yellow.

Antimony Yellow. Naples yellow.

Arsenic Yellow. King's yellow.

Aureolin. Cobalt yellow, or cobalt-potassium nitrate.

Auripigmentum. King's yellow.

Barium Chrome. Barium yellow.

Barium Yellow. Barium chromate. A greenish-yellow pigment produced as an artificial precipitate from neutral potassium chromate and barium chloride. Although low in tinctorial strength, it is permanent, stable, and will not blacken with hydrogen sulfide. It is also called barium chrome, barium yellow, baryta yellow, lemon chrome, lemon yellow, permanent yellow, and yellow ultramarine.

Baryta Yellow. Barium yellow.

Brown Pink. A brownish-yellow lake made from buckthorn berries or bark, or from quercitron bark. It is a fugitive color, similar to Dutch pink.

Cadmium Yellow. Cadmium sulfide. This pigment is made in a variety of shades (deep, medium, and light), all of which are bright, permanent, and very opaque. Cadmium colors were introduced in England around 1850.

Cadmium-Barium Yellow. Cadmium sulfide coprecipitated with barium sulfide. Also called cadmium lithopone, this pigment is also available in a variety of shades (deep, medium, and light), all of which are permanent. These yellows are generally superior in pigment qualities to straight cadmium sulfides, although their tinting strengths may be somewhat lower.

Cassel Yellow. Turner's yellow.

Chamois. An obsolete name for ocher.

Chinese Yellow. King's yellow. It is also a term occasionally applied to bright ochers.

Chrome Yellow. A lead chromate, this pigment is poisonous and even the best grades are not permanent to light. Cadmium yellows are easily substituted for this pigment. It is also called leipzig yellow and paris yellow.

Citron Yellow. Also called mimosa, this pigment is zinc yellow. The term is also applied to other pale greenish-yellow pigments.

Cobalt Yellow. Also called aureolin, this pigment is a cobalt-potassium nitrate. It is a bright, transparent yellow that is permanent for watercolor, tempera, and oil uses. When used in oil painting it is better applied in glazes or tints. It has a dull top tone when used as a body color alone.

Dutch Pink. A yellow lake made from fustic or persian berries with whiting and alum. It is a fugitive pigment and should not be used for permanent painting. It is also called english pink, italian pink, stil-de-grain, and yellow madder.

English Pink. Dutch pink.

English Yellow. Turner's yellow.

Ferrite, Ferrox. Trademarked names for mars yellow.

French Ocher. Yellow ocher.

Gallstone. A lake made from oxgall or, more often, from quercitron. The latter material comes from the inner bark of the black oak. It is not a permanent pigment.

Gamboge. A yellow gum resin produced by trees in India and Siam. It is not reliably permanent.

Giallo Indiano. Indian yellow.

Giallolino. Naples yellow.

Giallorino. Naples yellow.

Golden Ocher. A mixture of ocher and chrome yellow. It is not permanent.

Hansa Yellow. Pigments based on a coupling of a substituted phenyl amine with an aceto-acetanylide. These are permanent, synthetic dyes from which lakes are made. It is also called monolite yellow and pigment yellow. It is regarded as a permanent pigment.

Indian Yellow. A lake pigment made from the urine of cows fed on mango leaves. It is now virtually obsolete, having been replaced largely by hansa yellow. Some synthetic, coal-tar substitutes are occasionally sold under this name. It is also called giallo indiano.

Iron Yellow. Yellow oxide of iron. Synthetic iron oxide yellows are called *mars yellow.*

Italian Pink. Dutch pink.

Jaune Brillant. Naples yellow.

Jaune d'Antimoine. Naples yellow.

Kassler's Yellow. Turner's yellow.

King's Yellow. A bright yellow pigment made from artificially produced arsenic trisulfide. It is very poisonous and not dependably permanent. It was originally made from orpiment, the natural yellow sulfide of arsenic, and is easily replaced by the cadmium yellows or cadmium-barium yellows. It is also called arsenic yellow, auripigmentum, chinese yellow, and royal yellow.

Lead Ocher. Massicot.

Leipzig Yellow. Chrome yellow.

Lemon Chrome. Barium yellow.

Lemon Yellow. Barium yellow.

Litharge. The fused and crystalline oxide formed from the oxidation of molten metallic lead. It is a heavy, yellow powder, obsolete as a paint pigment.

Mars Yellow. Mars pigments are made artificially by precipitating a mixture of a soluble iron salt and alum with an alkali. The proportion of alum used affects the depth of yellow achieved. These pigments are permanent and similar to earth yellows.

Massicot. A pigment produced by gently roasting white lead. It is no longer used for painting purposes. If massicot is subjected to high temperatures it is transformed into litharge, then red lead.

Mercury Yellow. A basic sulfate of mercury, now obsolete as a paint pigment. It is poisonous.

Mimosa. Citron yellow.

Mineral Lake. Stannic (tin) chromate, or a mixture of stannic chromate and oxide, calcined with potassium nitrate. The term is also used occasionally to describe potter's pink.

Mineral Turbith. Turpeth mineral.

Mineral Yellow. Turner's yellow.

Minette. Ocher.

Monolite Yellow. Hansa yellow.

Montpelier Yellow. Turner's yellow.

Naples Yellow. This pigment is a lead antimoniate. It ranges in color from a greenish-yellow to orange and is made by calcining litharge with antimony trioxide. It is permanent, but poisonous. It is also called antimony yellow, giallolino, giallorino, jaune brillant, and jaune d'antimoine.

Ocher. Natural earth colors with a variety of dull yellow shades. They are clays colored by iron oxide and are permanent and opaque. Golden ocher contains chrome yellow and is therefore not a permanent pigment.

Orient Yellow. A deep shade of cadmium yellow.

Orpiment. King's yellow.

Paris Yellow. Chrome yellow.

Patent Yellow. Turner's yellow.

Permanent Yellow. A term usually meaning barium yellow, which is permanent. It also occasionally refers to synthetic colors that are only semipermanent.

Pigment Yellow. Hansa yellow.

Primrose Yellow. A nonstandardized term applied to any pale shade of yellow.

Puree; Pwree. Crude indian yellow.

Realgar. See ORANGE PIGMENTS.

Risalgallo. Realgar.

Royal Yellow. King's yellow.

Saffron. A dye rather than a pigment, this material is extracted from the dried stigmas of the crocus flower. It is a bright yellow color but fades badly in sunlight.

Sil. Native yellow ocher.

Stil-de-Grain. Dutch pink.

Strontium Yellow. Strontium chromate. It is similar to barium yellow as they are both lemon hues. Strontium yellow is a little deeper in tint, however, and has better hiding power. It is a permanent pigment.

Terra Merita. An obsolete yellow lake made from saffron or curcuma root. It is a fugitive color.

Turbith. Turpeth mineral.

Turner's Yellow. An obsolete lead oxychloride pigment patented in England in 1781 by James Turner. It is not permanent and turns black with age. It is also called cassel yellow, english yellow, Kassler's yellow, mineral yellow, montpelier yellow, patent yellow, and verona yellow.

Turpeth Mineral. A highly poisonous sulfate of mercury. Like Turner's yellow, it turns black with age and is not permanent. It is no longer used. A poisonous pigment, it is also called mineral turbith, and turbith.

Ultramarine Yellow. Ultramarine pigments other than blue can be produced by the same process, but they are very pale and find few applications in painting.

Uranium Yellow. Uranium oxide, now obsolete as a pigment. It was also used in ceramics.

Verona Yellow. Turner's yellow.

Weld. An obsolete yellow color obtained from herbs.

Yellow Carmine. An olive-yellow vegetable lake. It is transparent and fugitive.

Yellow Earth. A variety of yellow ocher.

Yellow Lake. Lakes made from aniline dyes. Some are fugitive and others are semipermanent. They are often used in printing inks.

Yellow Madder. Dutch pink.

Yellow Ocher. A form of ocher, the color is caused by the presence of various hydrated forms of iron oxide. It is also called french ocher.

Yellow Oxide of Iron. An artificially produced pigment. Mars yellow.

Yellow Ultramarine. An obsolete name for barium yellow.

Zinc Chrome. Zinc yellow.

Zinc Yellow. Zinc chromate. A greenish-yellow pigment that is permanent, but poisonous. It is also called citron yellow.

orange pigments

Antimony Orange. Antimony trisulfide. A pigment that is permanent to light, but usually contains sulfur that blackens other pigments containing lead. Replaced in painting by cadmium colors.

Arsenic Orange. See REALGAR *in this section.*

Cadmium Orange. Cadmium sulfide, or cadmium sulfoselenide. A stable and permanent pigment.

Cadmium-Barium Orange. Also called cadmium orange lithopone, this pigment is cadmium sulfide, or cadmium sulfoselenide, coprecipitated with barium sulfate. It is a stable and permanent pigment.

Chrome Orange. An orange shade of lead chromate. It is not permanent and can be replaced easily with cadmium orange.

Indo Orange. Halogenated anthanthrone, a recently developed organic pigment. In water-vehicle paints some tests indicate that this pigment has a permanency greater than alizarin.

Neutral Orange. A mixed color, usually of cadmiums and red oxide.

Orange Chrome Yellow. Chrome orange.

Orange Mineral. Lead oxide. Similar to red lead but more yellowish in color. It is not used as an artists' pigment.

Orange Vermilion. A variety of true vermilion.

Persian Orange. A lake made with an aniline dye. It is not permanent.

Realgar. A natural orange-red sulfide of arsenic. It is related to orpiment, also a sulfide of arsenic, and is poisonous and not reliably permanent.

red pigments

Alizarin Crimson. A pigment made from a coal-tar derivative, 1-2-dihydroxy anthraquinone and aluminum hydroxide. Among the few organic colors that are on approved lists for permanency. It was the first of the natural dyestuffs to be produced synthetically on a large scale, replacing *madder.* Alizarin crimson is more lightfast than madder lake.

Amatito. A pigment made from red hematite and once used for fresco painting.

American Vermilion. An opaque organic lake usually made with eosine or scarlet dye. It is not permanent.

Antimony Vermilion. Antimony trisulfide. Obsolete for artistic purposes and replaced by cadmiums.

Antwerp Red. Light red.

Armenian Bole. A native red oxide. *See* VENETIAN RED *in this section.*

Bole. Various native red oxides of iron.

Brazilwood Lake. A lake made from a blood-red extract of brazilwood. It is not permanent.

Brilliant Scarlet. Iodine scarlet.

Burnt Carmine. A variety of carmine. It is not permanent.

Burnt Ocher. Ocher heated until it has become brick red. It is permanent.

Cadmium Red. Cadmium sulfoselenide. Strongly colored pigments made in a variety of shades (deep, medium, and light), all of which are permanent. A very popular and widely used pigment.

Cadmium-Barium Red. Cadmium sulfoselenide coprecipitated with barium sulfate. Also called cadmium red lithopone, this pigment is made in a variety of shades (deep, medium, and light), all of which are permanent.

Caput Mortuum. The obsolete term describing a bluish-red oxide of iron.

Carmine Lake. A lake made from cochineal. It is not permanent to light and has a tendency to turn brown. It is also called munich lake.

Carthame. Safflower.

Chinese Red. (1) Chrome red. (2) Chinese vermilion. (3) Red oxide.

Chinese Vermilion. Genuine vermilion made in China.

Chrome Red. A basic red chromate made by boiling potassium dichromate with white lead and caustic soda. It is only moderately stable and is affected by sulfur gases. It sees little use as an artists' pigment and is easily replaced by cadmium colors. It is also called chinese red and derby red.

Cinnabar. Red mercuric sulfide. It is closely related to the artificially made material, vermilion (made by combining mercury and sulfur). It is now considered to be obsolete.

Cochineal. A dyestuff made from the insect *Coccus cacti,* native to Mexico, Central and South America. When precipitated as a lake it is called carmine lake and crimson lake. These colors are not stable to light and are not used in permanent painting.

Colcothar. An obsolete term for red oxide.

Crimson Lake. A lake pigment made from cochineal. It is also called florentine lake. It is not permanent.

Derby Red. Chrome red.

Dragon's Blood. A resin rather than a pigment, this material is not

permanent, but finds wide usage in the graphic arts, particularly photoengraving.

English Red. Light red.

English Vermilion. Genuine vermilion made in England.

Eosine. The potassium salt of tetrabromofluorescein. Once used for making red inks. It is not permanent, and neither is *geranium lake,* which is eosine precipitated on an aluminum hydrate base.

Fire Red. A nonstandardized term. Sometimes it refers to toluidine reds.

Florentine Lake. Crimson lake.

Garance, Garancine. Madder lake.

Geranium Lake. A lake pigment made from eosine. Also a lake made from an aniline dye. Neither is permanent.

Gulf Red. Persian Gulf oxide.

Harrison Red. A trade name that refers to lithol reds and para reds precipitated as lakes. Not a permanent pigment.

Imitation Vermilion. Victoria red.

Indian Lake. Lac.

Indian Red. A term that once referred to a variety of natural red iron oxides that came from India. The term now refers to pigments made artificially by calcining copperas. Rouge, colcothar, and caput mortuum all stand for the same pigment.

Iodine Scarlet. Mercuric iodide, which is very poisonous. It fades to a pale yellow after being exposed to light. It is also called brilliant scarlet.

Kermes. An obsolete lake, and one of the most ancient of the natural dyestuffs. Well known to the Romans, the material was produced from the dried bodies of insects found on the kermes oak, native to southern Europe.

Lac. A resin with a deep, brownish-red color, similar to the secretion from which shellac is made. It is not permanent and is now obsolete, having been replaced by alizarin.

Light Red. This term originally meant a pigment produced by calcining yellow ocher to a light, warm red. It now refers to the oxides of the mars or english red variety. The latter are brighter and more powerful, but both are equally permanent. It is also called antwerp red, english red, and prussian red.

Lithol Red. A cherry-red aniline pigment used in industrial paints and inks, but not used for permanent painting.

Madder. A natural dye prepared from madder root. The coloring matter is alizarin. This dye has been employed since Egyptian times.

Magenta. Also called *fuchsin,* this is a fugitive lake made from aniline dyes.

Mahogany Lake. A red or brown lake made on a base of burnt sienna. It is not permanent.

Mars Red. This pigment is artificial ocher and consists chiefly of

iron and manganese oxides. When mars yellow is heated, numerous orange, red, and violet colors are produced. They are all permanent.

Minium. Red lead. A bright red color produced by roasting litharge or white lead for long periods. In very early times the term "minium" was also applied to cinnabar, the natural sulfide of mercury. At some point in the Middle Ages minium came to be associated only with red lead. It is not a stable pigment.

Morelle Salt. Manufactured red oxide.

Munich Lake. Carmine lake.

Nacaret Carmine. Now obsolete, this referred to the best grade of carmine.

Naphthol ITR, Light and Crimson. Naphthol red pigments in the type known as "ITR" are brilliant, strong, and quite resistant to fading.

Para Red. Paranitraniline toners or lakes. Cherry red pigments used for industrial applications but not used in permanent painting.

Persian Gulf Oxide. A red oxide of iron native to the Persian Gulf area. It usually contains 25 percent silica.

Persian Red. Light red.

Poliment. Bole. Natural red oxide.

Pompeian Red. A variety of indian red.

Potter's Pink. So-called because it is used in ceramics. It is a permanent pink pigment produced by roasting stannic (tin) oxide and other metallic oxides. It has low tinctorial strength. It is also used by fresco painters.

Pozzuoli Red. A native red iron oxide from Pozzuoli, near Naples. The term also refers to a kind of clay or natural cement that sets in a hard mass when mixed with water.

Prussian Red. Light red.

Pure Scarlet. Iodine scarlet.

Quinacridone Red. A number of shades of red, magenta, and violet made from linear quinacridone compounds. They have very good lightfastness. These pigments are under consideration for possible future acceptance as standard colors by the U.S. Department of Commerce in its *Commercial Standard for Artists' Oil Paints.*

Red Lead. Red tetroxide of lead. Also called minium, it darkens on exposure to light.

Red Ocher. Venetian red. A red iron oxide, the *sinopia* of antiquity.

Red Oxide. Manufactured iron oxide. Pigments range from yellowish to bluish tones of red, and all have good opacity and absolute permanence.

Rose Madder. A weak grade of madder or alizarin lake.

Rose Pink. A brazilwood lake that is weak and fugitive.

Royal Red. An eosine lake that fades rapidly.

Rubens Madder. Alizarin brown.

Safflower. A red lake made from the petals of the safflower plant. It is a fugitive color.

Sanguine. A red the color of blood. It is made from red hematite and is permanent.

Saturnine Red. Red lead.

Scarlet Lake. Cochineal lakes and vermilion, also aniline lakes. These are not permanent colors.

Scarlet Vermilion. Vermilion.

Selenium Red. Cadmium red.

Signal Red. A variety of para red, a synthetic diazo dyestuff.

Sinopia. Red ocher. Also called sinope, or sinoper, this is the ancient name for native red iron oxides.

Solferino. Magenta.

Spanish Red Oxide. Venetian red. Red iron oxide.

Terra Cotta. A color imitating the natural appearance of terra cotta clay, composed of a mixture of red oxide, burnt umber, and a white material such as chalk or zinc oxide.

Terra Rosa. Venetian red.

Toluidine Red. Toluidine toner. One of the most permanent of the synthetic, organic dyestuffs.

Turkey Red. Native red oxide. A term that is also applied to madder-dyed textiles.

Tuscan Red. A red iron oxide brightened with alizarin. If not made with indian red and alizarin, it is not permanent. For industrial purposes, aniline colors are sometimes used.

Ultramarine Red. A pigment made by the ultramarine process. It is little used.

Van Dyke Red. Copper ferrocyanide. It is poisonous and darkens when exposed to sulfur fumes.

Venetian Red. This term once referred to a native red iron oxide. It now means an artificially produced material made by calcining copperas and whiting.

Venice Red. Venetian red.

Vermilion. Red mercuric sulfide. The natural sulfide is called cinnabar. Vermilion is produced artificially by heating a mixture of mercury and sulfur. It is not reliably permanent since some grades are apt to turn black.

Victoria Red. A pigment made on a base of red lead. It is fairly stable to light. Also called imitation vermilion.

Vienna Lake. Carmine.

Zinnober. Another name for vermilion.

violet pigments

Alizarin Violet. A pigment similar to alizarin crimson, but one that is not reliably permanent. It is also called violet madder lake.

Burgundy Violet. Manganese violet.

Byzantium Purple. Tyrian purple.

Cobalt Violet. Anhydrous cobalt phosphate or arsenate, the latter being poisonous. A permanent, semiopaque pigment made in several shades, both reddish and bluish. It is weak in tinting strength.

Dioxazime Purple. Dioxazime carbasole, a recently developed organic color with good light-resistance.

Folium. An obsolete term referring to violet or purple lakes of vegetable origin.

Grecian Purple. Tyrian purple.

Manganese Violet. Manganese ammonium phosphate. It is permanent but weak in tinting strength and hiding power. It is also called burgundy violet and permanent violet.

Mars Violet. An artificial iron oxide color made by heating mars yellow. It is permanent.

Mauve. An organic dyestuff made from aniline, the first ever made synthetically. It is a fugitive color.

Mineral Violet. Ultramarine violet. Also a term meaning manganese violet.

Ostrum. The Roman name for tyrian purple.

Permanent Violet. Manganese violet.

Purple of the Ancients. Tyrian purple.

Thioindigo Violet. Also called thioindigoid pigment and thiosa fast red, this aniline material has been available for some time. A type has been developed for painting use that is exceptionally fast to light.

Tyrian Purple. An organic dye prepared from mollusks in ancient times. It was the imperial purple used by the Romans. In addition to its use as a textile dye, it was used in the preparation of purple ink and for dyeing parchments. It is now obsolete as a pigment.

Ultramarine Violet. A pigment made by heating a mixture of soda ultramarine blue with sal ammoniac. It is one of the few violets that can be used in fresco painting. It is seldom used in oil painting because it has poor covering power.

Vegetable Violet. A very fugitive lake made from logwood.

Violet Carmine. A fugitive lake made from tropical woods. It first turns brown, then colorless.

Violet Madder Lake. Alizarin violet.

Violet Ultramarine. Ultramarine violet.

blue pigments

Academy Blue. A mixed color, usually ultramarine and viridian.

Alexandrian Blue. Egyptian blue.

Alizarin Blue. A lake pigment similar to alizarin violet in composition. It is not a permanent pigment as it has a tendency to turn dark on continued exposure to light.

Antwerp Blue. A pale variety of prussian blue. It is not used in permanent painting.

Azure Blue. (1) Cobalt blue. (2) Smalt. (3) A general term meaning a sky-blue color.

Azurite. A native copper carbonate. It is a clear, deep blue. It is permanent and has been used since ancient times. Since it works poorly with oil, it is now seldom used. Artificially prepared blues

have taken its place. It is also known as blue malachite and chessylite.

Berlin Blue. Prussian blue.

Biadetto. An Italian term synonymous with bice, or bremen blue.

Bice. Bremen blue.

Bleu Celeste. Cerulean blue.

Blue Ashes. Bremen blue.

Blue Bice. Bremen blue.

Blue Malachite. Azurite.

Blue Verditer. Bremen blue.

Bremen Blue. An artificial copper carbonate made since the beginning of the Middle Ages. It is chemically similar to azurite. A number of shades are produced, all of which are poisonous and not intended for permanent painting. They have been replaced by ultramarine pigments. Other names for this pigment include bice, blue bice, blue verditer, copper blue, mountain blue, neuwied blue, and water blue.

Bronze Blue. A variety of prussian blue.

Brunswick Blue. A variety of prussian blue, not used for permanent painting.

Celestial Blue. A variety of prussian blue, not used for permanent painting.

Cerulean Blue. Cobaltous stannate, a compound of cobalt and tin oxides. It is the only cobalt blue without a violet tint. It is stable, opaque, and permanent for all uses. It is also called bleu celeste and coelin.

Chessylite. Azurite.

Chinese Blue. A variety of prussian blue.

Cobalt Blue. A pigment made from the combined oxides of cobalt and aluminum, this is a bright, transparent blue with a slight greenish undertone. It is absolutely permanent. Other names for this pigment are hungary blue, king's blue, Leithner's blue, leyden blue, new blue, Thenard's blue, and vienna blue.

Cobalt Ultramarine. An outmoded variety of cobalt blue. Also called Gahn's blue.

Coelin. Cerulean blue.

Coerulium. Egyptian blue.

Copper Blue. Bremen blue.

Copper Glass. Egyptian blue.

Cyanine Blue. The name of an aniline dye. Also a term describing a mixture of cobalt and prussian blues.

Dumont's Blue. Smalt.

Egyptian Blue. An ancient artificial pigment made from copper silicates. It is similar in appearance to finely ground azurite. It is also called alexandrian blue, coerulium, copper glass, italian blue, pompeian blue, pozzuoli blue, and vestorian blue.

Eschel. A variety of smalt.

French Ultramarine Blue. Artificial ultramarine, having the same chemical composition as ultramarine made from lapis lazuli.

Frit. A vitreous material made by melting siliceous materials with copper. It also refers to a ceramic glaze which may be white or colorless.

Gahn's Blue. Cobalt ultramarine.

Gmelin's Blue. Artificial ultramarine.

Haarlem Blue. A pale variety of prussian blue.

Hungary blue. Cobalt blue.

Indian Blue. Indigo.

Indigo. One of the oldest organic blue colors, first developed in the Far East. It comes from plants of the genus *Indigofera,* and also woad (*Isatis tinctoria*). When used as a pigment it was not precipitated on a base, but used as a fine powder mixed with different mediums. It is not permanent in either its natural or synthetic forms.

Iron Blue. Prussian blue.

Italian Blue. Egyptian blue. Sometimes the term describes a blue lake (called also venetian blue and turquoise blue) that is not stable or permanent.

King's Blue. Cobalt blue.

Lapis Lazuli. A semiprecious stone pulverized to produce genuine ultramarine blue.

Lazuline Blue. Native ultramarine.

Leithner's Blue. A variety of cobalt blue.

Leyden Blue. A variety of cobalt blue.

Lime Blue. Bremen blue.

Manganese Blue. A pigment made from barium manganate with barium sulfate. A greenish-blue, it is stable and permanent, but is weak in hiding power.

Milori Blue. A term referring to the highest grades of prussian blue.

Mineral Blue. A nonstandardized term that may refer to azurite, manganese blue, or antwerp blue.

Mountain Blue. Bremen blue.

Neuwied Blue. Bremen blue.

New Blue. A variety of cobalt blue. Also a term to designate certain shades of ultramarine.

Paris Blue. Prussian blue.

Paste Blue. Prussian blue.

Permanent Blue. A nonstandardized term. It is sometimes used to describe ultramarine colors.

Phthalocyanine Blue. A pigment made from copper phthalocyanine, a synthetic organic dyestuff. A greenish-blue permanent pigment of intense color. It has a tinctorial strength twice that of prussian blue.

Pompeian Blue. Egyptian blue.

Pozzuoli Blue. Egyptian blue.

Prussian Blue. Ferric ferrocyanide. A greenish-blue permanent pigment, the first blue pigment to be made synthetically on any scale. A great many shades exist and the pigment is known by many names. Some of the varieties are antwerp blue, berlin blue, bronze blue, brunswick blue, celestial blue, chinese blue, iron blue, milori blue, paste blue, paris blue, soluble blue, and steel blue.

Royal Blue. A nonstandardized term used in the past to describe smalt, artificial ultramarine, and aniline lakes.

Saxon Blue. Smalt.

Sky Blue. A variety of pale artificial ultramarine.

Smalt. A variety of cobalt blue glass. It was made by adding cobaltous oxide to molten glass. The material was then cooled and ground. Since it is a glass, it has poor hiding power and will loose its color altogether if ground too finely. It finds a certain amount of use in ceramics. It is also called azure blue, Dumont's blue, eschel, and saxon blue.

Soluble Blue. A water-soluble variety of prussian blue.

Steel Blue. Prussian blue.

Thalo Blue. Phthalocyanine blue.

Thenard's Blue. Cobalt blue.

Turnbull's Blue. Not used as a pigment, this is a color produced at one stage of a process used to manufacture prussian blue.

Ultramarine Blue. A natural variety of ultramarine blue was made by grinding and powdering the semiprecious stone, lapis lazuli. The artificial material is the same as lapis lazuli in structure and chemical composition. Both are permanent. It is made artificially by fusing together potash, silica, and cobalt oxide. The blue glass thus produced is ground to powder form. Sometimes the artificial variety is called french ultramarine, because of the discovery and production of the material in France.

Vestorian Blue. Egyptian blue.

Vienna Blue. A variety of cobalt blue.

Water Blue. Bremen blue.

Windsor Blue. A trademarked name for phthalocyanine blue.

Woad. A blue dye chemically identical to indigo. It is obtained from the woad plant. It is not lightfast and is no longer used as a pigment.

Zaffer, Zaffre. Smalt in a stage before its final process. Cobaltous oxide.

green pigments

Aerugo. Verdigris.

Alizarin Green. Similar to alizarin crimson, but not used in permanent painting. It is a lake that turns very dark on exposure to light.

Arnaudon's Green. A variety of chromium oxide green.

Baryta Green. Manganese green.

Bladder Green. Sap green.

Bohemian Earth. Green earth.

Bremen Green. Green varieties of bremen blue.

Brunswick Green. A chrome green made from brunswick blue and chrome yellow. Not a permanent pigment.

Casali's Green. A variety of viridian.

Cassel Green. Manganese green.

Celadon Green. A permanent pigment containing the mineral celadonite, an iron silicate. It is a form of green earth.

Chrome Green. A mixture of prussian blue and chrome yellow. It is not a permanent pigment. It is also known as cinnabar green, leaf green, leek green, moss green, myrtle green, nitrate green, oil green, olive green, and royal green. In England, chrome green refers to viridian, which is a permanent pigment.

Chromium Oxide Green. Anhydrous chromic oxide. It is permanent for all purposes. It is opaque and dull, and not as popular as the transparent oxide, *viridian.* It is also called Dingler's green, Plessy's green, and Schnitzer's green.

Chrysocolla. A native green copper silicate.

Cinnabar Green. Chrome green.

Cobalt Green. A pigment made from the combined oxides of zinc and cobalt. An opaque, bright green, it is permanent for all uses. It is also called Gellert green and Rinman's green.

Copper Carbonate. Vert antique.

Copper Green. A variety of bremen blue.

Dingler's Green. A variety of chromium oxide green.

Egyptian Green. A greenish shade of egyptian blue.

Emerald Chromium Oxide. Viridian.

Emerald Green. An artificial pigment, aceto-arsenate. It is sometimes called schweinfurt green, after its place of discovery in Germany. It is identical with the insecticide, paris green. It is not lightproof and is very poisonous. It is blackened by sulfur-bearing pigments. It is also called english green, mittis green, Scheele's green, swedish green, and vienna green.

English Green. Emerald green.

French Veronese Green. Viridian.

Gellert Green. A variety of cobalt green.

Green Bice. Green earth. Also bremen green.

Green Earth. Natural earth consisting chiefly of the hydrous silicates of iron, aluminum, magnesium, and potassium. The shade of this pigment varies from a grayish green to a yellow green. It has low tinctorial power, but is very stable and permanent. It is also called bohemian earth, celadon green, holly green, stone green, terre verte, verdetta, and verona green.

Green Ultramarine. A greenish variety of ultramarine blue.

Green Verditer. A greenish variety of bremen blue.

Guignet's Green. Viridian.

Holly Green. Green earth.

Hooker's Green. A mixture of prussian blue and gamboge. It is not a permanent color because the gamboge is not lightfast and the mixture turns blue. A modern version made of phthalocyanine blue and cadmium yellow is permanent.

Horace Vernet Green. A green variety of bremen blue.

Hungarian Green. Malachite.

Iris Green. An obsolete organic dyestuff made by mixing the juice of the iris flower with alum. It was extensively used for manuscript illumination.

Leaf Green. Chrome green.

Leek Green. Chrome green.

Malachite. A natural basic copper carbonate, similar in composition to azurite. It is no longer used as a pigment. It is also called hungarian green, mineral green, mountain green, and verdeazzuro.

Manganese Green. A greenish variety of manganese blue. It is permanent but has poor hiding power. It is also referred to as baryta green, cassel green, and Rosenstiehl's green.

Mineral Green. Malachite.

Mittis Green. A variety of emerald green.

Mittler's Green. A variety of viridian.

Montpelier Green. Verdigris.

Moss Green. Chrome green.

Mountain Green. Malachite.

Myrtle Green. Chrome green.

Native Green. Native chromium oxide.

Nitrate Green. A bluish variety of chrome green.

Oil Green. A variety of chrome green.

Olive Green. A nonstandardized term, usually applied to varieties of chrome greens.

Pannetier's Green. Viridian.

Paris Green. Emerald green, which is identical to the insecticide.

Permanent Green. A nonstandardized term. Victoria green.

Phthalocyanine Green. A pigment made from copper phthalocyanine, a synthetic organic dyestuff. It is an intense, permanent pigment.

Plessy's Green. A variety of chromium oxide green.

Prussian Green. Brunswick green.

Rinman's Green. Cobalt green.

Rosenstiehl's Green. Manganese green.

Royal Green. Chrome green.

Sap Green. A lake made from buckthorn berries and alum. It is a fugitive color. It is also called bladder green and verde vessie.

Scheele's Green. Emerald green.

Schnitzer's Green. A variety of chromium oxide green.

Schweinfurt Green. Emerald green.

Smarago Green. Viridian.

Spanish Green. Verdigris.

Stone Green. Green earth.

Swedish Green. Emerald green.

Terre Verte. Green earth.

Titanium Green. A pigment made with titanium or with a mixture of iron and titanium compounds. It is no longer in use.

Transparent Copper Green. An obsolete pigment made of a fused copper resinate.

Transparent Oxide of Chromium. Viridian.

Turquoise Green. A pale, bluish-green compound of aluminum, chromium, and cobalt oxides. It is permanent and finds a certain amount of use in ceramics.

Verdeazzuro. Malachite.

Verderame. Verdigris.

Verdet. Poisonous copper acetate, formerly used in watercolor painting. Verdigris.

Verdetta. Green earth.

Verde Vessie. Sap green.

Verdigris. Pigments made from copper acetate, and from the blue or green corrosion products from copper, brass, and bronze. It is poisonous, reactive, and unstable. It is not used in permanent painting. It is also called aerugo, montpelier green, spanish green, verderame, verdet, and viride aeris.

Vernalis. A pigment made by heating chalk and viridian. It is permanent and used as a ceramic pigment.

Vernet Green. A green variety of bremen blue.

Verona Green. Green earth.

Veronese Green. A term meaning variously emerald green, chrome green, viridian, and verona green.

Vert Antique. A copper carbonate pigment, not used for permanent painting. It is chemically identical to the patina of copper and bronze. It is poisonous.

Vert Emeraude. Viridian.

Victoria Green. A pigment made from viridian and zinc yellow. It is not used in permanent painting.

Vienna Green. Mittis green, a variety of emerald green.

Viride Aeris. Verdigris.

Viridian. Hydrous chromic oxide. A transparent, cool green that is permanent for all uses. The opaque equivalent to viridian is chromium oxide green. Viridian is also known as Casali's green, emerald chromium oxide, french veronese green, Guignet's green, Mittler's green, Pannetier's green, smarago green, transparent oxide of chromium, and vert emeraude.

Zinc Green. A pigment made from the oxides of zinc and cobalt. It is a permanent pigment, also known as cobalt green.

brown pigments

Alizarin Brown. A transparent brown with properties identical with alizarin crimson. A permanent pigment, it is also called Rubens madder.

Asphaltum. Also called bitumen, this is a brownish-black mixture of hydrocarbons. This material, and other tarry petroleum compounds, were once used extensively in painting. They have the defect, however, of never completely drying. They cause crawling, wrinkling, and cracking of paint films, and should never be used.

Bistre. Similar to asphaltum in composition, this material is made from the tarry soot of burned, resinous wood. It is an unstable pigment and not used in permanent painting. It is also called brown lampblack.

Bitumen. Asphaltum.

Bone Brown. Made in the same general way as bone black, this pigment consists of partially charred organic matter. It is not permanent.

Brown Lampblack. Bistre.

Brown Ocher. A variety of ocher.

Burnt Green Earth. A deep, permanent brown. It is also called transparent brown and verona brown.

Burnt Sienna. Iron oxide prepared by calcining the natural earth, raw sienna. It is a warm, reddish-brown color and permanent in all processes.

Burnt Umber. Iron oxide and manganese dioxide pigment prepared by calcining raw umber. It is warmer and redder than raw umber, and somewhat more transparent. It is a permanent pigment variously known as euchrome, jacaranta brown, mineral brown, and spanish brown.

Caledonian Brown. A native earth consisting of hydrated oxides of manganese and iron, and similar in color to burnt sienna. It is permanent.

Cappagh Brown. A native earth found in Ireland. The color is similar to raw umber. It is a permanent pigment.

Cashew Lake. Mahogany lake.

Cassel Brown. Cassel earth.

Cassel Earth. A native earth containing organic matter such as lignite. It is not a permanent pigment. It is similar to van dyke brown.

Chestnut Brown. Umber.

Cologne Earth. Cassel earth.

Cyprus Umber. Raw umber from the island of Cyprus. Also called turkey umber.

Egyptian Brown. Mummy.

Euchrome. Burnt umber.

Fawn Brown. A combination of raw or burnt umber with dark ocher. It is a permanent mixture, and also called velvet brown.

Florentine Brown. A brown shade of van dyke red, it blackens if exposed to sulfur fumes. It is also called Hatchett's brown.

Garance Brun Rouge. A lake color made from the madder root. It is not a permanent pigment.

Garanze Roja Parda. Garance brun rouge.

Hatchett's Brown. Florentine brown.

Iron Brown. Prussian brown.

Italian Earth. Sienna.

Jacaranta Brown. Burnt umber.

Madder Brown. Garance brun rouge.

Mahogany Brown. The name given burnt umber and dark shades of burnt sienna when they are used as mahogany oil stains.

Mahogany Lake. Also called cashew lake, this is a brown lake made on a base of burnt sienna. It is not permanent.

Manganese Brown. A variety of manganese dioxide. It is permanent.

Mars Brown. Artificial ocher consisting chiefly of iron and manganese oxides. It is permanent.

Mineral Brown. Burnt umber.

Mummy. An obsolete pigment made by grinding up Egyptian mummies. The brown color was a result of asphaltum having been used in the embalming process. It is also called egyptian brown.

Prussian Brown. Also known as iron brown, this pigment consists of ferrous hydroxide. It is permanent but seldom used. It was once made by burning prussian blue.

Raw Sienna. Natural earth that consists chiefly of the hydrous silicates and oxides of iron and aluminum. It is absolutely permanent.

Raw Umber. Natural earth that consists chiefly of the hydrous oxides and silicates of iron and manganese. It is absolutely permanent. It is also called terra ombre.

Roman Ocher. A variety of ocher.

Rubens Madder. Alizarin brown.

Sepia. The brown coloring material taken from the ink sacs of cuttlefish or squid. It is used as an ink and as a watercolor paint, but it is not entirely lightfast.

Sicilian Brown. Umber.

Sienna. See RAW SIENNA *and* BURNT SIENNA *in this section.*

Spanish Brown. Burnt umber.

Terra Ombre. Raw umber.

Transparent Brown. Burnt green earth.

Turkey Brown, Turkey Umber. Raw umber from the island of Cyprus. One of the best varieties of umber.

Umber. See RAW UMBER *and* BURNT UMBER *in this section.*

Van Dyke Brown. A native earth containing such organic materials as lignite or brown coal. It has the same defects as asphaltum, and is not permanent.

Velvet Brown. Fawn brown.

Verona Brown. Burnt green earth.

black pigments

Acetylene Black. Carbon black.

Atramentum. The Roman name for carbon black.

Benzol Black. Carbon black.

Black Lead. Graphite.

Black Oxide of Cobalt. Not used as a pigment in paints, but as a glaze in ceramics. It produces a deep blue-black color. It is also called cobalt black.

Black Oxide of Iron. Mars black.

Black Oxide of Manganese. A brownish-black material no longer used as a pigment.

Blue Black. Vine black.

Bone Black. A carbon-black material made by charring bones. It should not be used in fresco work because it causes efflorescence. It has a brownish undertone, and is also called paris black.

Carbon Black. Pure carbon made by burning natural gas. It is absolutely permanent. Very often other pigments such as lampblack, ivory black, etc., are referred to as carbon blacks. Acetylene and benzol blacks are produced by burning those materials instead of natural gas. The blacks produced are somewhat bluer in tone.

Charcoal Gray. An obsolete gray-black powder made from charcoal. It is not suitable for permanent painting.

Cobalt Black. Black oxide of cobalt.

Coke Black. Vine black.

Cork Black. Spanish black.

Davy's Gray. Powdered slate.

Diamond Black. Carbon black.

Drop Black. Vine black.

Flame Black. Produced by burning coal tar and various oils. It is brownish in color and apt to contain oily impurities that make it unsuitable for artistic use.

Frankfurt Black. Vine black.

Gas Black. Carbon Black.

German Black. Vine black.

Grape Black. Vine black.

Graphite. A form of pure carbon that is grayish black and has a greasy texture. It is entirely permanent, but seldom used as a pigment in paint. It is widely used in pencils. At one time it was confused with lead.

Iron Black. Precipitated metallic antimony. It is not used as a pigment.

Ivory Black. Amorphous carbon produced by charring animal bones. Most of the pigment used today is a high-grade bone black, but true ivory black was made by charring ivory scraps. It is a permanent pigment.

Kernal Black. Vine black.

Lampblack. A nearly pure amorphous form of carbon made from the condensed smoke of a luminous flame. It is the most widely used of all the black pigments and is permanent for all painting purposes.

Manganese Black. Black oxide of manganese, a permanent pigment but seldom used.

Manganese Dioxide. Manganese black.

Marc Black. Vine black.

Mars Black. Ferro-ferric oxide. A dense, opaque pigment, permanent for all purposes. It is also called black oxide of iron.

Mineral Black. A term sometimes applied to graphite, also to native black iron oxide.

Mineral Gray. Ultramarine ash.

Neutral Tint. A watercolor pigment consisting of india ink, phthalocyanine blue, and a small quantity of alizarin crimson.

Oil Black. Lampblack.

Paris Black. Bone black.

Payne's Gray. A watercolor pigment consisting of ivory black, ultramarine blue, and ocher. It is a permanent pigment and also known as *gris de payne* and *grigio di payne.*

Pine Soot Black. A variety of lampblack.

Plumbago. Graphite.

Slate Black. Powdered slate or shale. A grayish black with low tinting power. It is permanent but little used.

Spanish Black. Charcoal made from cork, and also called cork black.

Ultramarine Ash. A bluish gray pigment made by crushing lapis lazuli with the gray rock in which it is found. It is permanent.

Vine Black. A pigment made by carbonizing vine twigs or vine wood. It has a blue hue and is permanent. It is not used in fresco, or in tinting cement or mortar, because it will effloresce. It is also called blue black, coke black, drop black, frankfurt black, german black, grape black, kernal black, and marc black.

planographic processes Nonrelief printing processes (such as aquatone, collotype, and lithography), in which the areas of the plate to receive ink are on the same level or plane as those that remain uninked.

plaster coloring Plaster casts can be tinted to resemble metal and terra cotta by the application of oil paint. A coat of shellac is first applied to act as a sealer. When this has dried, various combinations of green and brown oil paint can be applied to imitate patinas. If a more metallic effect is desired, various metallic powders can be applied to the high spots of the casting. When the paint is dry, a coat of furniture wax can be applied.

Plaster can also be colored with small amounts of dry pigment when it is mixed.

plaster of paris This material is calcined gypsum, and when mixed with water it solidifies into a hydrated calcium sulfate. It is useful for making ornaments and casts.

For a good consistency in casting plaster, about 2 parts water is mixed with 3 parts plaster. For a small amount, pour $\frac{2}{3}$ cup of water in a container and slowly sift 1 cup of plaster into the water until a small hill appears above the water line. The more evenly the plaster is sifted, the stronger will be the mix. Use the fingers to stir the mixture until it is evenly mixed. Then tap the bowl briskly and allow to stand for one minute, but no longer. It may then be used.

The addition of one-quarter of 1 percent of hide glue to plaster of paris will retard its setting for two hours. Mucilage or fish glue will have the same effect. Slow- and medium-setting plasters can be purchased with the retarding material already added.

The addition of a small amount of salt will accelerate the setting of plaster of paris.

It is a good idea to mix plaster in a flexible container, such as a plastic dishpan. If any plaster sets against the surface, the container can be bent and the plaster will pop off.

plasticizers Substances added to paints and varnishes to eliminate brittleness or to impart flexibility. They may also improve the brushing qualities of a paint. For permanent painting purposes, plasticizers should be nonvolatile.

plastics Plastics are synthetic organic materials that fall into two basic groups. The thermo*plastic* materials become soft when exposed to heat and harden when cooled. They can be softened and resoftened without undergoing physical changes. Thermo*setting* plastics undergo chemical changes during forming and their solidification is an irreversible process. They can never be resoftened.

For information about water-base plastic materials used in painting, see SYNTHETIC RESIN MATERIALS.

Following is a list of the more familiar plastics commercially available.

ABS plastics (acrylonitrile-butadiene-styrene). Tough, strong thermoplastic materials used for such things as football helmets, tool handles, battery cases, and pipe. They are available as powder or granules for injection molding, extrusion and calendering, and as sheets for vacuum forming. They were developed in 1948.

acetal resin. A rigid thermoplastic material used in such applications as carburetor parts, gears, bearings and bushings, and moving

parts in business machines. It is made in powder form for molding and extrusion. It was developed in 1956.

acrylic (polymethyl methacrylate) plastics. Thermoplastic materials with good optical clarity and a number of other excellent characteristics. Typical applications include airplane canopies, camera lenses, outdoor signs, auto tail lights, and skylights. They are available as rigid sheets, rods, tubes, and molding powders. They were commercially introduced in the United States in 1936.

alkyd plastics. Thermosetting materials. The molding materials are used in automobile starters, light switches, and electronic tube supports. In liquid form they are used in enamels and lacquers for automobiles, appliances, and farm machinery. They are available as molding powder and liquid resin. The liquid form was developed in 1926, and the molding material was introduced in 1948.

allyic plastics. Thermosetting materials used in electronic parts, electrical connectors, and low and high pressure laminates. They are available in the form of monomers, prepolymers, and as molding powders. These materials were introduced in the late 1940s.

amino plastics—melamine and urea. Thermosetting materials. Melamine is used in the manufacture of tableware and for such things as buttons, table-top laminates, and hearing-aid cases. It was developed in 1939. Urea is used in closures, radio cabinets, stove knobs and handles, and as a resin in baking enamel coating. It was developed in 1929. They are available as molding powders or granules, as a foamed material, and as resins.

casein. A thermosetting material used in such applications as buckles, buttons, game counters, knitting needles, and adhesives. It is the product of the protein of skim milk reacted with formaldehyde, and was developed in 1919. It is available in rigid sheets, rods and tubes, as a powder, and a liquid.

cellulosics. Thermoplastic materials of five basic types. *Cellulose acetate* is used for recording tape, photographic films, eyeglass frames, and vacuum cleaner parts. It is available as pellets, sheets, film, rods, tubes, and strips. It was developed in 1927. *Cellulose acetate butyrate* is used for applications such as pipe and tubing, steering wheels, and portable-radio cases. It is available in pellets, sheets, rods, tubes, strips, and as a coating. It was introduced in 1938. *Cellulose propionate* is used in telephone hand sets, pens, and appliance housings. It is available in pellet form, and was developed in 1945. *Ethyl cellulose* is used for electrical parts and edge moldings on cabinets. It is sold as granules, flakes, sheets, rods, tubes, film, and foil. It was developed in 1935. *Cellulose nitrate* is used in shoe-heel covers and as a fabric coating. It is available as rods, tubes, film, sheets for machining, and as a coating. It was developed in 1868.

cold-molding plastics. Thermosetting materials of three basic types: bitumin, phenolic, and cement-asbestos. They are used in such

applications as switch bases and plugs, small gears, and handles and knobs. They are available as compounds, and articles are produced by molding under heavy pressure. They were developed in 1909.

epoxy resins. Thermosetting materials used in casting, laminating, coating, and adhesive-bonding applications. They are available as resins, molding compounds, foamed blocks, liquid solutions, adhesives, and coatings. They were developed in 1947.

ethylene-vinyl acetate (EVA) materials. Flexible thermoplastic resins with characteristics similar to rubber. They are used in syringe bulbs, inflatable toys, shower curtains, and pool liners. EVA molding compounds are formed by injection molding, extrusion, and blow molding. The moldable grades were developed in 1964.

fluorocarbons. Thermoplastic materials. They include tetrafluoroethylene (TFE), chlorotrifluoroethylene (CTFE), vinylidene fluoride (PVF_2), and fluorinated ethylenepolypropylene (FEP). They are used in gaskets and packings, seals, antistick surfaces, and pipe and fittings. They are available as powders, granules, or dispersions, and were first introduced in 1943.

ionomers. Thermoplastic resins used for such things as skin packaging applications, extrusion coatings, bottles, closures, vials, and insulation for wire and cable. Flat sheeting can be thermoformed into covers and trays. It is available as a resin, and was developed in 1964.

nylon (polyamide). The generic name for a family of thermoplastic polyamide resins. It is used for such things as slide fasteners, tumblers, gears, and washers. As a filament it is used for fishing lines, brush bristles, and textiles. It is available as a molding powder and as sheets, rods, tubes, and filaments. It was introduced in 1938.

parylene plastics. A family of thermoplastic materials used for protective coatings on paper, fabrics, and ceramics, and for electronic parts such as photoelectric cells and microcircuits. Parylenes can be deposited as a uniform, adherent film or formed on a surface treated with a release agent and then stripped away. They were developed in 1965.

phenolic materials. Thermosetting plastics used for such things as automobile distributor heads, electrical insulation, tube bases, dials, knobs, and handles. Types of phenolic include phenolformaldehyde, cast phenolic, phenol-furfural, and resorcinol. They were developed in 1909.

phenoxy materials. Thermoplastic materials used for bottles, containers, battery cases, electrical appliance housings, and in adhesives and coatings. They are available in pellet form and as resins. They were developed in 1962.

polyallomers. A class of crystalline polyolefin polymers. Propylene-thylene polyallomer is a thermoplastic material and used for such things as closures, toys, pipe fittings, self-hinged containers, and

film and sheet for packaging and vacuum forming. It was introduced in 1962.

polycarbonates. Thermoplastic materials used for air-conditioner housings, handles of electric tools, street-light globes, lighting-diffusion panels, and sunglass lenses and frames. They are mainly a molding material, but can also be in the form of film, extrusions, and coatings. They were developed in 1957.

polyesters. Thermosetting plastics. The resins are used to impregnate cloth or mats of glass fibers and other materials, and are also used as casting compounds. Polyesters are produced as liquids, dry powders, premix molding compounds, and as cast sheets, rods, and tubes. They were developed in 1942. For more information, see POLYESTER RESIN as a main heading.

polyethylene. A thermoplastic material used for flexible ice-cube trays, rigid and squeezable bottles, pipe and tubing, bags, toys, and coated paper for freezer wrap. It is available in pellet form, powder, sheet, film, filament, rod, tube, and foamed. It was developed in 1942.

polyimide plastics. Plastics which have the linear structure of thermoplastics, but the nonmelting characteristics of thermosetting materials. They are used in aerospace parts, valve seats, bearings, seals, and relay actuators. A film is made for cable wrap, tapes, hose, and tubing. They were developed in 1962.

polyphenylene oxide resins. Thermoplastics with a wide range of applications as electrical insulating parts, sterilizable medical instruments, and household appliances exposed to hot water. They were developed in 1964.

polypropylenes. Thermoplastic materials used for such things as safety helmets, pipes, fittings, packing film and sheets, bottles, wastebaskets, flexible hinges, and wire insulation. They can also be produced as a foam plastic. They were first used in the United States in 1957.

polystyrene or styrene. A thermoplastic material used for refrigerator food containers, instrument panels, wall tile, and portable-radio housings. It is available as a molding powder and granules, sheets, rods and other shapes, foamed blocks, and as adhesives and coatings. It was developed in 1938.

polysulfones. Thermoplastic materials that find use in appliance housings, computer parts, switches, sheeting, and extruded pipe. They may also be used as adhesives. They were first developed in 1965.

polyurethane or urethane plastics. Thermosetting materials used for a variety of purposes as flexible to rigid foams, solid elastomers and plastics, and coatings for wood, metal, and wire. They were introduced commercially in 1954. For more information see URETHANE FOAMS as a major heading.

silicones. Widely used in the electrical industry for such things as switch parts, in power cables, and as insulation for motors and

generator coils. They are added to other materials in thermosetting systems to strengthen the bond between glass fibers or mineral fillers and resins. They are available as molding compounds, resins, coatings, greases, fluids, and as silicone rubber. They were first used around 1942.

vinyls. Thermoplastic materials ranging from flexible to rigid, and foamed. The major types are *polyvinyl acetal,* used as the interlayer in safety glass; *polyvinyl acetate,* used for heat-sealing films, flash-bulb linings, and paints; *polyvinyl alcohol,* used in paper coating and sizing, and as a mold release for polyester resins; *polyvinyl carbazole,* used in structural components in electrical assemblies; *polyvinyl chloride,* used as pipe, insulation, and foam applications; *polyvinyl chloride-acetate,* used as shower curtains, phonograph records, and surface coatings; and *polyvinylidene chloride,* made in both flexible and rigid forms. This family of materials was first developed in 1927.

plate (1) In etching, a plate is the piece of copper, zinc, steel, or other metal that constitutes the base from which prints are made. (2) In photography, the term refers to a sheet of glass coated with a sensitized emulsion. (3) In printing, the term refers to the reproduction of type or cuts in metal or other material. A plate may bear a relief, intaglio, or planographic printing surface.

plate burning After a negative has been prepared for an engraving it is placed on the plate in a vacuum frame. The rays from the light source "burn" the plate, passing through the transparent areas of the negative and hardening the plate surface coating. This coating is later developed and the unexposed areas washed away. Plates are also "burned" for offset printing.

plate oil A burnt linseed oil varnish used with dry pigments to make etching ink.

plate polishers There are several commercially produced paste polishes suitable for cleaning and polishing etching plates without danger of scratching. Other materials, such as charcoal blocks, abrasives in stick form, and emery polishing paper, are also used.

platen press A type of printing press with a flat surface bearing the inked type. Another flat surface, bearing the paper, is pressed against the type. Small hand presses are ordinarily of this sort. *See also* FLAT-BED PRESS.

Plexiglas Plexiglas acrylic plastic is a rigid, resilient material made from methyl methacrylate monomers. It is a product of the Rohn and Haas Company, and is easily available in the form of sheets,

rods, and tubes. It is manufactured as a colorless material, and also in a variety of transparent, translucent, and opaque colors. It combines optical clarity, light weight, and good resistance to weather and breakage. In England this material is called *perspex*.

plywood A laminated material made of two or more sheets of wood glued together. The grains in successive layers of plywood are always set at right angles; if the grain of the plies runs in the same direction, the material is simply a wood laminate.

When plywood is used as a ground for painting it should first receive a priming coat. This may consist of a thin coat of glue and gesso, polymer gesso, tempera, or shellac.

polyester film A plastic film base with high dimensional stability used for various photographic films and drafting materials. In these applications it has usually replaced cellulose acetate.

polyester resin Polyester resins are thermosetting materials used to impregnate cloth and other fibers in the manufacture of reinforced parts for boats, automobile bodies, skylights, photographic trays, and a host of other applications. They can also be used in cast form to make jewels, lenses, and numerous other shapes.

These resins have good surface hardness, strength, and resistance to chemicals and water. They take a complete range of bright opaque and transparent colors.

The resin itself is an easily handled liquid. A catalyst is added just before using to polymerize or cure the liquid to a hard final product. This catalyst is usually volatile and very toxic. When used in cast form, the amount of catalyst added to the resin varies with temperature, humidity, and the thickness of the casting. It must be remembered that clear casting resin will not cure well at temperatures under 74°F. Also, thicker castings require a much lower catalyst ratio. Read the mixing instructions for resins very carefully.

Acetone can be used for cleaning tools that have been used with polyester resin.

To dissolve polyester casting resin to recover something that has been imbedded, the part should be soaked in methylene chloride or methylene dichloride for three or four days.

polymer paints These paints are made of acrylic or vinyl resins, or a combination of both resins, in liquid form with water as the base. The paint spreads out in a layer, and the water evaporates to leave a continuous, flexible, and waterproof film of plastic. This paint can be applied to surfaces such as paper, cloth, acetate, canvas, wood, Masonite, and plaster. For more information see SYNTHETIC RESIN MATERIALS.

portfolio

block scrapers

clean-up tools

palettes

polyurethane *See* URETHANE FOAMS.

polyvinyl acetate (PVA) A vinyl resin that requires a plasticizer to make it flexible. It is used in the production of polyvinyl acetate emulsion for painting purposes.

poppy-seed oil *See* DRYING OILS.

porcelain The finest variety of pottery produced. It is made of kaolin, a clay which is a hydrous silicate of aluminum. When heated to high temperatures this material unites with fusible bisilicate feldspar to make the final material. Porcelain is very hard, brilliantly white, impermeable to liquids, and unaffected by acids. It was first made in China about 206 B.C. *See also* CERAMICS TERMS.

porphyry A dark, purplish-red stone used in sculpture, first quarried in ancient Egypt. It is also used to make mullers and grinding slabs for artists who wish to grind their own pigments.

portfolio (1) In commercial art, a sampling of artwork and printed pieces shown by an artist to a prospective customer. (2) A container or cover for drawings and other works on paper. It is usually made with two boards hinged at one of the long sides, and strings or tape to hold the other three sides. Professional portfolios are zippered.

poster colors Also called *tempera* (a misnomer), and show-card colors, these are water paints with a gum binder. They are brilliant, opaque, and fast-drying paints usually sold in jars. Some of the finer ground varieties can be used for airbrush work. They dry to a satiny matte finish and are widely used in commercial work and for school and educational use.

The material is also available as a prepared powder to which water can be mixed to make any quantity of paint desired.

pottery There are two general classifications in ceramics: pottery and porcelain. Pottery usually refers to objects made of clay which may be nonvitreous, porous, opaque, and either glazed or unglazed. It also includes earthenwares such as stoneware. Porcelain is an extremely hard, vitreous material. *See also* CERAMICS TERMS *and* PORCELAIN.

pottery tools Some of the common tools used in pottery work include the following.

block scrapers. Flat, rigid pieces of steel having either plain or toothed edges. They are used for smoothing plaster and clay and for other applications such as pottery mold making.

clean-up tools. Double-ended tools set in wooden handles. The sharp blades are of several patterns for scraping and cleaning.

palettes. Flexible rubber or steel tools used for smoothing the surfaces on plaster and clay forms. Toothed palettes produce various textured and decorative effects.

plaster bats. Basic working surfaces on which clay is turned or modeled.

potter's tools. Such instruments as lace tools, needle tools, notch knives, fettling knives, mold maker's knives, and palette knives.

sieves. Used for sifting dry clays and other materials to remove lumps.

turning tools. Made of steel and used for shaping clay and plaster while the material is spinning on the potter's wheel.

wedging boards. Hard plaster surfaces with an arm or side extending upward at the back. A wire extends from this upper surface to the front of the plaster. Clay pushed against this taut wire is easily cut.

pounce bag A loosely meshed cloth bag containing a colored powder. The powder sifts out of it when it is patted along a pricked drawing used to transfer a design or sketch.

pouncing A method of making copies of pattern and signs. A master drawing is made on paper of the design to be copied. The lines are traced with a pounce wheel (also called *tracing wheel* or *perforating wheel*). This is an instrument having a toothed wheel at the tip, and is used to follow the lines of the master drawing. The teeth actually perforate the paper with from 12 to 24 holes per inch. The master drawing is then placed on the permanent support and pouncing powder is forced through the holes, effectively transferring the drawing.

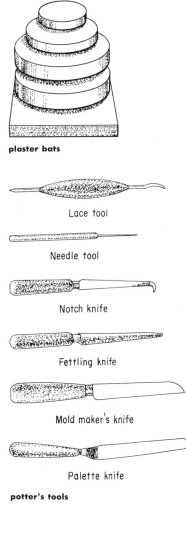

plaster bats

Lace tool

Needle tool

Notch knife

Fettling knife

Mold maker's knife

Palette knife

potter's tools

sieve

turning tools

wedging board

pounce wheel

pouncing products Other pouncing materials, besides colored pouncing powders, are employed in drafting. One such material is a fine powder used on greasy or very slick papers to provide a better working surface.

presentation books Multi-ring loose-leaf binders holding several two-sided acetate pages. They are used for displaying photos, layouts, drawings, and presentations. Some are designed to close with a zipper.

presswork In printing, the actual operation of putting ink on paper. This activity is preceded by composition and perhaps plate making, and is followed by binding. Presswork consists of make-ready (preparation) and running time.

printing press A machine for the production of printed impressions on paper and other materials. *See individual headings such as* FLAT-BED PRESS; PLATEN PRESS; *and* ROTARY PRESS.

printing terms *See* TYPOGRAPHIC TERMS.

print mounting Prints and photographs can be harmed if they are mounted with glues, gums, or rubber cement. Dry mounting is usually the best method to employ, but starch paste, dextrin, and gelatin can also be used. *See also* DRY MOUNTING *and* MOUNTING LARGE PHOTOGRAPHS.

prints and print processes There are three general print processes: *relief process,* in which the printing areas stand above the surface of the plate; *intaglio process,* in which the printing areas fall below the surface of the plate; and *planographic process,* where there is no appreciable difference between the level of the printing areas and the general surface. Examples of the relief process include woodcuts, linoleum blocks, and zinc cuts. The intaglio process includes the various techniques of etching, mezzotint, aquatint, and drypoint. Planographic processes include offset lithography, lithography on stone, aquatone, and silk-screen and other stencil printing techniques.

process cameras Large cameras used to produce materials for photomechanical reproduction. A *darkroom camera* has its rear section built into the wall of a darkroom and permits direct access to the back of the camera for easier film handling in darkness or in the illumination of special safelights. A *gallery camera,* on the other hand, has no such darkroom connection and requires the use of individual film or plate holders. Process cameras permit a large range of enlargement and reduction. An integral part of any system is a calculating wheel

that enables the operator to relate scaled artwork against numbers on the bed of the camera.

process color (color printing) Process color is the method of reproducing full-color originals such as paintings and color photographs. Four-color process plates print in yellow, magenta, cyan, and black. The first three produce the foundation for the basic color reproduction, and the black is used for type matter, for solid blacks and grays, and to make some of the combined three colors darker or more neutral. In some instances the fourth color can be gray, or even another blue, usually of a deeper shade than that used for the three basic printing colors.

In making process-color plates, the copy must be photographed through color filters, once for each printing color to be used. (*See* COLOR SEPARATION). Each plate prints only the color for which it was made, but when they are all combined by printing the separate impressions one on top of another, in exact registration, the colors of the original copy are exactly constructed.

In order to keep the dots from the four plates from printing over each other, the screen is rotated to a different angle for each color. This produces a definite dot pattern for each. The black screen is shot at 45 degrees, the yellow at 60 degrees, the magenta at 75 degrees, and the cyan at 105 degrees.

progressive proof The proofs from color plates showing each color alone, and also in combination with each succeeding color in printing rotation. The order is yellow, magenta, cyan, and black.

proof The inked impression of composed type or a plate. It is used for inspection purposes or for pasting up with other artwork. It may also be called *press proof.*

process camera

pumice A powdered volcanic glass used in metal polishes and scouring compounds. When ground to a very fine powder it is called *pounce* and is used to impart tooth on various smooth surfaces, particularly drafting papers and films.

punch (1) A device to punch holes in sheets of paper so they can be placed in ring binders. (2) A steel instrument with two large, blunt ends used in engraving to add masses of black on a plate after it has been bitten.

putty A mixture of calcium carbonate with about 18 percent linseed oil. Occasionally, white lead is added. Glazier's putty dries, but plumber's putty does not.

pyrometric seger cones *See* CERAMICS TERMS.

Q

quads Small pieces of type metal used in printing to space or to fill out the lines not filled by type. They are used mostly to fill space where first lines are indented, and to fill out last lines.

quenching Hardening metal by plunging it into water or oil while it is red hot. This imparts a certain brittleness to the metal, but this is removed in the tempering operation. *See also* STEEL HARDENING AND TEMPERING.

quire Twenty-five sheets, or one-twentieth of a 500-sheet ream. A quire formerly consisted of 24 sheets.

quoins Wedge-shaped devices made of steel, generally triangular, and less than type-high. They are used to lock type and plates in chases for the press. The word is pronounced "coins."

R

rasps Numerous rasps are used for shaping and finishing metal, plaster, stone, and wood. An important class are riffler rasps and files which are designed in a number of useful curved shapes. *See also* WOODWORKING TOOLS.

recto A right-hand page, which always bears an odd number. A left-hand page, bearing an even number, is called the *verso*.

reducer (1) In photography, a method of decreasing the contrast or density of a negative or positive. *See* PHOTOGRAPHIC TERMS, RE-DUCER. (2) In printing, the varnishes, solvents, and waxy or greasy materials used to reduce the tack or consistency of printing inks.

reducing glass A double concave lens that reduces the apparent size of objects viewed through it. It is used by illustrators and painters to create an artificial sense of distance from their work.

reed pens Short sections of bamboo sharpened to a point at both ends and used for ink drawings.

reflex printing A method of copying in which a sensitized film or paper is placed face down on the material to be copied. Light passes

rasps

through the base of the sensitized material and is reflected from the light and dark portions of the original back to the emulsion.

register (1) Exact agreement in the position of printed material on both sides of a sheet or on all pages of a book or pamphlet. (2) Exact overprinting of color plates, or other subsequent plates, so that all printed detail is correctly combined. Proper color overprinting is checked by the exact superimposition of the register marks that are printed with each color run. (3) In flat preparation, the exact agreement between color or complementary flats.

register marks A set of marks, usually cross-shaped, placed on the margin of colored originals to be photographed for color plates. They are used to register the images when the plates are printed.

relief printing A method of printing in which the type or other images stand above the surface. Even though the lower areas may have ink in them, they do not print because the paper does not contact them. There are numerous methods for lowering the non-printing areas of relief plates, but the ones most generally used are either to cut or engrave them by hand or machine or to etch them. Each is a form of engraving.

repeat glass Used by textile and wallpaper designers, this device consists of four lenses formed in one piece of glass. When a single drawing or pattern is viewed, the subject matter is repeated four times.

repoussage In etching, when a plate is repaired, scraped, and rubbed, there is a hollow left that will print a gray smudge. The hollow is hammered out by putting the plate, face down, on a flat steel surface and tapping it gently from the back with a repoussage hammer. The process is called *repoussage.*

repoussé A method of producing a relief design on a thin sheet of metal or leather by hammering or otherwise working the reverse side. *See also* CHASING TOOLS.

resins *See* GUMS AND RESINS.

resist A protective layer applied to the image, or other parts of a plate, to protect that portion of the metal from the action of an etching bath or a sandblasting operation.

retarding the drying of oil paint The usual material used to retard the drying of linseed oil colors is oil of cloves. A drop, or a few

gold with repoussé decoration
CROWN: HUNTING SCENE. (Pre-Islamic, c. 1200 B.C.) Found in Northwest Iran. (*Eugene Fuller Memorial Collection, Seattle Art Museum.*)

drops, added to each color on the palette will work very well. This method is sometimes used by portrait painters who wish to work on a painting over a period of several days. Oil of cloves is one of the slowest-drying of the essential oils and will not harm the paint film of linseed oil colors.

retouch grays Water paints with a gum binder available in a range of warm, cool, and neutral gray values graduated in steps from light to dark. The highest number is the darkest. They are manufactured in tubes, jars, and cakes, and were developed for use in retouching black-and-white photographs. They can be used with pen, brush, and airbrush, and do not crack or chip when dry. They are also used in producing black-and-white commercial illustrations.

retouch varnish *See* VARNISHING PAINTINGS.

retouching Hand work carried out on a negative or print using pencils, knives, brushes, or airbrushes to remove or disguise defects.

retroussage The method of bringing ink up from incised lines in an intaglio plate. It is done by dragging a soft cloth across the ink-filled lines prior to printing. This makes the lines wider and renders certain passages darker and richer.

rifflers *See* RASPS.

rocker A type of chisel, with a sharp beveled edge, used in mezzotint engraving. It is set on the surface of a copper plate and rocked back and forth to produce a rough grain which, when printed, produces a velvety black.

rosin Also called colophony, this material is the residue left after turpentine has been distilled from the balsam collected from pine trees. It is used in some varnishes and as a flux in soldering.

rotary press A press utilizing two cylinders, one of which supports the paper while the other one prints on it. Large rotary presses are web-fed, and accept continuous strips of paper from large rolls. This "web" of paper is not cut or trimmed until after it is printed.

rottenstone A soft, decomposed limestone, light gray to olive in color. It is used in powder form as a polishing material for metal and wood.

rouge Artificial red oxide of iron. The finest and smoothest grades are used as polishing compounds. Crocus cloth is a fabric coated with rouge, and is marketed in sheets for polishing metals.

roulette An engraver's tool consisting of a toothed wheel and used to produce rows of dots on a plate. It is used to correct mezzotint plates or to make characteristic patterns of its own.

RTV silicone rubber A material manufactured by a number of companies and useful for mold and model making. It consists of a fluid silicone rubber which has good flow characteristics and which vulcanizes at room temperature. It is a two-part mixture with a catalyst that is added just before use. It is poured over the original, allowed to set up, then stripped off. It faithfully reproduces even the finest details.

 The molds may then be used for making casts with plaster, polyester resins, epoxies, or waxes.

rubber cement *See* ADHESIVES.

rubbing An impression made by moistening a thin, tough paper and patting it into the incised parts of a carved or modeled surface, then rubbing it with pencil, chalk, inked pad, or watercolor. An actual-size image of the original is produced on the paper. *See also* FROTTAGE.

rulers There are numerous types, and lengths, of rulers. Some simply consist of inches marked off in sixteenths. Others may be graduated in picas and agate lines, tenths and millimeters, or in varying decimal parts to the inch. Engineers' triangular rules are divided in 12, 20, 30, 40, 50, and 60 parts to the inch. Architects' scale rules are divided in fractions of an inch to the foot. Adjustable rulers are used to draw curves. They will hold any curve to which they have been bent.

runaround In composition, the arrangement of lines of type so that they fit around halftones or other matter.

rutile Titanium dioxide. A reddish-brown color used as a base in ceramic processing.

S

sable The hair of Siberian minks, used for making fine brushes. The highest grade comes from the kolinsky. The brushes are usually round, fairly long, and have tapered points.

safflower oil *See* DRYING OILS.

sandpaper Tough paper covered with glue and sharp sand or other abrasive materials. It is obtainable in 50-yard rolls in widths from 6 to 48 inches. It is usually purchased in 9- by 11-inch sheets.

The cheapest grade is covered with quartz or flint particles. More serviceable grades are made with crushed garnet. Other papers and cloths may be covered with silicon carbide, boron carbide, and crystalline alumina, but these are more often used in metalwork. Sandpapers are graded from extra fine grits to coarse.

sandpaper blocks These blocks consist of several strips of sandpaper attached to a wooden strip. They are used to sharpen pencils, pastels, and stumps, and when the top sheet wears out or becomes dirty it is removed.

sandpaper block

sanguine drawings Sanguine refers to a blood-red color, usually produced in crayons by the use of red hematite. A sanguine drawing is one done in red crayon, red chalk, or the like.

scene paint Theatrical scene painting is done with dry pigment mixed with a glue-water mixture called size water. The dry color is available from paint stores and theatre supply houses and is very inexpensive.

The best glue for making size water is gelatin flake glue. To use this glue, it is soaked overnight in enough water to cover it, and then cooked in a double boiler until soft. It should never be allowed to boil, since this will destroy its glue action. The glue is then diluted with warm water and mixed well. Size water is strong enough when it causes fingers to stick together slightly. Size water that is too strong will make the fingers very sticky and paint made with it will tend to crack. Weak size water will have very little adhesion, and paint made with it will rub off the canvas flats.

Dry color is added to size water to form a smooth, even paste. Additional size water is then added until the mixture has the consistency of thick cream. The paint should be stirred frequently and kept warm while it is used. Unless a teaspoon of disinfectant is added to each gallon or so of the mixture, scene paint that is allowed to stand for a few days will begin to smell.

Pigments mixed with size water tend to appear much darker than they will be when dry. To sample a color, let it dry on your hand; your body warmth will hasten the drying. The white pigment used in scene paint is whiting, and it is mixed with other pigments to lighten them.

scene painting Ordinary brushes are used for applying priming coats and ground coats on sets. Flat coats of a given color are seldom used on large areas of a set. More often a broken or irregular texture is desired for greater depth, or to make a surface take light better.

The following are standard methods of obtaining textures and other effects on surfaces that have first been given a flat coat of scene paint.

glazing. Sometimes a finished, textured paint job is overpainted with a thin coat of scene paint. This serves to pull the entire scene together, or to accentuate a certain color. The thin coat is practically transparent.

rolling. A piece of canvas or burlap is dipped in paint, wrung out, and twisted into a roll. This is then rolled over the surface of the canvas to produce a textured effect.

scrumbling. A brush containing only a little paint is swept over the surface of the canvas in long, irregular strokes. Its main purpose is to blend contrasting ground colors, and a different brush should be used for each color. A variation of this is dry brushing, in which even less paint is used. In light, sweeping strokes it is possible to obtain textural effects such as wood graining.

spattering, splattering. A brush is dipped in paint and struck on

the wrist, causing tiny drops of paint to spatter on the canvas. Spattering is usually done with several different colors, but each color must dry before the next is applied.

sponging. This method consists of dipping a sponge in paint, squeezing out the excess, then patting or rolling the sponge on the surface of the canvas.

stenciling. Regularly repeated patterns, such as wallpaper patterns, can be stenciled on the set. A chalked snap line is used to mark the area so that the stencil can be applied evenly. A light spatter, rolling, or sponging can be used afterward to blend the stenciled pattern into the background.

stippling. Touching the end (not the side) of a medium-full brush against the surface of the canvas. Stippling is usually done with several colors, one being applied after the other is dry. It is often done in connection with sponging.

scissors Small shears used for cutting. *See also* SHEARS.

scorpers *See* ETCHING TOOLS.

scraper A sharp, three-cornered tool used in scraping plates to correct errors. If a stylus or graver leaves a burr or ridge on the plate, the scraper can be used to level it down.

scratch knives Knife points that fit in standard penholders. They provide fine to broad lines on scratchboards and are also used in the graphic arts for cutting, erasing, and retouching.

scratch knife

scratchboard Scratchboard is essentially an ink technique. In practice, a specially surfaced white board is covered with india ink, producing a uniformly black surface. When the board is dry it is possible to scratch very fine lines into the ink, revealing the white board underneath. Numerous stipple, dot, and crosshatch patterns can be made with ease and great control. Special multiple-line gravers, of varying widths, can be employed. Drawings done in this technique can be reproduced as line engravings, rather than as more expensive halftones.

scratchboard tools In addition to scratch knives, common scratchboard tools include screen knives. These instruments have multiple cutting heads to produce screens of 20, 30, 35, 40, 45, 50, 55, and 60 lines (lines to the inch).

sculpture Sculpture is the art of carving or shaping stone, wood, metal, and other materials into figures, or of modeling figures in wax or clay to be cast afterward in plaster, bronze, or other metals.

Sculpture is often three-dimensional in form, in contrast to paintings and other flat surfaces. Contemporary sculpture may utilize virtually any material or technology at hand, and often includes such diverse things as glass, plastics, welded structures, wire, paper, wood, and electrical and mechanical contrivances such as neon tubing and motors of various kinds.

Following are some of the more common terms used in sculpture to describe various tools and methods. The materials of sculpture may be found under such headings as ALABASTER; MARBLE; WOODS; *and* URETHANE FOAMS.

acrolith. A statue made of more than one material, such as stone and wood.

alto-relievo. An Italian term meaning high relief, in which figures are carved to project almost entirely away from the surface of the block.

armature. A rigid skeleton or framework to support the weight of modeling materials such as clay or wax. Heavier armatures can be built to support the weight of wet plaster. They can be made of almost any material that is strong and stiff, such as wood, chicken wire, pipe, and rod. Other useful materials include window screen, aluminum foil, and styrofoam. Factory-made armatures of figures and heads can be purchased. They are available in various sizes and heights.

bas-relief. Sculptural work in low relief, executed on a flat or curved surface. Its projection from the surface is less than *mezzo-relievo.*

boaster. A tool used for working wax or clay and consisting of a short piece of metal, wood, or ivory rounded or curved at one end and flat at the other. They vary in size.

boasting chisel. A flat chisel with a 2-inch edge used in rough-shaping stone.

boss. A term that describes any projecting mass that will later be carved or cut.

bust peg. A wooden support upon which clay or wax is modeled in making a bust. It remains in the finished work.

calipers. A compasslike instrument used by sculptors to check measurements. They can be used to measure both inside and outside surfaces. Proportional calipers can be used to enlarge and reduce.

armatures

proportional calipers

casting plaster. A specially prepared white plaster used for castings and carvings.

cavo-relievo. Carving in relief so that the highest part of the sculpture is level with the surface of the stone and the rest of the detail is below it.

chisel draft. Marks on the edge of a stone that serve as guides to cutting.

chisels. Tools with sharp beveled edges used for wood and stone carving. They are made of steel. Wood chisels are often mounted in wooden handles.

chisels (stone-carving)

coil method. One of the methods used in terra cotta sculpture. The clay is rolled into cylindrical strips about the size of an ordinary pencil and wound up to create the desired shape.

double-end tool. An instrument for shaping or modeling clay and wax. It usually consists of heavy wire mounted in a wooden handle. The wire is formed in the shape of loops, points, squares, and other patterns.

form lacquer. A thin coating of varnish or lacquer on the relief parts of a mold that prevents material from sticking to it during casting.

double-end tools

ganosis. The process of toning or dulling the glare of stone sculpture, sometimes by the application of colors mixed with wax.

gelatin. Gelatin in flake form can be prepared with water to make flexible molds in which plaster can be cast.

gradine. A gradine is a toothed chisel used to remove large pieces from marble or other stone.

grounding. Polishing marble with a fine abrasive substance.

hammer. Hammer heads used in sculpture are usually cubical in shape and mounted on very short handles.

high-relief. Alto-relievo. Sculpture having only a few points of contact with the surface of the block from which it is cut.

low-relief. Bas-relief. Sculpture having only a slight projection.

mallet. Sculptors' mallets usually consist of cylindrical blocks of wood with slightly curved faces.

maquette. A small, rough model built as a guide for a large sculptured work.

mezzo-relievo. Sculpture that projects about halfway from the ground on which it is carved.

modeling stand

modeling clay. Some modeling clays are moist when purchased; others are in powder form and must be mixed with water for use. Clay works in progress should be covered with a damp cloth to prevent the clay from drying out.

modeling stand. A stand used in clay and wax modeling to keep the material at a comfortable working height. It has a large top that revolves easily, and most are adjustable in height.

plaster tools. Strong, steel tools used for modeling plaster, retouching, and in ceramics work.

plaster tools

stone-working tools

pointing. The technique whereby a plaster model is reproduced in stone or clay. Holes are made in a stone block to correspond with points on the model.

rasps. Steel tools of different sizes used for working stone, plaster, or wood.

single-end tool. A tool with a looped wire at only one end. *See* DOUBLE-END TOOL *in this section.*

stone-working tools. Forged steel tools of varying sizes and shapes used in working marble and other stone materials.

wire-sculpture methods. The connections in wire sculpture are generally soldered or welded, but they can also be made by tying junctions with thread or string which are then coated with liquid solder or liquid aluminum.

Colored plastic film can be attached to wire sculpture with ordinary white glue. It forms a transparent joint.

scumbling The technique of placing a light, semitransparent color over a darker portion of the underpainting. It serves to unify the colors or to soften colors that are too brilliant. The object is to alter the underpainting without covering it completely. An almost dry brush is used.

secco A technique of painting on dry plaster. It produces a dull, matte finish.

separation negatives The negatives made from full-color originals and used in the preparation of color plates. Four negatives are made, one for yellow, magenta, cyan, and black printing plates. *See* COLOR SEPARATION.

serigraph The term applied to the silk-screen process when it is used as a fine art reproduction method. *See* SILK-SCREEN PRINTING.

set Printing inks are said to be *set* when the printed sheets, although not completely dry, can be handled without smudging.

sfumato From the Italian word for "smoked," this term refers to hazy atmospheric effects in painting. This blurring or misting is often used in the background of landscapes.

sgraffito (graffito) *See* CERAMICS TERMS.

shading sheets and screens Dot, line, and halftone patterns printed on clear, transparent plastic sheets with pressure-sensitive adhesive on the back. They are applied to various portions of line drawings to produce shading, stippling, or tinting values to specified areas.

The finished art can be shot as a line shot, but will still retain the effect of a halftone. Special tinting screens are available to impart specific percentage values in artwork.

Other special-effects screens are used to produce halftones with unusual patterns, including wavy-line screens, concentric-circle screens, mezzotint, and pebble-grain screens. Unusual textures can be produced by putting different screens over the tops of other screens and turning them at different angles.

shale *See* SLATE BLACK *under* BLACK PIGMENTS *on page 163.*

sharpening stones It is very important that edged tools be kept properly sharpened. There are numerous stones for doing this. They have names such as arkansas stones, india stones, and silicon-carbide stones. Oil is used with fine-abrasive stones for sharpening knives, blades, ruling pens, and other drawing instruments. Specially shaped stones are used for sharpening gouges and curved cutting edges. *See also* WOODWORKING TOOLS, OILSTONES.

shears Larger than scissors, and more powerful, shears are used for a variety of cutting applications. Some are as much as a foot long.

shears

sheet-fed Printing presses are either sheet-fed or web-fed, accepting sheets or a large reel of paper (the web) which is printed and later cut. Usually only the large high-speed rotary presses are web-fed.

shellac The resinous secretion of the lac insect, a material produced mainly in India. When shellac is refined it is an orange-brown resin, but it can be bleached white. Shellac can be thinned with alcohol, but not with turpentine or mineral spirits. It should be stored in glass since prolonged contact with metal, in the presence of air, tends to darken it.

Shellac finds limited use as a sizing material for gesso panels, but should not be used as a final picture varnish. It turns brown in time and is likely to develop cracks. Also, it sometimes dries with a rough "orange peel" effect. For further information see WOOD FINISHING.

shoder Special skins in which thin sheets of gold are hammered in the manufacture of gold leaf.

"short" and "long" paint Fairly thick paint that retains its shape when manipulated is called "short" paint. Paint that flows more easily and does not hold brush marks well is called "long" paint.

show-card colors *See* POSTER COLORS.

siccatives Material added to oil paint to make it dry faster. They should be used very sparingly because they can harm the paint film. They are usually derived from lead, cobalt, or manganese compounds.

Siccatif de Haarlem is made from stand oil and dammar varnish, with manganese resinates and lead. *Siccatif de Courtrai* is made of linseed oil, lead, and manganese salts. The use of these materials can lead to brittleness and cracking of the paint film.

Cobalt linoleate is a cobalt salt cooked in linseed oil and is considered to be among the least harmful of the driers. Painting and glazing mediums usually contain a few drops of this material.

Japan driers should not be used in permanent paintings because they cause cracking and can darken pigments.

sign cloth A white cloth specially primed for sign and display work. It is available in widths of 50 inches and lengths up to 48 yards.

signature (1) A folded, printed sheet, usually consisting of 16 or 32 pages, that forms a section of a book or pamphlet. The sheet may consist of fewer pages, but always in multiples of four. The pattern of arranging the pages so they will be in sequence after folding is called the *impostion;* this is supplied by the binder. (2) The artist's signature on a painting or an etching.

silica Silicon dioxide, or powdered quartz. An inert material used sometimes as a filler or extender in paints, and also as an ingredient in glass making, fired enamels, and glazes.

silk-screen printing The process of printing a flat color design through a piece of silk. The silk is tightly stretched on a wooden frame and a design is transferred to the silk. The parts of the design not to be printed are stopped out with a resist medium. To print, ink is pushed through the open mesh of the design area by use of a rubber-edged squeegee. Only one color can be printed at a time. The silk and the frame can be cleaned and used repeatedly for other designs.

The design on the screen can be produced mechanically or photographically by applying a sensitized coating to the silk. In the latter system, it is possible to print fine lettering, various screened patterns, and halftones.

Silk-screen printing can be used to apply watercolors, lacquers, and oil-base materials to wood, glass, metal, paper, cloth, and plastics. Care must be taken when choosing a color for printing on plastic because the use of an incompatible coating material can cause trouble as much as several months later. Standard and special colors are available for printing on acrylics, cellulose acetate, cellulose

silk-screen printing

acetobutyrate, cellulose nitrate, mylar, phenolics, polyesters, polystyrene, polyvinyls, polyethylene, and polypropylene. Suppliers should be asked for advice about the proper paint or ink to use.

When used as a method of fine art reproduction, the silk-screen method is called *serigraphy*. In this technique, the screen is stretched on the wooden frame in the usual way. An oily, lithographic tusche is then used to make the precise designs to be printed. After the tusche has dried, the screen is coated with a solution of 1 part glue and 1 part water. The glue fills all the open spaces in the mesh except for those portions covered by the tusche. This occurs because the glue-water solution will not mix with the oily tusche. The tusche is then removed with turpentine, leaving the open design. Oil-base colors (which will not dissolve the glue) are then forced through the screen.

silverpoint Silverpoint drawings are made with a sharpened piece of silver on a paper coated with a fine abrasive. The paper holds small grains of the metal, which later turn a darker, warmer tone. If special silverpoint paper is not available, it can be made by coating watercolor paper with a thin layer of chinese white.

silver soldering Silver solder requires higher melting temperatures than ordinary solders, and is used where higher strength is needed. Silver solders are alloys of copper, zinc, and silver. Soldering must be done with a blowtorch or furnace.

size, sizing (1) Any material used to cover or fill the fibers of a support used in painting. Canvas, for example, is sized with glue to protect the fibers. The oil ground would otherwise rot the fabric. (2) Size is used on paper to alter its qualities or to stiffen it. Gelatin and resin are common sizes for this purpose. Some paper is treated so that it will take ink better. In printing by offset lithography, the paper is usually sized to withstand the moisture inherent in the process.

sketch box A sturdy, flat box designed to carry tubes, mediums, brushes, palette, and canvas boards or paper.

slip *See* CERAMICS TERMS.

slug A slug is a strip of metal used to space between lines of type. It is usually 6 points thick and is, of course, lower than the height of the type. In normal composition, line spaces are cast integrally with the characters, so that hand-inserted slugs are only needed for special spacing around headings, illustrations, and the like.

A slug is also the name for a line of type made by a line-casting machine.

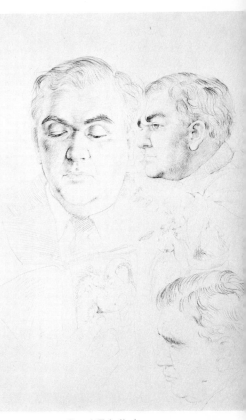

silverpoint Pavel Tchelitchew. PORTRAIT OF NICHOLAS KOPEKIN. 18⅞ × 12⅜ inches. (*Gift of Paul J. Sachs. Fogg Art Museum, Harvard University.*)

smoking The use of a candle to smoke the hard ground of a line etching. The melted ground combines with the carbon black of the candle to form a surface on which a drawing is easily seen.

soapstone A rock soft enough to be carved with a knife. It is used in statuary work and its colors range from green to bluish gray. *Nile* is a variety that is light green, occasionally with gray and brown. *Chiampo* is mottled green and grayish brown. *Madras* is a buff-colored variety from India.

soldering To unite or join by means of solder, a metal or metallic alloy. Solder is commonly applied by means of a soldering iron or blowtorch with a flux. Solders which melt readily are *soft;* others fusing at higher temperatures are *hard* solders. The flux materials needed in soldering usually consist of borax, resin, sal ammoniac, or chloride of zinc. The most common solder is composed of equal parts of lead and tin. It is called plumber's solder and melts at 360°F.

solvents Broadly speaking, a solvent is a liquid having the power to dissolve various materials. Water, for example, is a solvent for most acids and alkalies, and for many materials both organic and inorganic. Solvents are often used to make a solution that may be applied in liquid form, as is done with paints, after which the solvent evaporates, leaving the desired residue. The usual commercial solvents are organic materials with varying degrees of volatility. A few of the common solvents follow.

 acetone. This material, dimethyl ketone, is an extremely strong solvent. It will dissolve natural resins, cellulose nitrate, vinyl resins, and many other materials. It can be used for cleaning tools used with polyester resins. Because it will remove dried oil films, it is a common ingredient in paint removers. It has the unusual characteristic of being miscible with water, oils, and most other solvents. It should be used with adequate ventilation because it is poisonous. It is also very flammable and must be treated with caution.

 Methyl acetone is a mixture of acetone, methyl acetate, and methanol. It is used in lacquers, cellulose plastics, and paint removers.

 alcohol. This is the common name for ethyl alcohol, but it also includes a large group of other organic compounds.

 Ethyl alcohol (also called ethanol or grain alcohol) is used in varnish making and gilding and also as a shellac thinner. When combined with certain natural or synthetic resins, it is the main ingredient of fixatives. Ordinarily, grain alcohol contains about 6 percent water. Water-free alcohol is called anhydrous alcohol and is the best material to use in varnishes. This grade must be kept well-sealed or it

will absorb water vapor from the air. (Ethyl alcohol is the only alcohol that can be consumed in beverage form.)

Amyl alcohol (fusil oil) is used as a solvent for oils, resins, and varnishes. It imparts good brushing properties to industrial coatings. It is related to amyl acetate and is only slightly soluble in water.

Butyl alcohol (butanol) is used as a solvent for paints and varnishes. When used in varnishes it improves brushing qualities and tends to level brush strokes. It is also used in the manufacture of plastics.

Methyl alcohol (wood alcohol or methanol) is used as a solvent for lacquers, varnishes, and shellac. This material should not be taken internally because it is extremely poisonous. Even the fumes should not be breathed for any length of time.

amyl acetate. Also called *banana oil,* this material is widely used as a solvent for various synthetic resins.

benzene. Also called *benzol,* this material is made from petroleum by fractional distillation and is used as a paint and varnish remover and as a solvent in such products as rubber cement. It is an extremely dangerous material. It is more flammable than gasoline, and prolonged inhalation of the fumes is believed to cause certain types of blood cancer and aplastic anemia.

benzine. A general term to describe petroleum products that are less volatile than gasoline, but more volatile than mineral spirits. Their principal use is as dry-cleaning solvents.

n-butyl acetate. An ester of butyl alcohol and acetic acid, it is a strong solvent for cellulose plastics and synthetic resins. In the lacquer industry it has largely replaced amyl acetate. The vapors of this material are not extremely toxic.

butyl lactate. An ester of butyl alcohol and lactic acid, this material has a low rate of evaporation and is added to coatings to delay their setting and improve their flowing characteristics.

carbon tetrachloride. This solvent is prepared by the chlorination of carbon disulfide. It is nonflammable and has a rapid rate of evaporation. Its fumes are dangerously toxic. It is a solvent for oils and soft resins and also has an antiseptic action.

denatured alcohol. Ethyl alcohol made unfit for drinking by the addition of poisonous or distasteful material. It can be safely used to increase the gloss of polyvinyl acetate paint films, but should not be used as a solvent for varnishes.

diacetone alcohol. This material mixes with most organic solvents and with water. It is useful in retarding the drying of varnishes, and is a good solvent for cellulose acetate. It will soften or dissolve dried linseed oil films.

ethyl acetate. An ester of ethyl alcohol and acetic acid sometimes used as a solvent for old varnish films. It is not used in varnishes because it evaporates too rapidly. It must be kept away from flames.

ethylene dichloride. A solvent for oils, fats, and waxes, and a

diluent for cellulose derivatives. The vapors of this solvent are anaesthetic if breathed in high concentrations.

gasoline. A volatile, liquid hydrocarbon obtained in the distillation of petroleum. It is sometimes used as a solvent for paint and as a common cleaning agent. Its vapors are highly explosive. Most brands contain added substances that are very poisonous, even on simple skin contact.

glycerin. Also called glycerol, this material is classed as an alcohol. It is miscible with water, alcohol, and many organic solvents. It is used as a plasticizer for aqueous mediums such as egg, gelatin, and gum. Since it does not evaporate easily it is used in such products as stamp-pad inks.

kerosene. A petroleum product which evaporates very slowly and contains a nondrying oily residue. It is a poor solvent.

methanol. *See* METHYL ALCOHOL *on page 193.*

methyl ethyl ketone. A colorless, flammable liquid used as a solvent for many synthetic resins. It is commonly called MEK. It is used for cleaning up after using epoxy resins and urethane foams.

methyl isobutyl ketone. A solvent used to thin certain of the synthetic paint resins.

mineral spirits. A material distilled from petroleum and called white spirits, petroleum thinner, and mineral thinner. It has properties similar to those of turpentine, but it cannot replace turpentine in varnish making (dammar). Also in oil painting, it can be used to thin colors and to clean painting utensils. In flammability it falls somewhere between kerosene and gasoline, and must be used with caution.

naphtha. A light petroleum distillate used as a solvent for waxes, but not for paints or varnishes.

strasbourg turpentine. A balsam from the European white fir. It is a heavy, thick material sometimes used in painting mediums and glazes. An excessive amount causes smearing and slow drying of the paint.

tetrachlorethane. Also called acetylene tetrachloride, it is a solvent for oils and resins. It is nonflammable, but its fumes should not be inhaled. It finds other uses as a paint remover and an insecticide.

toluol. Also called toluene, methyl benzene, and methyl benzol. It is a solvent made from coal tar and is a by-product of coke ovens. It is a safer material to use than benzol.

trichlorethylene. A powerful solvent for oils, resins, and waxes. It mixes with alcohol and most solvents, and is nonflammable. It is less toxic than tetrachlorethane.

turpentine. The best turpentine is labeled "Pure Gum Turpentine" or "Gum Spirits of Turpentine" and often bears the emblem of the American Turpentine Farmers Association. "Double Rectified Turpentine" is the same material and a name used by art supply stores.

"Steam Distilled Turpentine" may be used, but it has a less agreeable odor.

Mineral spirits can be used by people who are allergic to turpentine. It is safe for paint thinning and cleaning, but is no substitute for turpentine when dissolving dammar or for thinning dammar varnish.

venice turpentine. This material is an exudate from the Austrian larch. It is a thick, resinous liquid sometimes used in painting mediums, glazes, and varnishes. It is similar to strasbourg turpentine.

xylene. Also called xylol, this is a coal-tar derivative that is less toxic than benzol. Impure commercial grades may, however, contain substantial amounts of benzol.

spackling The process of repairing a portion of a plaster wall or mural by digging out the defective spot and making a patch with Keene's cement or some other plastering material.

spar varnish *See* WOOD FINISHING.

spatter The technique of spattering ink or paint on a surface, often by running a straightedge along the bristles of a toothbrush loaded with color. The result is an overall dotted effect similar to stippling. Areas that are not to be spattered are first masked out.

sponges Sponges are often used for blending pastels and charcoal, for thinning watercolor washes on paper, and for picking out highlights in oil paintings.

spray products Convenient spray products are packaged in aerosol cans by several manufacturers. Some typical uses include the following.

adhesives. These are quick-drying materials the characteristics of which vary with each manufacturer. Some kinds become permanent adhesives if left in place for a certain period of time.

clear and matte fixatives. Widely used materials for protecting pastels, charcoal and pencil drawings, layouts, type proofs, and artwork of all kinds.

compressed air. Used in certain applications, such as slide production, where clean dry air is used to blow away dust particles and lint.

dammar varnish. A standard varnish in an aerosol can used for the protection of oil paintings.

dulling spray. A material used for eliminating highlights on surfaces that must be photographed or televised.

fluorescent paints. Spray paints used on white surfaces of wood, paper, or glass.

glass frosting spray. A material that obscures vision but admits light when sprayed on glass.

imitation snow. A product used for various decorating applications.

primers. Substances, such as zinc chromate, that are sprayed on bare metal surfaces to provide good bonds.

retouch varnish. Sprays used on oil paintings where parts of the picture have dried flat, and also used to protect paintings until they are completely dry.

rust-release agents. Oil sprays used to free rusted bolts and nuts and other parts that have rusted shut.

spray dyes. Transparent dyes in a fair range of colors. They are best used on porous surfaces, but can also be fixed on nonporous ones. No claim is made for the permanency of these materials.

spray paints. A number of spray lacquers and enamels are produced in a wide range of colors.

stencil inks. A line of spray inks used for filling in stencil patterns without the need for brushes.

synthetic resin varnish. Crystal-clear protective varnishes for artwork, maps, leather, wood, and metal.

ultraviolet absorber fixative. A protective fixative that includes a material to filter ultraviolet light from the sun and from lights. It helps to keep colors from fading.

wood spray stains. Easily applied stains in a range of light and dark wood colors.

spread Copy running across an entire page instead of being held in columns. The term is also short for *two-page spread,* where copy runs across two facing pages.

squeegee

squeegee A rubber blade mounted in a broad wooden handle, similar to the kinds used for window washing. They are used in silk-screen printing to push ink through the mesh onto the paper. In photography they are used to remove excess water from large pieces of film and paper prior to drying.

stabilizer An ingredient in artists' pigments to make them more easily brushed and to keep the oil from separating. Aluminum stearate is commonly used as a stabilizer.

stains *See* WOOD STAINS.

stapler

staplers In addition to standard office-type staplers, used mainly for stapling sheets of paper together, there are also heavy-duty staplers and tackers. The latter are compression devices that drive heavy-gauge wire staples into wood, plaster, and Masonite. Staples

for these hand-operated tackers have leg lengths in a range from
$3/16$ to $1/2$ inch.

stats The word *stat* originally comes from *Photostat,* the trade name
of the Photostat Corporation in Rochester, New York.

Stat machines are now made by a number of companies and
consist essentially of a camera that produces a paper negative of
line work only. If a positive print is desired, two stats are made,
the second of which is a shot of the negative. It is a high-resolution
system with provisions to reduce and enlarge. Its use is fairly inexpensive, as compared with a photographic method using a film negative.

Stat machines are made in a number of sizes and produce line
reproductions of black-and-white artwork on either matte or glossy
paper. Stats are used mostly as the primary art on layouts and
dummies and for the visual scaling of artwork.

statuary bronze Special bronze alloys are used for casting statues
and other ornamental objects. A typical bronze for statuary work
contains 90 percent copper, 6 percent tin, 3 percent zinc, and 1
percent lead.

stay-flat adhesive A temporary adhesive is sometimes useful in
holding film in engraving cameras, keeping large sheets of photographic paper flat when large blowups are made, and holding papers
flat while they are copied. The following mixture can be coated on
a sheet of plywood to produce a sticky surface that will hold such
materials.

Mix 2 ounces (60.0 grams) of golden syrup (such as Karo) with
2 ounces (60.0 grams) of glycerin in 24 ounces (750.0 cubic centimeters) of water. In this mixture soak 2 ounces (60.0 grams) of gelatin
for half an hour, warming it to 120°F.

Dissolve 16 grains (1.1 grams) of chrome alum in 2 ounces (60.0
cubic centimeters) of water and add it to the above mixture. Add
another 6 ounces (180.0 cubic centimeters) of water to the mixture,
making a total of 32 ounces (1.0 liter) of the solution. It is then
strained through cheesecloth.

Each ounce of this adhesive mixture will cover about 100 square
inches. It is applied to the surface of the plywood and allowed to
stand for twenty-four hours. Paper or film will adhere to the surface
with only slight pressure, but will peel off easily. The stickiness of
the surface may be preserved by covering it with acetate sheeting
when not in use.

steel hardening and tempering A steel tool is hardened by heating
it red hot and plunging it into oil, or into water having a small

amount of salt added to it. The sudden cooling makes the steel hard, but very brittle. To overcome brittleness, the tool must be tempered. This is done by reheating it until a certain temperature has been reached, at which time the metal is a characteristic color, ranging anywhere from a pale yellow to dark blue, as explained below.

After steel has been hardened, it should be cleaned with emery cloth until it is very bright. Avoid oil or grease on the cloth, also fingerprints on the cleaned metal surface. The tool should then be reheated slowly, applying heat to the end opposite to the cutting edge. A range of colors will form along the entire length. When the desired color reaches the tip, the tool should be quenched in one of the following baths: water, linseed oil, tallow, or sealing wax. If a very hard point is desired, quench in turpentine.

Following are the colors of steel, in increasing temperature order, and corresponding applications.

light straw (428°F). For steel-engraving tools and light turning tools.

dark straw (469°F). For ivory-cutting tools, planing tools, and hammer faces.

orange (491°F). For leather-cutting tools, blades for shears, wood-engraving tools, and paper-cutting knives.

red (509°F). For bits, knife blades, dies, punches, and picks.

purple (531°F). For wood-boring tools, circular saws for metal, and stone-cutting tools.

bright blue (550°F). For augers, axes, adzes, circular saws for wood, and saws for bone and ivory.

dark blue (600°F). For wood saws, molding and planing cutters for soft wood, and hacksaw blades.

steel wool A mat of fine steel fibers used for cleaning and polishing surfaces of all kinds. Steel wool is available in a number of standard grades ranging from superfine (No. 0000) to coarse (No. 3).

stencil A means of applying patterns with ink or paint. The stencil itself is cut from thin metal or cardboard sheet and the paint or ink is brushed or sprayed into the areas left open.

stereo, stereotype Stereotyping consists of making a duplicate printing plate from type and cuts. A paper matrix, or mat, is forced down over the type and cuts to form a mold, and molten metal is later poured into it. The result is a new metal printing surface that exactly duplicates the original.

Stereotypes are useful for short runs and for cuts not finer than 65 lines (those used for newspapers, for example). For longer runs, and more critical work, electrotypes are usually made.

stereochromy This system is also known as *water-glass painting*. Pigments are ground into a solution of potassium or sodium silicate, which serves as the binder of the paint. It has been used for mural work, but with only limited success.

sticking caps To prevent caps from sticking on tubes of paint, be sure to keep the necks of tubes clean and free of oil color that might dry on them. If a cap cannot be unscrewed with the fingers, a pair of pliers should be used. Another method is to hold the cap over the flame of a match for a few seconds and then grasp it with a cloth.

stipple A stippled area in a drawing is one that consists of many fine dots. Stipple board (such as Ross board) is a kind of illustration board with a pattern of raised dots on its surface. A pencil or crayon drawn across this surface leaves a stippled line, not a solid one.

stopping out The process of stopping certain portions of a plate from further action of the mordant while other portions are etched deeper. It is also sometimes used to protect the back of the plate from etching. Liquid ground is sometimes employed for this purpose, as is asphaltum, but a varnish is better because it has the advantage of drying faster. Some varnishes have a red color so that stopped-out parts can be easily seen.

storyboard A series of small drawings intended to show the sequence and continuity of a proposed motion picture, television production, or slide presentation. Only key portions of the action or story are shown, and this is helpful in visualizing the total idea. Storyboard pads are often used for the drawings. The pads consist of small white areas, shaped like television screens, on a background of dark gray. Beneath each screen area is another box in which copy, for the audio portion, can be written.

stretchers *See* CANVAS STRETCHERS.

stripping film (1) The process of assembling photographic negatives or positives to make printing plates is called *stripping*. The various film elements are assembled on a large piece of yellow-colored opaque paper called a flat (or, from the color of the paper, a *goldenrod*), which is the same size as the plate to be made from it. The negatives are attached in their proper positions with transparent tape and an appropriately sized window is cut out of the flat behind it. (2) A film with an emulsion that can be removed from its base and transferred to another one. In practice, the emulsions from a number

of negatives can be stripped off and remounted on a single plate which is then ready for exposure on a press plate.

stump

stumps Rolled-up pieces of chamois skin or paper. They are made in several sizes and are used for smoothing out tones of charcoal or pastel in drawings. A small stump is called a *tortillon*.

stylus A rather blunt metal point sometimes used in painting to make lightly ruled lines.

styrofoam A polystyrene plastic expanded into a volume about 42 times its original size. It has one-sixth the weight of cork. It is thermoplastic and cannot withstand hot water or temperatures of more than 170°F.

sulfuric acid Also called oil of vitriol, this is a corrosive oily liquid sometimes used in reducers and clearing baths in photographic processing. It evolves considerable heat when mixed with water. Never add water to acid; the explosive reaction can splatter acid and cause serious burns.

sumi ink The Japanese name for an ink made from carbon black and glue. It is molded into cakes or sticks, and ground or rubbed in water for use. It is basically the same as india ink.

sumi reeds Reeds used for drawing in ink. They are about a foot long and have sharp points cut at one end.

support Generally speaking, the underlying material on which pictures are painted; the structure which holds or carries the ground or paint film. For example, canvas is the support for oil, and wood panels form the support for egg tempera paintings.

synthetic resin materials The following notes describe some of the more commonly used synthetic resin materials used in painting.

acrylic resin. A kind of resin used in synthetic paints. It is formed of acrylate and methacrylate resins.

alkyd resins. Synthetic resins used in lacquer paints to provide better flexibility and durability.

copolymer. The basic molecule of a synthetic resin is called a monomer. When many of these basic units are linked together to form a huge molecule, the material is called a polymer. A copolymer is the product of condensing two polymers together, and it is a different product from either material formed by separate polymerization.

In synthetic media, the term "copolymer" is taken to mean any combination of any kind of monomer, but particularly the chemical combination of acrylic and vinyl monomers.

gel medium. A pure polymer emulsion in thick, viscous form. It dries clear and is mixed with polymer emulsion colors to give them the viscosity of oil colors.

gesso (polymer emulsion). A water-base synthetic resin material used for priming canvas and other surfaces. It is flexible and quick-drying, and provides a ground for oils as well as other polymer paints. It is very adherent and can be used on cardboard, plaster, plywood, and Masonite.

gloss medium. A polymer emulsion medium which dries to a shiny finish.

modeling paste. A material consisting of polymer medium and marble dust used for various impasto, modeling, and sculpturing techniques.

monomer. The basic molecule of a synthetic resin; the unpolymerized form of a compound.

polymer. A compound formed by uniting a number of similar molecules into larger molecules. The process of polymerization takes place through the action of heat, light, pressure, or a chemical catalyst. In this manner volatile monomers are converted to stable, elastic polymers.

polymer cement. A mixture of polymer emulsion and cement, used as a sculptural medium.

polymer emulsion pigments. The polymer emulsion paints use most of the same pigments as those used in oil painting. A few pigments, however, react unfavorably with the alkaline emulsions and cannot be used. Viridian and alizarin crimson are examples, and other pigments must be used in their place.

polymer emulsions. A polymer emulsion consists of a suspension of small particles of plastic resin in water. When the water evaporates the particles flow together and form a strong, clear film. This film is waterproof and the dried film is the binder for pigment particles.

Synthetic emulsions do not mix with oil or other studio solvents. They will mix with some other water-base paints and inks. Any such mixture should, however, be checked for compatibility. Acrylic-base and vinyl-base polymer emulsions should not be mixed because the former is alkaline and the latter is acidic.

Polymer emulsion paints should not be diluted too greatly with water, or a weak paint film will result. Colors can be diluted, however, with any concentration of polymer medium.

The layers of polymer emulsion paints expand and contract as a unit. There is no danger of one layer cracking another one. These paints will adhere to almost any surface that is not oily or greasy,

synthetic polymer paint on canvas
Nicholas Krushenick. RED, YELLOW,
BLUE AND ORANGE. (1965) 84 × 71¼
inches. (*Gift of the Friends of the Whitney
Museum of American Art. Collection
Whitney Museum of American Art, New
York.*)

but not to a hard, polished surface such as metal or glass. It can
be used on masonry surfaces, hardboard, Masonite, paper of all types,
and most textiles.

Mild soap and water are the recommended cleaning agents for
a polymer painting, and a note to this effect should be attached
to the back of the work. The solvents normally used to clean an
oil painting could seriously damage a polymer painting.

polymer medium. Both a gloss medium and a matte medium
are available for use with polymer emulsion paints. They are used
for diluting colors to produce transparent effects. The gloss medium
can also be used as a final picture varnish.

T

taboret A taboret is an artist's table, a piece of furniture he can use for his tools and materials. It is often equipped with doors and shelves, and sometimes has a glass top that is used as a palette.

tack, tackiness Adhesive stickiness, such as the surface of a varnish or ink that has not completely dried.

tacking iron *See* DRY MOUNTING.

talc A native magnesium silicate, used as a filler for paints and paper.

tapes There are two general categories of tape; one kind is used for making lines and patterns on artwork, the other for holding, masking, wrapping, and mounting. Both kinds are pressure sensitive. They are divided in the following two sections, TAPES, CHARTING and TAPES, UTILITY.

tapes, charting
 colored tapes (opaque). These tapes are available in many widths and colors. They are made with either matte or glossy surfaces and used for making graphs, charts, floor plans, and layouts.

colored tapes (transparent). These tapes also have either matte or glossy surfaces, and are used widely for audiovisual applications, particularly in transparencies for overhead projection. Mat-surface transparent tapes can be placed over photos and artwork without obscuring important details. Colored tapes are made in widths ranging from $\frac{1}{64}$ to 1 inch.

metallic tapes. Gold tape is available in a number of widths from $\frac{1}{32}$ to 1 inch. It has a number of decorative uses, including embellishment on mats for prints and paintings. Silver tape is used both for decoration and, because of its sharp, clean edge, as a masking film.

pattern tapes. These are used for charts, graphs, borders, and layouts. Dotted lines, stars, arrows, dots, diamonds, and many other symbols are available.

tapes, utility

cloth tape. Strong, waterproof cloth tapes are made in a number of colors and are used for various decorative purposes and for binding such things as folders and portfolios.

double-coated tape. Tape with adhesive on both sides used for mounting and other applications where a two-sided adhesive is needed. It is made with both a tissue and a transparent base.

drafting tape. A thin crepe-paper tape used to hold down drawings, blueprints, tracings, and other artwork to drafting boards and other surfaces. This tape can be removed without lifting the surface to which it has been applied. For this reason it, and not *masking tape,* should be used in drafting applications.

electrical tape. A black plastic or cloth tape used for a variety of electrical and nonelectrical repairs.

masking tape. A crepe-paper tape made in a variety of widths and used for all sorts of paint masking applications.

passe-partout binding tape. A gummed tape used for framing pictures. The picture, or photograph, is placed facing a sheet of glass of the same size. The two are sealed together by running passe-partout tape around the edges.

photographic tape. An opaque, black paper tape used in photographic applications such as making masks and blocking out negatives.

red lithographers' tape. A transparent, ruby-red tape used on portions of negatives to block them out. Offset plates and high-contrast orthochromatic line films are not sensitive to red light.

red opaque tape. An opaque tape used on artwork that is to be shot with orthochromatic film which "sees" red as black. The tape is used for making lines and windows in negatives.

splicing tapes. Various tapes are produced for splicing motion picture films and recording tapes.

transparent tapes. These tapes are made on a base such as cellophane or acetate film and are used in a variety of splicing, mending, and holding operations.

white correction tape. A lightweight, opaque white tape used for making corrections on white surfaces.

tarlatan A soft cloth used for wiping plates in the etching process. It is a strong, very absorbent cloth made in several grades, weights, and weaves. It will not mar or scratch plates. In some cases, cheesecloth is also used to wipe plates.

T chisel A boring tool used in sculpture. It has a cutting edge in the shape of the letter T.

tempera Strictly speaking, tempera is an opaque watercolor paint consisting of pigment ground in water and mixed with egg yolk. Tempera is also a term used to describe a poster paint that uses glue or gum as a binder.

Egg tempera is best used on a gesso ground prepared over a wood support, and is usually applied with sable brushes. It can be made with most pigments normally used for oil painting, with the exception of the poisonous ones. Pigments are mixed with distilled water to a stiff paste and kept in glass jars, preferably ones with plastic tops. (The colors will last indefinitely if a little water is added from time to time to prevent their drying out.)

For use, an egg is broken and the yolk separated from the white by passing it between the shells, and then from one hand to the other. When dried, the yolk sac is punctured and the contents drained into a clean jar. The sac is discarded. About $\frac{1}{2}$ teaspoon of water is then added to the egg yolk and the mixture is stirred. Equal amounts of egg and pigment paste are then mixed together to form the egg tempera paint. To make a thinner brushing consistency, more water can be added. Tempera colors dry out lighter because of the difference in refraction of the air which replaces the water. The yellow color of the egg yolk, however, has little effect on colors.

The egg will spoil in a short time, usually after a couple of days, and another must be prepared.

It is not necessary to varnish a completed egg tempera painting.

tempering When metal is hardened by quenching it is made very brittle. Tempering is a reheating process that removes this brittleness. *See* STEEL HARDENING AND TEMPERING.

terra cotta A brownish-orange brick clay used in the production of high-quality earthenware, vases, statuettes, and for tile floors and roofing.

terra cotta Jo Davidson. FEMALE TORSO. (1927) 22½ inches high. (*Collection Whitney Museum of American Art, New York.*)

tessara An individual unit of a mosaic. The plural form is *tessarae* and these are the small pieces of ceramic tile, stones, or other materials used in the design.

theatrical scene paint *See* SCENE PAINT.

thermography Raised printing that resembles authentic engraving. A job is printed with ordinary type but, while the ink is still wet, a special resinous powder is sprinkled on it. It is then heated and the fused resin material raises slightly to produce the effect of raised lettering. It is used on business cards, letterheads, envelopes, announcements, and greeting cards.

thermoplastic, thermosetting *See* PLASTICS.

thinner Technically a diluent rather than a solvent, a thinner is used to produce a better brushing consistency in a painting medium.

tint block Cuts used to produce areas of plain, solid color. No etching is needed, since they are simple flat shapes.

tip-ins Occasionally halftone illustrations on smooth, coated paper are inserted on pages of a book printed on rough paper. A blank space is left on the rough page and the halftone is attached (tipped in) by a narrow coating of paste applied at the top edge. The term is also used to describe the insertion of a plate or full-page illustration on smoother or heavier stock than the rest of the book.

tjanting needle The traditional tool for applying wax in the batik process. It is used for fine line work and for outlining areas to be filled in by brush. The melted wax flows out from the fine needle spout.

tjanting needle

toners *See* PHOTOGRAPHIC TERMS.

tooth The coarse or abrasive quality of a paper or a painting ground that assists in the application of charcoal, pastels, or paint. Also, a paper texture that holds ink more readily.

tortillons Small stumps used to spread or smooth charcoal, pastel, and pencil drawings. They are made of chamois or soft paper rolled to a point and are used in the execution of delicate work.

tortillon

tracing tables (tracing boxes) *See* LIGHT TABLES (LIGHT BOXES).

traction A defect in a paint coating in which the film cracks and

wide fissures reveal the underlying surface. This condition is also called *crawling* or *creeping*.

transfer method The following method may be used to transfer a drawing to canvas. Coat newsprint with a dark, powdered pigment (such as burnt umber) and shake off the excess. Place it on the canvas by taping the corners. The drawing is then placed on top of this and the pattern traced with a sharpened stick. The paper can be lifted from time to time to check the results, and the lines can be intensified with diluted paint if need be.

transferring A process of taking a crayon drawing on a special material called gesso paper and printing it on a stone. The stone is then used to produce lithographic prints. It also refers to the method of taking a print on gesso paper from one stone and transferring it to another.

transparentizing fluid Various fluid materials are available from drafting supply houses to make drawing papers, even heavy ones, transparent to light. The use of such a fluid is helpful when printing through old or soiled drawings. The liquid does not affect pencil or ink drawings.

tubes Oil paint, casein, watercolor pigments, and other paints are sold in collapsible metal tubes with screw caps. These tubes are made in several sizes ranging from those holding a pound of paint to those which are only 2 inches long and about $\frac{1}{2}$ inch in diameter. The smallest are used for watercolors. The first metal tubes were manufactured around 1840. *See also* STICKING CAPS.

tung oil *See* DRYING OILS.

tusche A liquid lithographic ink that can be used with pen or brush on lithographic stones or metal plates. It is also used in the silk-screen process in a glue-resist system of pattern making. Tusche is an extremely greasy material.

TV pads *See* STORYBOARD.

tweezers There are many occasions in arts and crafts work where tweezers are very useful. They are widely used in paste-up work and in assembly operations of all kinds, particularly in model making. Tweezers are made with round, square, and pointed ends. Some are built with reverse action, and hold materials until pressure is applied to force the arms apart.

typographic terms and equipment Following are some of the standard terms and common equipment used in typography.

agate line. Fourteen agate lines equal one column inch. It is the standard measurement for the depth of columns in advertising space.

agate type. A small size of body type, used mostly in the printing of classified advertising and market reports.

ascender. The part of a lowercase letter that extends above the body of the letter as in b or d. The size of a typeface is measured from the top of the tallest character to the bottom of the lowest descender.

base. The metal below the shoulder of an individual piece of type.

bearer. In composition, the type-high slugs that are locked up in the chase to protect the printing surface.

body type. Type used for straight composition in paragraphs or pages of one face. It is distinguished from display type used for headlines.

border. A line or design around an illustration. It may be drawn on the artwork or later engraved on the negative.

brownline. A white background brownline print made by contact printing a negative on sensitized paper rather than on a plate. It serves as a final check of copy and alignment before the plate is burned and the job printed. It is also called a *brownprint,* a *van Dyke,* or a *silverprint.*

casting off. Computing the amount of space a manuscript will occupy when set in type of a particular size and face. Different typefaces of the same size will set up very differently.

character. Any unit of type. It may be a letter, a numeral, a punctuation mark, or the space between words.

cold type. This refers to systems that produce composition by direct impression, and most consist of typewriters or similar equipment such as that made by IBM, Justowriter, or VariTyper. Another definition refers to the hand-setting of foundry type or the use of transfer type. *See* TRANSFER TYPE *in this section.*

composing rule. A piece of brass or steel against which type is placed in setting.

compositor. One who sets type, composes and arranges it, and prepares it for printing.

Coxhead liner. A photographic composing machine made by the Coxhead Corporation. It sets display type in sizes from 14 to 72 points.

descender. The part of the letter extending below the main body, as in g or p.

display type. Large type, usually 14 point or larger, normally used for headlines and advertising material.

face. (1) A particular size or style of letter as distinguished from another size or style. (2) The printing surface of a plate, or the front side of a piece of paper.

font. A complete assortment of all the different characters of a given size and style of type.

foundry proofs. Proofs of this kind are identified by black bands around each page of type. These are caused by bearers that lend support to the type page when stereotypes or electrotypes are made. Proofs are received from a printer in the following order: galleys, revised galleys, page proofs, revised page proofs, foundry proofs, and plate proofs. The last two are needed only if duplicate plates are being made.

galley, galley proofs. A galley is a shallow metal tray used to hold type, and each one holds enough for two or three book-size pages. Proof pulled before the type is divided into pages is called galley proof. It is usually about 6 to 8 inches wide by about 24 inches long and made with wide margins so that proofreader's marks can be made.

justification. In type composition, the adjustment of words and characters so that each full line of type fills a specified space. Type may be justified against a left margin (flush left), a right margin (flush right), or both margins (full measure).

keep standing. To hold type so that it can be used at another time. It refers to both metal type and film.

leading. Insertion of space material between lines of type composition to increase readability or to expand the text to a specified body of column length. The term derives from the thin strips of type metal, or "lead," inserted between hand-set lines, but today most leading is cast into the body of the type.

Linotype. A trademarked name for a method in which the type molds of letters are arranged in lines, and solid slugs or lines of type are cast. To make a correction, the entire line must be reset and recast.

Ludlow. A trademarked method of typesetting that uses hand-set matrixes from which lines of type are cast. New type is cast for each job and never reused.

make-ready. The process of adjusting type on a press so that it yields the best impression possible. Type and cuts must be set evenly and exert exactly the right pressure on the paper.

Monotype. A trademarked name for a system in which each type character is cast as a separate piece of type. Corrections are made by hand from a case of handsetting type.

phototypesetting machines. Devices that compose justified text matter on photographic film or paper. Copy is usually produced by operating a keyboard, and some of the better-known systems bear the following trade names: ATF Photo Typesetter, Filmotype, Foto-

character-size chart: gauge indicates
height of capitals

setter, Fototronic, Linofilm, Monophoto, and Photon. The reproduction is generally of very high quality, and changeover from one size or face to another requires little time.

pica. The width and depth of columns, and the size of margins, are measured in picas instead of inches. A pica is 12 points, or almost exactly $\frac{1}{6}$ inch. One foot is about 72 picas.

point. The point system is a method used to standardize type sizes. One point is $\frac{1}{12}$ pica, or approximately $\frac{1}{72}$ inch. The point system is also used to measure the depth of a line. There are 72 points to the inch. This line is set in 10-point type leaded 2 points, generally referred to as 10/12-point type.

proportional rule. A rule, often circular, for computing the proportions on enlarged or reduced photographs and artwork. The rule provides the number of times of reduction, percentage of size, plus the new proportions. Some also give information about exposure time, lens settings, and process-camera position settings.

repro, reproduction proof. Page proofs made with great care on smooth paper and used for photographic reproduction. They smudge easily and must be handled with care. They are sometimes called *slick paper proofs.*

transfer type. Adhesive-backed letters mounted on paper or plastic sheets. They are transferred to artwork by burnishing or rubbing. They are sometimes called dry transfer type. They are available from several companies in numerous colors, faces, and sizes.

U

ultraviolet absorbers Certain spray products are now manufactured that contain ultraviolet absorbers, notably a clear fixative used to help protect dyes and pigments from fading. Other materials are available for addition to plastic formulations to help prevent the crazing, embrittlement, and discoloration brought on by the effects of ultraviolet light.

underpainting A layer of paint that is intended to be seen through a subsequent paint layer. An underpainted section of red, for example, can be altered to a violet or purple color with the application of a thin, blue glaze.

urethane foams The most common forms of urethane plastics are foams, and these are available in flexible, semirigid, and rigid types, each with several density grades. They have high strength, low density, and good abrasion and chemical resistance.

Polyurethane foam is available as a two-component system for preparation of a rigid, low-density, foam-in-place compound. It has good adhesion to itself, and also to many other plastics, and to paper, wood, glass, and metals. Release agents include polyethylene film, carnauba waxes, silicone materials, and machine oil.

In use, the two components are mixed in the specified ratio and

poured into the mold or cavity. The foam rises immediately, hardens within a few minutes, and can be machined and cut after a few hours. It can be cut and shaped with woodworking tools.

The tools and containers used in foam preparation should be cleaned, before the foam sets on them, with a mixture of 1 part alcohol and 1 part hydrocarbon or ketone solvent such as benzene. MEK (methyl ethyl ketone) can be used quite effectively. Disposable paper containers should be used wherever possible.

When working with foams, protective clothing, goggles, and gloves must be worn and forced ventilation must be used to keep fumes away from the operator. Once the foam has set up it no longer has any toxic effect.

Rigid urethane is on the market under several names as a sculpturing material. It can be foamed in various densities, anywhere from 2 pounds to the cubic foot to 32 pounds. The 6-pound density is said to have a response similar to soft wood.

V

vacuum printing frame Vacuum printing frames are employed in the graphic arts to keep materials flat or to keep them in absolute contact with one another. They are useful in making positives, contact prints, screened tints, and plates.

varnish A resin solution in a drying oil. A common resin is ordinary rosin, and the most common drying oils are linseed and tung oils. Spirit varnishes are those containing alcohol or ether, and they dry by evaporation of the solvent. When varnishes are mixed with pigments they become enamels. Dammar is the varnish usually used on oil paintings.

varnishing paintings After an oil painting is completed and has dried thoroughly, it must be given a coat of varnish to protect it from atmospheric dirt and moisture.

Retouch varnish is considered a temporary varnish and is applied when the surface of the oil painting is dry to the touch. It consists of 5 parts dammar varnish (5-pound cut) mixed with 13 parts gum turpentine.

Final picture varnish is applied after the painting has dried thoroughly. Paintings with moderate impasto may be varnished after about six months, while those with heavy impasto may require a

year's drying time. Final picture varnish is made with 4 parts dammar varnish (5-pound cut) and 1 part gum turpentine. Up to 5 percent stand oil can be added.

Before varnishing, the painting should be cleaned with a soft, lintfree cloth. Varnishing should take place on a dry day, with the painting surface and the brush free from any moisture. The varnish should be applied methodically, one area at a time. If the varnish dries with a few dull spots, these may be eliminated later by rubbing in a small quantity of painting medium.

Velox The trade name of one of the chloride printing papers made by Eastman Kodak. This term is sometimes used as a general description of a photographic print.

velvet painting The use of oil paint on velvet is not a permanent painting method. The linseed oil causes the material to deteriorate and become brittle.

verdaccio A neutral, brownish color used in underpainting and also in outlining. It may be composed of various combinations of browns and other colors.

vermiculite An expanded mica material sometimes used as a textural material in painting. It is also used as an aggregate in certain plaster formulations used in sculpture.

verso The left-hand page in a book is a *verso* page; the right-hand page is the *recto*.

vignette To lighten the edges of a photograph or a halftone illustration so it gradually disappears into the surrounding white of the paper, leaving no sharp edge.

visible light Visible light falls within the region between 400 and 700 mμ (millimicrons) wavelength, with the following divisions of color: violet, 400–450 mμ; indigo, 450–460 mμ; blue, 460–500 mμ; green, 500–580 mμ; yellow, 580–590 mμ; orange, 590–620 mμ; and red, 620–700 mμ. The wavelengths shorter than 400 mμ are known as ultraviolet; those longer than 700 mμ are known as the infrared. Both of these, although invisible to the human eye, can be recorded on certain photographic films.

W

walling wax When a large plate must be etched and there are no trays large enough to accommodate it, walling wax (sometimes called *bordering wax*) is used. This material becomes soft in hot water and can then be molded around the edge of the plate to form a tray. After the etching is complete, the wax may be peeled off and used again later.

walnut oil *See* DRYING OILS.

water Water is used as the thinner in gouache, tempera, aquarelle, and fresco. If ordinary tap water has too much mineral content—a characteristic of "hard" water—it is apt to cause some emulsions to separate from each other, and some watercolors may curdle. If this happens, distilled water should be substituted.

water-base paints Water-base paints include such materials as gouache, designers' colors, watercolors, tempera, and polymer paints.

 The transparent paints include artists' watercolors, brilliant watercolors, certain drawing inks, certain airbrush colors, and finger paints.

 Opaque watercolors include tempera colors, gouache colors, designers' colors, polymer paints, poster colors, some drawing inks, most

airbrush colors, water-soluble block-printing inks, and process or silk-screen colors.

watercolor binder Watercolor binder can be made by dissolving 3 ounces of gum arabic in 6 fluid ounces of very hot distilled water, and then adding $1\frac{1}{2}$ fluid ounces of glycerine as a plasticizer. A very small amount of oxgall, or a photographic wetting agent (such as Kodak Photo-Flo solution), can be used to make the paint spread more easily. For the appropriate pigments to use with this binder, see WATERCOLOR PIGMENTS.

watercolor painting display Since watercolor paintings cannot be cleaned, they must be protected by glass in a frame. The glass should be separated from the picture by a thickness of cardboard mat made from a rag cardboard. Cardboard made from wood pulp can stain the painting.

watercolor paper The best watercolor paper is made from linen rags. No chemicals are used other than a mild bleach, and the pulp is run over a fine wire screen, dried, and pressed. Good paper is heavy and preserves its shape well even when wet. Rough grains of paper create better depth of tone.

watercolor paper wetting Many watercolor papers are prepared for painting by wetting them, taping them to a board, then allowing them to dry. To test to see if enough moisture has been absorbed by the paper, lay the wet paper on a clean, flat surface. Extend the paper a couple of inches beyond the edge and bend down a corner. If it snaps back quickly it is not wet enough. If it remains bent down, it is too wet and should be allowed to dry out a little. If the corner comes back to position slowly, it is just right and can be taped to the board.

watercolor pigments The following are permanent pigments used in watercolor painting.

> WHITE: Chinese white (zinc white) and titanium oxide
> YELLOW: Cadmium yellow (light, medium, and deep), mars yellow, ocher, cobalt yellow, and strontium yellow
> ORANGE: Cadmium orange and mars orange
> RED: Cadmium red (light, medium, and deep), alizarin red, mars red, indian red, light red, and cadmium maroon
> VIOLET: Cobalt violet, mars violet, and manganese violet
> BLUE: True cobalt blue, cerulean blue, ultramarine, manganese blue, and phthalocyanine blue
> GREEN: Chromium oxide green, viridian, green earth, cobalt green, phthalocyanine green, and ultramarine green

BROWN: Alizarin brown, burnt sienna, raw sienna, burnt umber, raw
umber, and burnt green earth
BLACK: Lampblack, mars black, and ivory black

watercolor technique The watercolor painter must remember that
his approach is sometimes quite different from that of the painter
in opaque mediums such as oil paint. In oil painting, whites are
opaque. In watercolor painting, the paper creates the white. Also
in watercolor painting, a color can be built up with several applica-
tions of a diluted color, but no color can be covered by overpainting.
The watercolor painter uses tissues, sponges, and other materials to
create patterns or to lift color out of his painting. Razor blades are
often used to create various textures and effects.

watercolors Watercolors consist of a pigment ground in a solution
of gum arabic, water, and a plasticizer such as glycerin. The glycerin
keeps the color from drying in the tube and keeps the resulting paint
film from becoming brittle. Transparent watercolors are called
aquarelle, and opaque ones *gouache,* the latter having a white pigment
added to it. Watercolors are available in tubes or cakes. Professional
grades are higher in price, while student grades are cheaper, but
of somewhat lower quality. Impure watercolors, or very hard water,
can affect the working quality of paint and its color, and can discolor
and spot the ground. Good-quality watercolors possess maximum
optical brilliance and purity, good brush response, and smoothness
of texture. They should be quite transparent if used in aquarelle,
and mix well with each other.

waterproofing photographs If prints are to be displayed outdoors,
or are to receive hard handling, they may be waterproofed with
commercially available preparations such as Kodak W.P. solution.

wax-coating machines Machines of various sizes that apply a
pressure-sensitive coating of wax to the backs of proofs, stats, photos,
overlays, and other materials. Artwork so treated is then burnished
onto another surface, paper or otherwise, where it adheres securely.
It can be shifted, or lifted entirely and repositioned, without rewax-
ing. Smaller, hand-held coaters roll on a narrow width of wax. Both
have electrically operated heating elements.

waxes Various waxes have been used in the arts and graphic arts
for numerous purposes. They are sometimes used as surface coatings
for paintings and sculpture, as the binder in encaustic painting, and
as a plasticizer or stabilizer in the manufacture of paint. Following
are a few of the more common waxes.

 beeswax. This material is used in protective coatings, as an

ingredient in adhesives, and as a modeling substance. Beeswax when new is light yellow, but it turns brown with age. It melts at about 65°C. It is bleached with acids or with sunlight.

candelilla wax. A hard, brownish, brittle wax used in the manufacture of certain lacquers and varnishes where a high gloss is desired.

carnauba wax. A hard wax obtained from a deposit on the leaves of the Brazilian palm. It is yellowish gray in color, harder than beeswax, and has a high melting point. It is used in wax mixtures where a high gloss is desired.

ceresin wax. A mineral wax, harder than paraffin, that is very white in appearance. It is used for surface coatings on sculpture and other objects.

paraffin wax. A petroleum distillate, commercial paraffin wax is white to bluish white in color, and soluble in mineral oils and benzene.

web, web-fed press When paper pulp moves through a papermaking machine, it is converted into a continuous web of paper. This web is sometimes cut into sheets or is accumulated on rolls. Certain printing presses are designed to accept paper from rolls instead of sheets. They are called web-fed presses. Large web presses offer great speed and economy for long press runs, but high make-ready and plate costs make them too costly for short runs.

weights, measures, and conversion factors The following tables are for direct conversions.

Grams to Grains		*Grains to Grams*		*Grams to Ounces*		*Ounces to Grams*	
g	grains	grains	g	g	oz	oz	g
1	15	1	0.06	5	.18	1	28.3
2	31	2	0.13	10	.35	2	56.7
3	48	3	0.19	15	.53	3	85.0
4	62	4	0.26	20	.71	4	113.4
5	77	5	0.32	25	.88	5	141.7
6	93	6	0.39	50	1.76	6	170.1
7	108	7	0.45	100	3.53	7	198.4
8	123	8	0.52	150	5.29	8	226.8
9	139	9	0.58	200	7.05	9	255.1
10	154	10	0.65	250	8.81	10	283.5
15	231	15	0.97	300	10.58	11	311.2
20	309	20	1.30	350	12.34	12	340.2
25	386	25	1.62	400	14.10	13	368.5
30	463	30	1.94	450	15.87	14	396.9
35	540	35	2.27	500	17.63	15	425.2
40	617	40	2.59	600	21.16	16	453.6
45	694	45	2.92	800	28.21	24	680.4
50	772	50	3.24	1,000	35.27	32	007.2
75	1,157	75	4.86				
100	1,543	100	6.48				
500	7,716	500	32.40				
1,000	15,432	1,000	64.80				

Grains to Ounces		Ounces to Grains		Fluid Ounces _to_ Cubic Centimeters		Cubic Centimeters _to_ Fluid Ounces	
grains	oz	oz	grains	fl oz	cc	cc	fl oz
30	.07	0.1	44	1	30	50	1.69
50	.11	0.2	88	2	59	75	2.54
60	.14	0.3	131	3	89	100	3.38
80	.18	0.4	175	4	118	150	5.07
90	.21	0.5	219	5	148	175	5.92
100	.23	0.6	262	6	177	200	6.76
150	.34	0.7	306	7	207	225	7.61
200	.46	0.8	350	8	237	250	8.45
250	.57	0.9	394	9	266	300	10.14
300	.69	1.0	438	10	296	350	11.83
400	.92	2.0	875	11	325	400	13.52
500	1.15	3.0	1,313	12	355	450	15.21
750	1.72	4.0	1,750	13	384	500	16.91
1,000	2.29	5.0	2,185	14	414	750	25.36
2,000	4.58	6.0	2,625	15	444	900	30.43
3,000	6.88	7.0	3,060	16	473	1,000	33.81
4,000	9.16	8.0	3,500	24	710	2,000	67.63
5,000	11.45	9.0	3,940	32	946	3,000	101.44
6,000	13.75	10.0	4,375	64	1,892	4,000	135.26
7,000	16.00	16.0	7,000	128	3,785	5,000	169.07

conversion factors. To make small quantities from a formula involving large amounts, the following reduction step is useful: convert pounds to ounces by multiplying by 16; convert gallons to fluid ounces by multiplying by 128 (if quarts, multiply by 32; pints, by 16).

If a recipe requires 6 pounds of dry material and 1 gallon of water, you will convert to 96 ounces and 128 fluid ounces.

Now find a figure that will divide both amounts into conveniently measurable terms. The number 32, for example, will divide to produce 3 ounces and 4 fluid ounces—an easily handled small amount. (If your arithmetic is shaky, successive divisions by 2 will take longer, but will yield the same result.)

welding To unite metal parts by melting the surfaces of the parts to be joined, either with or without additional molten material. Also, to hammer or compress the materials to be joined without previous softening by heat.

Among the standard methods is oxyacetylene, which utilizes the flame temperature of oxygen and acetylene for welding, brazing, and cutting. Arc welding, or stick electrode welding, utilizes an arc struck between an electrode and the part to be welded. The metal is fused at both ends of the arc and the fused electrode deposited in the joint in a series of layers until it is filled. The arc is kept as short as possible to minimize oxidation. There are some systems of welding which employ gases, such as CO_2, to eliminate oxidation. Resistance welding

is a method in which the two pieces to be joined are pressed together, and then a large electric current is passed through the joint until it reaches welding temperatures. *See also* BRAZING *and* SOLDERING.

whitewash A simple mixture of hydrated lime and water used mostly for painting fences and outbuildings. Common whitewash is not water-resistant and rubs off easily. The more expensive whitewash powders contain a binder.

whiting Powdered chalk, native calcium carbonate, used in grounds for certain kinds of painting and also for gilding.

wood block (woodcut) A picture, design, or lettering carved on a block of wood with hand tools. The nonprinting areas of the block are carefully carved away, and only the raised areas of the design carry the ink. A woodcut differs from a wood engraving because the design is carved along the side of the block parallel with the grain, rather than perpendicular to it. It is therefore characterized by broad areas and strokes running with the grain.

wood-block printing Prints can be made from wood blocks by use of a press, a baren, or the following process. Place about 20 sheets of newspaper on a smooth floor and cover with a clean piece of paper or cloth. On this put the sheet of paper to be printed. Carefully place the inked block face down on this sheet of paper, then cover the block with a piece of cloth. You may now stand on the block, being certain to exert pressure on all corners as well as the middle.

wood-block printing tools There are numerous knives and chisels used in wood-block carving. The traditional Japanese chisels include the flat chisel (*Aisuki*), the long flat chisel (*Soainomi*), the U gouge (*Komasuki*), the long U gouge (*Inarunomi*), and the V gouge (*Sankakuto*).

wood-carving tools The tools normally used in wood carving consist of adzes, chisels, gouges, files, and rasps. All vary in size and shape. The gouges may run from $1/16$ inch to over an inch in width, with a variety of curves on the cutting edge. Chisels are of different widths and shapes. Mallets are sometimes used for larger, heavier work, and a variety of screws and clamps are available for holding the work steady. *See also* WOODWORKING TOOLS.

wood cleaner A useful wood cleaner can be made from a mixture of 1 part acetone and 4 parts pure ethyl alcohol. It is applied with a soft cloth and will not darken wood.

color wood-block print Sharaku. THE ACTOR, MATSUMOTO KOSHIRO IV. (Eighteenth century.) $14\frac{3}{8} \times 9\frac{3}{4}$ inches. (*Courtesy of the Denver Art Museum, Denver, Colorado.*)

Adz

Chisel

Gouge

Mallet

wood-carving tools

wood engraving An engraving carved on the edge grain of a piece of wood. Wood engravings are capable of rendering much finer detail than wood blocks (woodcuts) because they are not constrained by the flaw of the grain. By the same token, however, they are much harder to carve.

wood-engraving tools A graver, also known as a solid burin, is used primarily for making straight lines, while a spitsticker is used for curved lines. Tint tools are used to lay tints of even lines, the width of which depends on the size of the tool. Scaupers, also called scorpers or scoopers, are clearing tools for the lowering of unwanted surfaces of wood. Multiple tools are threading tools used for engraving two, three, or more lines at once.

Knives are also used for defining various lines and shapes. These are of various sizes and shapes, some held like a pen, and others grasped in the fist.

wood filler A paste filler designed to fill open-grained woods such as ash, chestnut, mahogany, and oak. It enters the pores of the wood and completely fills them. It is then possible to make an extremely smooth surface on the wood with finishing coats of varnish or lacquer and wax.

wood finishing After wood has been satisfactorily shaped, sanded, and otherwise smoothed it sometimes must be filled. The filler is applied, then wiped off and allowed to dry. It is then sanded lightly across the grain of the filled wood. When filler is used with dark-colored or stained woods, it must first be tinted the same color. If applied as is, it will tend to dry quite light.

After the wood has been filled it may be desirable to apply a coat of sanding sealer. This material is intended to size or seal the wood to prevent the penetration of subsequent coats, and also to fill slight imperfections and roughness left by the wood filler. No more than one coat of sanding sealer should be used, after which the surface should be lightly sanded. The surface is then ready for a finish coat.

Three of the favorite materials for finish coats are brushing lacquer, shellac, and spar varnish.

brushing lacquer. A fast-drying finish for wood and furniture, and also for surfaces such as metal and glass. It usually dries in about an hour. A subsequent coat can be applied after about two hours. It should not be applied to recently painted, varnished, or enameled surfaces.

shellac. The product of the lac bug, an insect native to India. When this pure material is dissolved in alcohol it is used as a sealer and a finish coat. When 5 pounds of shellac are dissolved in 1 gallon

of alcohol, the mixture is called 5-pound cut. For general use a 2-pound cut in multiple coats is best. Two thin coats are better than one thick one. Five-pound cut shellac can be reduced to 2-pound cut by mixing equal parts of shellac and alcohol. Shellac is also useful as a seal coat when staining porous woods. It is used in diluted form, 1 part 3-pound cut shellac to 5 parts alcohol. It seals the more porous and absorbent parts of the wood so that a smooth tone is achieved when the stain is applied about four hours later. Three-pound cut shellac is made by mixing $\frac{7}{8}$ pint of alcohol with 1 quart of 5-pound cut.

spar varnish. A clear varnish that produces a tough, elastic, and durable film. It is resistant to water (both salt and fresh) and also to sunlight and wind. It dries in about three hours and hardens in about twelve hours.

If several coats of lacquer or varnish are used, the surface should be sanded between each coat. Sanding will remove embedded specks of dust and level off any minute unevenness in the finish. It should be done with fine cabinet paper and very light pressure.

After a lacquered surface has received the last coat, it should be allowed to dry for several days. The surface will then have fine particles of dust and lint, and possibly some "orange peel" effect. It will not have the warm, mellow appearance of rubbed and polished wood.

To create this effect, the surface must be sanded with wet or dry sandpaper no coarser than 320, usually 360. A wetting liquid (such as a mixture of petroleum rubbing oil and mineral spirits) may be used at this point. When sanded the surface will then be uniformly dull and finely scratched. It is then rubbed with powdered triple F pumice and rubbing oil, a light grade of lubricating oil. If a glossier finish is desired, rottenstone, or a proprietary paste rubbing compound, can be used. After this is completed evenly, the surface can be waxed with a good paste wax.

wood pulp The broken up fibers of wood used in papermaking. Mechanical pulp is produced by grinding and soaking the fibers. Chemical pulp is made by separating the fibers of wood chips by the action of alkalies or acids.

wood stains There are numerous ways of staining and coloring wood. A few of the better-known techniques are listed below.

alcohol stains. Prepared by dissolving about $\frac{1}{2}$ ounce of dye to 1 quart of alcohol. These stains are available from building supply houses, but the variety of shades is limited.

chemical stains. Prepared in a number of ways, and cause a reaction that permanently colors wood.

Antique-gray colors are achieved by placing iron filings or nails in

a glass container with 1 pint of vinegar. This solution is left to stand overnight, and then is strained and applied to the wood with a brush.

Light-brown colors are achieved with a mixture of 2 ounces of household lye dissolved in 1 quart of water. If sal soda is used instead of lye, a *yellowish brown* is produced.

Medium-brown effects are produced with a solution of 2 ounces of permanganate of potash crystals dissolved in 1 quart of water. Varying the amount of crystals will vary the depth of color.

Dark-brown effects are produced on oak by a mixture of 26 percent ammonia (available from a paint dealer) and water.

Black effects on wood are achieved by painting the surface with a mixture of $2\frac{1}{2}$ ounces of cupric chloride, $2\frac{1}{2}$ ounces of potassium bichromate, and 32 ounces of water. When the surface has dried, apply a mixture of 5 ounces of aniline hydrochloride and 32 ounces of water. If a yellow powder forms it should be wiped off. The process is repeated until the desired shade of black is obtained. The surface should then be rubbed with boiled linseed oil.

The above chemical stains must never be stored in anything but *glass* containers. They are very caustic and care must be exercised in using them. Wear rubber gloves and protect the eyes.

penetrating oil stains. Available from various manufacturers and consist of aniline dyes dissolved in naphtha, benzine, or turpentine. They can be used on all kinds of wood, but they will not produce the same results on all types. These stains are available in a limited number of colors.

pigment oil stains. Prepared by using actual pigment colors instead of dyes. The powdered pigment is mixed with linseed oil to form a paste, and the mixture can be thinned with turpentine. (Artists' oil paint can be used for small jobs, but would not be economically practical for large surfaces.) Powdered pigments are available from a paint dealer, and virtually any color can be produced.

varnish stains. Made of varnish and a penetrating oil stain. They are hard to control and very often streak.

water stains. Not available as prepared materials. The dyes are obtained from a paint dealer in powder form. For use, 1 quart of boiling water is poured in a metal container and 1 ounce of dye stirred in. Almost any color can be produced with water stains.

woods Wood is an excellent sculpting medium because of its natural warmth, tonal variations, and the ease with which it can be cut. The wood used for carving must be well aged, or it may crack as it dries or shrinks.

Trees native to the United States are of two classes—hardwoods, which have broad leaves; and softwoods, which have scalelike or

needlelike leaves. Softwoods are also called conifers, because all native species bear cones of one kind or another.

The terms "hardwood" and "softwood" cannot be relied upon as an index to the hardness of the wood. Some hardwood trees, such as the cottonwood, have softer wood than the white pine. Some softwoods, such as Douglas fir, produce wood that is as hard as basswood.

Following are some of the woods, domestic and foreign, that are popular for sculpting and fine woodwork. The lighter the weight per cubic foot, the softer the wood.

Alaska cypress. Sometimes known as *yellow cedar,* this is a variety of softwood timber used widely in carving. It weighs about 35 pounds per cubic foot.

alder. A wood having a reddish-brown color. It has an even grain, is easily worked, and takes a high polish. It weighs about 35 pounds per cubic foot.

amaranth. Also called *purpleheart,* a hardwood imported from the Guianas. The wood is brown when cut, but turns purple on exposure. It has an open grain and an even texture. It weighs about 53 pounds per cubic foot.

ash. There are a number of varieties of ash, ranging in color from white to dark brown. The grain is broad and strongly marked. It is a fairly tough wood to carve. It weighs from 40 to 45 pounds per cubic foot.

avodire. A light-colored African hardwood used for decorative work. *Ayous* is a wood similar to it, but softer.

balaustre. A bright orange-colored wood imported from South America.

balsa. This is the lightest of the commercial woods, weighing only 8 to 10 pounds per cubic foot. It is quite strong, easily worked, and has long been a favorite of model makers, particularly of aircraft.

balsam fir. This wood is neither strong nor very durable. It is a brownish white in color, soft, and has an even grain. It weighs 26 pounds per cubic foot.

basswood. A hardwood, the product of several species of lime trees native to the United States and Canada. Also called linden, it has an even texture and is easily worked, but it is not very strong or durable on exposure. It takes stain well, and weighs about 26 pounds per cubic foot.

beech. This wood is strong, fine-grained, and durable. It varies in color from grayish pink to warm light red. It carves and polishes well and readily takes stain. It weighs 47 pounds per cubic foot.

birch. There are several varieties of American birches. The wood is strong, hard, and of a yellow color. It is easily stained to resemble cherry or mahogany.

boxwood. A hard, tough, and fine-textured wood. It has a uniform yellow color and will take very small carved detail without breaking. It weighs about 58 pounds per cubic foot.

brazilwood. This wood has a rich bright-red color and is native to tropical America, Ceylon, India, and Malaya. At one time a great deal of brazilwood was used to produce dyes.

butternut. A wood that resembles walnut in most respects except color. It is a yellowish gray to gray brown and weighs 27 pounds per cubic foot.

camphor wood. A hardwood native to Formosa and other parts of the Far East. It has a strong camphor odor.

canaletta. Also called *canalete,* this is a hard, dense wood from the West Indies. The heartwood is purple.

cedar. Cedar ranges from yellow to brownish red in color, takes a beautiful polish, and is very durable. It weighs about 36 pounds per cubic foot.

cherry. This wood is brownish to light red in color, and darkens on exposure. Its texture is fine and even, and it takes a smooth polish. It weighs 40 pounds per cubic foot.

chestnut. A light-brown or yellowish wood. It has an open grain and splits fairly easily in nailing. It can be mistaken for oak, even though it is about 25 percent lighter. It weighs 32 pounds per cubic foot.

cocobola. A very hard, dense wood with a fine even texture. It ranges in color from yellow through red and purple. It is one of the finest carving woods, and takes a high polish without oil or wax. Cocobola sawdust can cause a rash similar to poison ivy, so care must be taken in its handling. The wood is very heavy, weighing from 75 to 85 pounds per cubic foot.

cottonwood. Sometimes called poplar, or whitewood, it is a soft wood of a yellowish-white color. It is easily worked, but is not strong, warps easily, and tends to split easily. It weighs about 30 pounds per cubic foot.

crab apple. A fine-grained wood suitable for fine carving. Its color is pinkish gray to light brown and it takes a fine natural polish with handling. It weighs 46 pounds per cubic foot.

curupay. A very hard wood used for sculpture and ornamental work. It has a reddish color and an attractive wavy grain. It is a South American wood weighing about 74 pounds per cubic foot.

cypress. There are a number of different species of cypress, and they vary in color from light brown to yellowish red or pink. It is a very durable wood with an open grain. It weighs 32 pounds per cubic foot.

degame. Also called *lemonwood,* this is a durable fine-grained hardwood that is yellow to creamy white in color.

dogwood. A very heavy hardwood with a fine, uniform texture. It is known for its ability to stay smooth under long rubbing, and is often used for shuttles in weaving.

Douglas fir. A strong, hard wood with an even, close grain. It does, however, have a tendency toward checking and splitting. It weighs 34 pounds per cubic foot.

ebony. A black, dense wood with a fine grain. It will take fine detail and a high polish. It comes from Africa, South America, and Asia, but the type from Ceylon is the blackest. Any gray streaks in the wood will turn black if brushed with unrefined crude oil. It weighs about 78 pounds per cubic foot.

elm. A tough, strong wood suitable for large wood carvings. It is very durable and is a whitish brown in color. It weighs about 36 pounds per cubic foot.

harewood. Also called *English sycamore,* this is a variety of maple, with a close, firm texture. It takes a fine polish and weighs 38 pounds per cubic foot.

hazel. A variety of hardwood with a straight grain and fine texture. It is a light reddish-brown color and weighs about 40 pounds per cubic foot.

hemlock. A coarse wood with an uneven texture. The wood is light colored with a pinkish tinge, and it splinters easily. It weighs about 28 pounds per cubic foot.

hickory. This wood has a fine, straight grain and is very tough. The sapwood is white and the heartwood is reddish brown. It weighs from 45 to 52 pounds per cubic foot.

holly. A fine-grained, heavy wood that is white in color. It will take detail without breaking or splitting and is valued for inlays. It is easily stained to resemble ebony. It weighs 47 pounds per cubic foot.

imbuya. A heavy South American hardwood with a figured grain. Because of its brownish-black color it is sometimes called *Brazilian walnut.*

iroko. An African hardwood very popular for carving. When cut, the wood is a straw color. With exposure to air, the surface hardens and the wood turns red.

ironwood. A very hard, tough wood that is brown in color and has a coarse, open grain. It weighs about 55 pounds per cubic foot. A Burmese wood called *Gangaw* is also known as ironwood. It is a red color and extremely hard. It weighs about 70 pounds per cubic foot.

ivorywood. A white wood with a straight grain and fine texture. It is sometimes used for wood engraving and inlay work.

jarrah. A wood from Western Australia. It is brick red in color, durable, and has a straight rippled grain. It carves well and takes a high natural polish. It weighs 55 pounds per cubic foot.

juniper. This wood is reddish in color and light in weight. It is soft and brittle, but durable.

kingwood. A hardwood with a very dark color streaked with yellow. It is imported from South America, and the wood polishes to a high luster. The grain is very uniform, and the wood weighs about 70 pounds per cubic foot.

koa. A lightweight, but hard and durable wood from Hawaii.

koko. This wood is also called *East Indian walnut* and is a hard, dense material, dark brown in color. It is found in tropical Asia and Africa, and weighs about 50 pounds per cubic foot.

lacewood. Also called *silky oak,* this is a brownish wood with a uniform texture and a straight grain. It comes from Australia, and weighs about 40 pounds per cubic foot.

lancewood. A wood from tropical America, it is yellowish in color and has a close, smooth grain. It has great strength and resiliency and is very hard. It weighs from 50 to 60 pounds per cubic foot.

laurel. The East Indian variety of this wood is sometimes used for carving. It is dark brown in color and is very strong.

lignum vitae. This is the hardest, heaviest, and densest of the commercial woods. The grain is uniform and fine, and the color is brown to greenish black. It is difficult to work, but has a high resistance to checking and cracking. It is found in tropical America, and weighs 80 to 90 pounds per cubic foot.

lime. A wood often used for sculpture, it is white to yellowish pink in color. It is moderately hard and takes a good polish. Easily stained or bleached, this wood weighs 33 pounds per cubic foot.

linden. *See* BASSWOOD *in this section.*

mahogany. There are numerous species of mahogany with colors ranging from golden brown to dark red. It is a coarse-textured wood that tends to split easily. It takes a fine polish, and weighs about 43 pounds per cubic foot.

maple. There are numerous species of maple in the United States and Canada. Red maple is easily worked and sometimes has a curly twisted grain. Birds-eye maple is a variety of sugar maple with a wavy grain that causes eyelike markings. The color of maples may be a yellowish white to brown. It takes a high polish, and weighs about 40 pounds per cubic foot.

oak. This is a strong, hard wood that withstands weathering and decay. White American oak is a firm-textured, coarse-grained wood useful for large surfaces. It weighs about 45 pounds per cubic foot.

padouk. Also called *corail* and *vermilion,* this is an African hardwood that is deep red in color.

pearwood. A hard wood with an even texture. It is amber in color and will hold delicate and detailed work.

peroba. A rose-colored wood from Brazil. It is a hardwood with a firm, close grain.

pine. There are numerous species of pine. *Northern white pine* has colors ranging from pink to yellow, and has distinct grain markings. It is good for carving and weighs 25 pounds per cubic foot. *Ponderosa pine* has a fine grain and finishes well. It is soft and easily worked, and weighs about 28 pounds per cubic foot. *Sugar pine* is yellowish white with a straight grain. It is durable and easily carved. It weighs about 25 pounds per cubic foot.

plane. *See* SYCAMORE *in this section.*

poplar. *See* COTTONWOOD *in this section.*

prima vera. A Central American hardwood sometimes called *white mahogany.*

purpleheart. *See* AMARANTH *in this section.*

red alder. A reddish-brown wood with a fine, even grain. It is very tough, can be easily worked, and takes a high polish. It is durable even in damp climates. It weighs 28 pounds per cubic foot.

rosewood. Several species of this wood exist, with colors ranging from a dark brown to purple. It is hard and heavy, and takes a very fine polish. Brazilian rosewood is also called *jacaranda* and *palisander.* It is a purple-red color. East Indian rosewood has more of a striped grain and is colored from straw yellow to red. Honduras rosewood is the lightest color of all. African rosewood has very good durability and is called variously *bubinga, bois de rose d'Afrique,* and *faux bois de rose du Congo.* Rosewood weighs about 54 pounds per cubic foot.

sandalwood. A wood from Southern Asia. The heartwood is sometimes used for small carved work and for boxes and chests.

satinwood. Different varieties of this wood come from Brazil, East India, and San Domingo. It is a golden-colored wood with a hard texture and figured grain. The Brazilian variety is sometimes called *canary.*

snakewood. A wood from Indonesia, also called *letterwood.* It is reddish brown with spots which resemble the markings of snakes. It is a very dense wood.

spruce. Eastern spruce is a soft wood, but fairly strong and close-grained. It has fair workability, and weighs about 32 pounds per cubic foot.

sycamore. Also called *plane tree,* this wood is a whitish-yellow color that turns light brown with exposure to air. It is easily carved and takes a fine polish. The wood is tough and has a straight grain. It must be protected from weather since it rots easily. It weighs about 38 pounds per cubic foot.

teak. Several varieties are found in different parts of Indonesia. The wood is a rich golden-brown color, sometimes with a wavy grain. It is very durable and has great strength. It is well-suited for carving large figures, and weighs 41 pounds per cubic foot.

tigerwood. A variety of African walnut.

vermilion. *See* PADOUK *in this section.*

walnut. This hardwood grows in many places and is generally dark brown to black in color. The wood is firm, has a lustrous surface, and takes a high polish. It has great uniformity of texture, and does not split easily. It weighs from 45 to 50 pounds per cubic foot. *American walnut,* or *black walnut,* is a popular material for carving. It is usually dark brown in color, takes a beautiful polish, and is very durable.

white afara. An African hardwood that is even in texture and carves fairly well, but splits easily. It is a straw-colored wood weighing from 30 to 40 pounds per cubic foot.

willow. A straight-grained wood that is brownish-yellow in color. It is fairly soft, does not shrink, and is very durable. It weighs 30 pounds per cubic foot.

yew. A wood with a fine decorative grain, excellent for wood carving. It weighs 46 pounds per cubic foot.

woodworking tools Following are some of the standard tools used in woodworking and carpentry.

awl. A pointed tool in a wooden handle used for starting holes for nails or screws.

bits. Tools for boring holes. They vary widely in size and are used in power tools of all kinds and also with hand drills and hand braces.

chisels. There are numerous chisels used in carpentry. Paring chisels are used for light work, while framing or mortise chisels are employed for heavy-duty work where deep cuts are necessary. Slicks are chisels with wide blades and long handles. Gouges are chisels with hollow-shaped blades and are used for scooping operations. All wood chisels bear classifications that refer to the length of their blades. Regular lengths are butt chisels (from $2\frac{1}{2}$ to $3\frac{1}{4}$ inches), pocket chisels (from 4 to 5 inches), and mill chisels (from 8 to 10 inches).

clamps. Used for tightly joining pieces of wood after they have been glued. Clamps can be roughly classified as single-screw jaw (C clamp), double-screw, beam, miter, and chain.

drawknife. A tool consisting of a large, sharp knife with a handle at each end. It is used for trimming wood by pulling the knife toward the user. The blades are made in various shapes for a variety of uses.

awl

auger bit

chisels (woodworking)

drawknife

files and rasps. Tools having a surface covered with sharply edged furrows or teeth. They are used for abrading or smoothing the surfaces of metal or wood. A file consists of a number of V-shaped projections and is used for smoothing operations on wood and soft metal. A rasp has sharp, projecting points and is used for shaping and smoothing wood.

gimlets. A T-shaped tool with a steel shank and a wooden head used to make small holes in wood, thus making it easier to start nails or screws.

hammers. Tools used for driving nails and tacks. The most common variety has a claw arrangment behind the head and is used for pulling out nails. There are also ball-, cross-, and straight-peen hammers, soft-faced hammers, and riveting hammers.

hand brace. An instrument used for drilling holes. The turning movement of a brace is applied to the bit by a handle swing.

hand drill. An instrument used for drilling small holes. It is operated with the turning motion of a crank.

miter box. A device used for cutting lumber at specific angles.

oilstones. Stones used to put a sharp edge on tools. So-called because oil is used on them to carry off the friction-produced heat and to wash away particles of stone and steel. The process of rubbing the tool on the stone is called honing. One of the best stones is a natural material called *washita* oilstone and is found in the Ozark mountains. It is almost pure silica. *Lily white washita* is the best of the several grades. Other good materials are arkansas oilstone (hard and soft) and such artificial materials as Carborundum and india oilstones, both of which are available in three grades—fine, medium, and coarse.

plane. A plane is used for smoothing boards or other wood surfaces. There are numerous designs for different purposes, including the block, chamfer, fillister, fore, grooving, jack, jointer, molding, rabbet, router, and smoothing planes.

saws. The ordinary *handsaw* consists of a thin, flat blade having a row of teeth along one edge. The number of teeth per inch determines the fineness or coarseness of the saw's cut. A *ripsaw* (for sawing

gimlet

hammers

hand brace

hand drill

jack plane

with the grain of wood) has about 6 teeth per inch, while a *crosscut* saw has 7 or 8 teeth per inch. A *backsaw* is a smaller version of the handsaw and is used for fine work such as making joints. It has about 14 teeth per inch. A *keyhole* or *compass* saw has a very small, narrow blade with a pistol-grip handle. It is used for cutting along curves or in small work of all kinds. A *coping* saw has a thin, narrow blade and is used for cutting curves in thin wood. A *hacksaw* has a sturdy blade in a fairly heavy frame. It is normally used for cutting metal, but is also used for wood. It has blades with from 14 to 32 teeth per inch. A *circular* saw is a power saw used for ripping, crosscutting, beveling, mitering, and, with special attachments, grooving and dadoing. Another unit of power equipment is the *band* saw. It consists of an endless steel belt with saw teeth on one edge. In small-shop operation this saw will have a blade from $\frac{1}{2}$ to 1 inch wide. It is used for curved cuts, scroll work, and other fine cutting. A *jig* saw is also power-driven and can be used for even finer work than a band saw. The blade, which is quite short, is operated in a rapid up and down movement.

screwdriver. A tool similar to a chisel but with a blunt working end. It is used for tightening screws. An automatic screwdriver has a rachet drive and saves considerable time and effort. Two or three strokes with a spiral-rachet screwdriver does the work of about 25 turns on an ordinary screwdriver. There are also attachments for electric drills that simplify the task of driving screws.

spokeshave. A small tool resembling a modified drawknife but, when used, it is pushed away from the user. It is used for making smooth curved edges and for rounding irregular surfaces. It is made with cutters of various shapes, such as straight, round, hollow, and angular.

squares. Tools used for measuring angles when cutting wood. A *try square* measures 90-degree angles. It consists of a steel blade mounted at right angles in a wooden stock. A *miter square* has a blade set at an angle of 45 degrees. A combination *try-and-miter square* will measure both 45- and 90-degree angles. A *framing square* is an L shaped tool consisting of a shorter, narrower part called the tongue, and a longer, wider part called the body. The most commonly used size

Handsaw

Backsaw

Keyhole or compass saw

Coping saw

Hacksaw

saws

spokeshave

Ordinary screwdriver

Spiral ratchet screwdriver

screwdrivers

framing square

has an 18-inch body and a 12-inch tongue. On the face of this tool are engraved a number of useful scales and tables.

wrenches. Tools used for tightening nuts on bolts. They are classified as plain, adjustable, and socket wrenches.

wrap A wrap in a book or magazine is an insert, usually on a different stock, that is not tipped in but has been wrapped around one of the signatures. It usually consists of at least two leaves (four pages) and is stitched into the binding as securely as any other pages.

X, Y, Z

yardstick compass A simple arrangement consisting of two fully adjustable clips that slide on an ordinary yardstick. One has a sharp point, and the other has a pencil holder. It is used for making large, accurate circles.

yardstick compass

bibliography

Abels, Alexander, *Painting: Materials and Methods,* Pitman Publishing Corporation, New York, 1959.

Adeline, Jules, *The Adeline Art Dictionary,* Frederick Ungar Publishing Co., New York, 1966.

Adhesive Products Corporation, 1660 Boone Ave., Bronx, N.Y. 10460. Molding and casting materials catalogs.

Advance Process Supply Company, Chicago. Screen process materials catalogs.

Agfa-Gevaert, Inc., 275 North St., Teterboro, N.J. 07608. Photographic and graphic arts data sheets.

A. I. Friedman, Inc., 25 W. 45 St., New York. Artists' materials catalogs.

Aller, Doris, and Diane Lee Aller, *Mosaics,* Lane Book Co., Menlo Park, Calif., 1965.

The American Crayon Company, 1706 Hayes Ave., Sandusky, Ohio 44870. Miscellaneous art supply catalogs.

Art Materials Buyers Guide, American Artist, New York, issued annually.

Arthur Brown & Bro., Inc., 2 W. 46 St., New York 10036. Art supply catalogs.

Atlantic Powdered Metals, Inc., 225 Broadway, New York 10017. Metallic powders catalogs.

Bahti, Tom, *Southwestern Indian Arts and Crafts,* KC Publications, Flagstaff, Ariz., 1964.

Barber, Philip, *New Scene Technicians Handbook,* Holt, Rinehart and Winston, Inc., New York, 1948. Theatrical scene construction.

Bazzi, Maria, *The Artist's Methods and Materials,* John Murray (Publishers), Ltd., London, 1960.

Bergen Arts and Crafts, Inc., Shetland Industrial Park, Box 689, Salem, Mass. 01971. Miscellaneous catalogs.

Bienfang Paper Company, Inc., Linsley Place & Amboy Ave., Metuchen, N.J. Paper samples and catalogs.

Binney & Smith, Inc. (The Studio), 380 Madison Ave., New York 10017. Art material catalogs and data sheets.

Blu-Ray, Inc., Essex, Conn. 06426. Reproduction Guide of the International Association of Blue Print and Allied Industries.

Bocour Artist Colors, Inc., 552 W. 52 St., New York 10019. Art materials catalogs.

Brady, George S., *Materials Handbook,* 9th ed., McGraw-Hill Book Company, New York, 1963.

Capitol Stage Lighting Company, Inc., 527–529 W. 45 St., New York. Miscellaneous lighting catalogs.

Carroll, John S., *Photo Lab Index,* Morgan & Morgan, Inc., New York, 1964.

Chaet, Bernard, *Artists at Work,* Webb Books, Inc., Cambridge, Mass., 1960.

Cole Ceramic Laboratories, Gay Street, Sharon, Conn. 06069. Miscellaneous ceramics catalogs.

Colonial Process Supply Company, 180 E. Union Ave., East Rutherford, N.J. Screen process supply catalogs.

Commercial Standard CS98-62, Artists' Oil Paints, U.S. Department of Commerce, 1962.

Cotton Fiber Paper Manufacturers, 122 E. 42 St., New York 10017. Miscellaneous paper data sheets.

Crafters, Inc., Cascade, Wis. 53011. Craft materials catalogs.

The Craftool Company, Wood-Ridge, N.J. 07075. Arts and crafts catalogs, instruction sheets, and data sheets.

Crescent Cardboard Company, 1240 N. Homan Ave., Chicago 60651. Paper catalogs and samples.

Dawson, Robert, and Joan Dawson, *Sculpture with Simple Materials,* Lane Book Co., Menlo Park, Calif., 1966.

Delta Brush Manufacturing Company, 120 S. Columbus Ave., Mt. Vernon, N.Y. 10553. Art supply catalogs.

Derujinsky, G., "Wood for Sculpture," *National Sculpture Review,* Winter, 1966–1967.

Dick Blick, P.O. Box 1267, Galesburg, Ill. 61401. Miscellaneous art supply catalogs.

The Dictionary of Paper, 3d ed., American Paper and Pulp Association, New York, 1965.

Directory of Art and Craft Materials, Art Material Trade News, Chicago, revised annually.

Douglas and Sturgess, 730 Bryant St., San Francisco 94107. Modeling and molding materials catalogs.

Dow Corning, Midland, Mich. Miscellaneous RTV silastic catalogs and data sheets.

Duddle, R. S., *The Craft of the Metalworker,* The Technical Press, Ltd., London, 1951.

Eastlake, Charles, *Methods and Materials of the Great Schools and Masters,* 2 vols., London, 1869. Reprinted by Dover Publications, Inc., New York, 1960.

Eastman Kodak Company, 343 State St., Rochester, New York 14650. Miscellaneous catalogs and data sheets.

Eberhard Faber Pen and Pencil Company, Crestwood, Wilkes-Barre, Pa. 18703. Miscellaneous catalogs.

Economy Handicrafts, Inc., 47–11 Francis Lewis Blvd., Flushing, N.Y. 11361. Crafts catalogs.

Erwin M. Riebe Corporation, 149 E. 60 St., New York. Art supply catalogs.

Fezandie and Sperrle, Inc., 103 Lafayette St., New York 10013. Catalogs of colors and dyes.

The Focal Encyclopedia of Photography, Focal Press, Inc., New York, 1965.

The Franklin Glue Company, 2020 Bruck St., Columbus, Ohio 43212. Data sheets, adhesive comparison charts, and catalogs.

Freytag, H., *Reinhold's Photo and Movie Book,* Reinhold Publishing Corporation, New York, 1964.

Garland, Ken, *Graphics Handbook,* Reinhold Publishing Corporation, New York, 1966.

General Aniline and Film Corp., 140 W. 56 St., New York 10020. Dye and chemical catalogs and data sheets.

General Electric Company, Waterford, N.Y. RTV silicone rubber data sheets.

Gettins, R. J., and G. L. Stout, *Painting Materials: A Short Encyclopedia,* 1942. Reprinted by Dover Publications, Inc., New York, 1966.

Gibbia, S. W., *Wood Finishing and Refinishing,* D. Van Nostrand Company, Inc., Princeton, N.J., 1954.

Giesecke, Mitchel, and Spencer, *Technical Drawing,* The Macmillan Company, New York, 1949.

Goodway Printing Company, 4030-40 Chestnut Street, Philadelphia, Pa. Miscellaneous printing booklets.

Graphic Chemical and Ink Company, 728 N. Yale Ave., Villa Park, Ill. 60181. Printmaker's materials catalogs and data sheets.

Handbook of Chemistry and Physics, 46th ed., Chemical Rubber Publishing Company, Cleveland, 1966.

Harold M Pitman Company, 515 Secaucus Road, Secaucus, N.J. 07094. Graphic arts supply catalogs.

Higgins Ink Company, 271 Ninth St., Brooklyn, N.Y. 11215. Miscellaneous ink and paint catalogs.

Hoffman, Malvina, *Sculpture Inside and Out,* Bonanza Books, New York, 1939.

Ickis, Marguerite, *Arts and Crafts,* A. S. Barnes and Co., Inc., New York, 1966.

Inko Screen Process Supplies Mgf. Co., 1199 E. 12th St., Oakland, Calif. Screen process catalogs.

Interchem Printing Inks, 67 W. 44 St., New York 10036. Miscellaneous ink catalogs.

Kay, Reed, *The Painter's Companion,* Webb Books, Cambridge, Mass., 1964.

Kliegl Bros. Universal Electric Stage Lighting Co. Inc., 321 W. 50 St., New York, N.Y. Lighting equipment catalogs.

Koh-I-Noor/Pelikan, 100 North St., Bloomsbury, N.J. 08804. Artists' materials catalogs.

Laurie, A. P., *The Painter's Methods and Materials,* 1960. Reprinted by Dover Publications, Inc., New York, 1967.

Levitan, Eli, *Alphabetical Guide to Motion Picture, Television, and Videotape Production,* McGraw-Hill Book Company, New York, 1968.

Lumsden, E. S., *The Art of Etching,* 1924. Reprinted by Dover Publications, Inc., New York, 1962.

Magnan, George, *Visual Art for Industry,* Reinhold Publishing, Corporation, New York, 1961.

Mascelli, J. V., ed., *American Cinematographer Manual,* American Society of Cinematographers, Hollywood, Calif., 1966.

Massey, Robert, *Formulas for Painters,* Watson-Guptill Publications, New York, 1967.

Maurello, S. Ralph, *Commercial Art Techniques,* Tudor Publishing Company, New York, 1963.

Mayer, Ralph, *The Artist's Handbook of Materials and Techniques,* The Viking Press, Inc., New York, 1965.

Melcher, Daniel, and Nancy Larrick, *Printing and Promotion Handbook,* 3d ed., McGraw-Hill Book Company, New York, 1966.

Meyer, Herbert, "Plastics, Materials and Technologies for Use in Motion-Picture Studio Production," *Journal of the SMPTE* (Society of Motion Picture and Television Engineers), vol. 76, February, 1967.

M. Grumbacher, Inc., 460 W. 34 St., New York 10001. Artists' materials catalogs and data sheets.

Minnesota Mining and Manufacturing Co. (3M Company), 2501 Hudson Road, St. Paul, Minn. 55119. Art products catalogs.

National Art Materials Trade Association (NAMTA), 182 A Blvd., Hasbrouck Hts., N.J. 07604. Miscellaneous training manuals and data sheets.

National Steel and Copperplate Company, 700 S. Clinton St., Chicago. Photoengraving supplies catalogs.

Neblette, C. B., *Photography: Its Principals and Practice,* D. Van Nostrand Company, Inc., Princeton, N.J., 1949.

Ninth Graphic Arts Production Yearbook, Colton Press, Inc., New York, 1950.

Ormsbee, T. H., *Care and Repair of Antiques,* Gramercy Publishing, New York, 1949.

Parker, Dean H., *Principles of Surface Coating Technology,* John Wiley & Sons, Inc., New York, 1965.

Pelikan-Werke (Gunther Wagner), Hanover, Germany. Ink catalogs and data sheets.

Pentel International, 333 N. Michigan, Chicago 60601. Art and writing materials catalogs.

Permanent Pigments, Inc., 2700 Highland Ave., Cincinnati 45212. Art materials catalogs and data sheets.

Pittaro, Ernest M., *TV and Film Production Data Book,* Morgan and Morgan, Inc., New York, 1959.

Pittsburg Paints. Catalogs and buying guides.

Plasticrafts, Inc., 2800 N. Speer, Denver, Colorado 80211. Adhesives and plastics catalogs and data sheets.

Pocket Encyclopedia of Paper and Graphic Arts Terms, Thomas Printing and Publishing Co., Ltd., Kaukana, Wis., 1960.

Pocket Pal, 9th ed., International Paper, New York, 1966.

Rembrandt Graphic Arts Company, Stockton, N.J. 08559. Graphic arts equipment catalogs.

Rohm and Haas Company, Philadelphia, Pa. 19105. Plexiglas data sheets.

Sculpture Associates, 114 E. 25 St., New York 10010. Sculpture supply catalogs.

Sculpture House, 38 E. 30 St., New York 10016. Sculpture supply catalogs.

Sculpture Services, Inc., 9 E. 30 St., New York 10003. Sculpture supply catalogs.

Shiva Artists' Colors, 10th & Monroe, Paducah, Ky. 42001. Artists' materials data sheets.

Skinner, Freda, *Wood Carving,* Bonanza Books, New York, 1961.

S.O.S. Photo-Cine-Optics, 387 Park Ave. S., New York. Motion picture equipment catalogs.

Stanley, Thomas B., *The Technique of Advertising Production,* Prentice-Hall, Inc., Englewood Cliffs, N.J., 1950.

Stevenson, George A., *Graphic Arts Encyclopedia,* McGraw-Hill Book Company, New York, 1968.

Stewart Clay Company, Inc., 133 Mulberry St., New York. Pottery supplies catalogs.

The Story of the Plastics Industry, The Society of the Plastics Industry, Inc., New York, 1965.

Sylvania, 730 Third Ave., New York 10017. Lighting data sheets.

Talens and Son, Iorio Court, Union, N.J. 07083. Miscellaneous art supply catalogs.

Taubes, Fredric, *The Mastery of Oil Painting,* Bramhill House, New York, 1953.

Taylor, Joshua C., *Learning to Look: A Handbook for the Visual Arts,* The University of Chicago Press, Chicago, 1957.

The Tension Envelope Corporation, 270 Madison Ave., New York 10016. Paper and graphic arts literature.

Thompson, Daniel V., *The Materials and Techniques of Medieval Painting,* 1936. Reprinted by Dover Publications, Inc., New York, 1956.

United States Gypsum, 300 W. Adams St., Chicago. Plaster and cement data sheets and catalogs.

Utrecht Linens, 119 W. 57 St., New York. Art supply catalogs.

Van Nostrand's Scientific Encyclopedia, D. Van Nostrand Company, Inc., Princeton, N.J., 1947.

Varn Products Co., Inc., 26-15 123rd St., Flushing, N.Y. 11354. Graphic arts catalogs.

Weber, W., *A History of Lithography,* McGraw-Hill Book Company, New York, 1966.

Wescott & Thompson, Inc., 1027 Arch St., Philadelphia, Pa. Typography catalogs and information sheets.

Weyerhauser Company, Paper Division, 230 Park Ave., New York 10017. Paper catalogs.

Winsor and Newton, Inc., 555 Winsor Drive, Secaucus, N.J. 07094. Artists' materials catalogs.

Wolf, Martin L., *Dictionary of the Arts,* Philosophical Library, Inc., New York, 1951.

Wood Handbook, U.S. Department of Agriculture, 1955.

Woody, R.O., Jr., *Painting with Synthetic Media,* Reinhold Publishing Corporation, New York, 1965.

index

241